Experimental Layout

Published and distributed by RotoVision SA

Sales, Production & Editorial Office
Sheridan House, 112–116A Western Road
Hove, East Sussex, BN3 1DD, UK

Tel: +44 (0)1273 72 72 68
Fax: +44 (0)1273 72 72 69
Email: sales@rotovision.com
Website: www.rotovision.com

ISBN 2-88046-610-5

10 9 8 7 6 5 4 3 2 1

Design by Visual Research

Photography by Xavier Young, London, except for pp. 38, 40, 71, 83, 85, 87,
92, 93, 94–95, 96–97, 112–113, 114, 115, 136, 137, 138–139, 144, 145 by
Sarah Dryden and Keith Woodland at the University of Portsmouth.

Glossary of terms by Tony Pritchard, Ian Noble and Russell Bestley
Glossary diagram by Tony Pritchard

Production and separations by ProVision Pte. Ltd., Singapore
Tel: +65 334 7720 Fax: +65 334 7721
Printed and Bound in China by Midas Printing Ltd

Experimental Layout

Ian Noble & Russell Bestley

160201

contents

DESIGN FUNDAMENTALS: EXPERIMENTAL LAYOUT

introduction

EXPERIMENTATION IS AN ANTICIPATION OF INNOVATION

>GRAPHIC DESIGN, A PROFESSION FOR SO LONG CONCERNED WITH COMMERCIAL APPLICATION AND FACILITATION, HAS IN RECENT YEARS BEGUN TO REDEFINE ITS ACTIVITIES. PART OF THIS DISCUSSION HAS BEEN TO EMBRACE THE NOTION OF DESIGN NOT ONLY AS A PRODUCT BUT ALSO AS PROCESS — AS A VISUAL COMMENTARY OR DOCUMENTARY. THE EXPLORATION OF ALTERNATE WAYS IN WHICH WE MIGHT REGARD GRAPHIC DESIGN HAS BEEN AN INWARD-LOOKING ONE, BUT HAS HAD A PROFOUND IMPACT ON CONTEMPORARY DESIGN AND THE AWARENESS OF THE ACTIVITY BY A WIDER AUDIENCE — THE CONSUMERS OF DESIGN, THOSE WE AIM TO COMMUNICATE WITH.

>THE INVESTIGATION OF THESE NEW APPROACHES COULD BE ENTITLED RESEARCH, BUT GRAPHIC DESIGN ITSELF COULD BE CALLED 'VISUAL RESEARCH'. THIS BOOK EXPLORES THAT NOTION, AND IS CONCERNED WITH LAYOUT AND GRAPHIC DESIGN FROM DESIGNERS AROUND THE WORLD THAT MIGHT BE CONSIDERED EXPERIMENTAL. BUT WHAT IS MEANT BY THIS? PERHAPS IT IS THE CONSIDERATION OF WORK WHICH IS SPECULATIVE IN ITS OUTCOME, OR IS TO SOME EXTENT ONGOING, RATHER THAN ULTIMATELY RESOLVED AS A VISUAL STYLE. THE WORK OF THE DESIGNERS FEATURED IN THE FORTHCOMING PAGES IS UNITED IN ITS CONCERN TO TRY DIFFERENT AND CHALLENGING APPROACHES, NOT FOR THE SAKE OF BEING DIFFERENT BUT BECAUSE IT IS GROUNDED IN DIFFERENCE.

>MANY OF THE LAYOUTS INCLUDED HERE CAN BE REGARDED AS VISUALLY EXPERIMENTAL, OFFERING THE READER A RANGE OF EXCITING OR UNUSUAL VISUAL CONUNDRUMS, GIVING CLUES TO THE MESSAGE WITHOUT 'CLOSING IT DOWN'. OTHER WORK BY DESIGNERS OR DESIGN GROUPS HAS BEEN CHOSEN BECAUSE IT REPRESENTS WHAT COULD BE TERMED CONCEPTUAL EXPERIMENTATION — THE MESSAGE HERE CAN BE DEDUCED FROM THE SIGNIFICATION OF VISUAL OR TEXTUAL ELEMENTS WITHIN THE WHOLE. IN EACH CASE, THE DESIGNER HAS WORKED TO QUESTION OR TO EXTEND THE BOUNDARIES OF THE DISCIPLINE, TO FIND NEW TERRITORIES TO EXPLORE BOTH WITHIN THE REPRESENTATION OF A PERSONAL VISUAL STYLE AND THROUGH THE MEANS OF COMMUNICATION ITSELF — THE VOCABULARY OF THEIR PRACTICE.

visual research

>THIS WORK DOES NOT REJECT THE MAINSTREAM CONCERNS OF THE DISCIPLINE IN A COMMERCIAL SENSE, BUT OFTEN INDICATES NEW RELATIONSHIPS BETWEEN INVESTIGATION THROUGH RESEARCH AND THE INDUSTRY, OR BUSINESS, OF GRAPHIC DESIGN. LAYOUT IS CENTRAL TO THIS DISCUSSION, NOT ONLY IN TERMS OF THE INTERNAL CONSIDERATIONS WITHIN A SINGLE OR SERIATED DESIGN BUT ALSO THE CONSIDERATION OF AN EXTERNAL OR WIDER CONTEXT. AMERICAN DESIGNER AND WRITER KATIE SALEN HAS ARGUED THAT WE NEED TO RECOGNISE THE MERIT OF EXPERIMENTATION AS A TOOL OF CONSEQUENCE; IT IS NOT 'JUST AN EXPERIMENT' BUT AN ACTIVE INVESTMENT RATHER THAN A SITUATIONAL ACTIVITY, A WAY OF PROCEEDING IN THE 'REAL' WORLD.

>RESEARCH AND EXPLORATION ARE KEY ELEMENTS IN THE GROWTH OF A DISCIPLINE. GRAPHIC DESIGN CONTINUES TO ADJUST, AND TO ACCOMMODATE, NEW APPROACHES WHICH DEFINE THE ACTIVITY OF WHAT HAS BEEN CALLED VISUAL COMMUNICATION. THE BREADTH OF THE FIELD IS NOW NO LONGER ONLY CONTAINED BY THE VOCATIONAL DEMANDS OF TECHNICAL RATIONALITY AND COMPETENCE. IN FACT THE DISCIPLINE HAS TO AN EXTENT BECOME ITS OWN BENEFACTOR, AND THE MORE ECLECTIC AND IDIOSYNCRATIC METHODS OF DESIGNERS AND DESIGN GROUPS SUCH AS TOMATO OR GRAPHIC THOUGHT FACILITY IN LONDON, UK, HAVE BECOME SIGNIFICANT FACTORS IN THE FURTHER DEVELOPMENT OF THE SUBJECT IN GENERAL. THE NEW TECHNOLOGIES, IN PARTICULAR THE MAC, HAVE CHALLENGED THE ACCEPTED 'RULES' OF DESIGN AND WE HAVE BEEN FORCED TO CONSIDER WHAT THE RESULTING NEW RULES MIGHT BE. IN

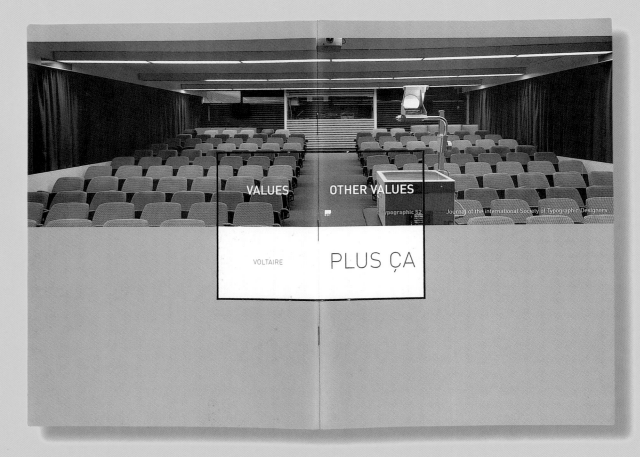

THE PROCESS OF DOING THIS WE ARE LEARNING TO CONSIDER NEW VISUAL LANGUAGES, IDEAS AND METHODS, WHILE CREATING A NEW DESIGN VOCABULARY TO DESCRIBE THEM. THIS DESCRIPTIVE LANGUAGE, DEVELOPED IN PART FROM WITHIN THE DISCIPLINE ITSELF, WILL CONTINUE TO BE A KEY FACTOR IN THE MATURATION OF GRAPHIC DESIGN.

>A SIGNIFICANT DEVELOPMENT WITHIN THIS NEW VOCABULARY HAS ALSO OCCURRED THROUGH THE BORROWING OF THEORETICAL CONCERNS FROM OTHER RELATED DISCIPLINES WITHIN THE HUMANITIES WHICH — UNLIKE GRAPHIC DESIGN — HAVE, AS VICTOR MARGOLIN DESCRIBES, "long traditions of debate over theory, style and purpose". THIS PROCESS IS PART OF THE ONGOING (RE)DEFINITION OF GRAPHIC DESIGN. TRADITIONALLY, THE SUBJECT HAS DEFINED ITSELF EITHER BY ITS

design as process

RELATIONSHIP TO OTHER RELATED ACTIVITIES SUCH AS ADVERTISING, OR IN RESPONSE TO TECHNOLOGICAL DEVELOPMENTS — CREATING WHAT COULD BE DESCRIBED AS A DISCIPLINE OR FIELD WITHOUT A SPECIFIC SUBJECT MATTER OF ITS OWN. GUNNAR SWANSON DESCRIBES GRAPHIC DESIGN AS A PROCESS EXISTING "in practice only in relation to the requirements of given projects", REACTING TO EXTERNAL STIMULI AND THE NEEDS OF CLIENT AND AUDIENCE, BUT LACKING A CENTRAL CORE OF ACTIVITY BY WHICH TO DEFINE ITSELF. THE EMERGENCE OF A DISCOURSE FROM WITHIN GRAPHIC DESIGN — DEBATING AND QUESTIONING ITS OWN ACTIVITY — SUGGESTS THE ARRIVAL AT A KEY POINT IN ITS EXISTENCE. IT ALSO MARKS THE BEGINNING OF WHAT MIGHT BE CALLED AN EPISTEMOLOGY OF GRAPHIC DESIGN — THE DETERMINATION OF THE GROUNDS OF KNOWLEDGE OF THE DISCIPLINE AND THE PROFESSIONALISATION OF THE SUBJECT.

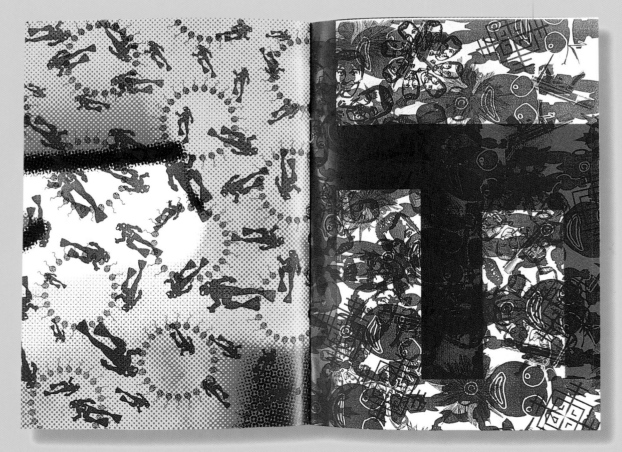

THIS RETHINKING MUST CONSIDER THE TECHNICAL, PRACTICAL AND AESTHETIC DEMANDS OF THE DISCIPLINE ALONGSIDE THEORETICAL CONCERNS REGARDING ITS POSITIONING WITHIN A WIDER CULTURE.

Theory and Practice

>A DEGREE OF CYNICISM OR SUSPICION PERSISTS AMONGST DESIGNERS REGARDING THE ATTEMPTS MADE TO REDEFINE THE ACTIVITY OF GRAPHIC DESIGN. KATHERINE MCCOY, FORMER CO-CHAIR OF POST-GRADUATE DESIGN AT THE CRANBROOK ACADEMY OF ART, MICHIGAN, US, A DESIGN SCHOOL RESPONSIBLE FOR SOME OF THE MORE SIGNIFICANT ATTEMPTS TO INTEGRATE THEORETICAL APPROACHES INTO DESIGN PRACTICE AND EDUCATION, DESCRIBES THIS SITUATION; "Another thing one hears

spatial dynamics

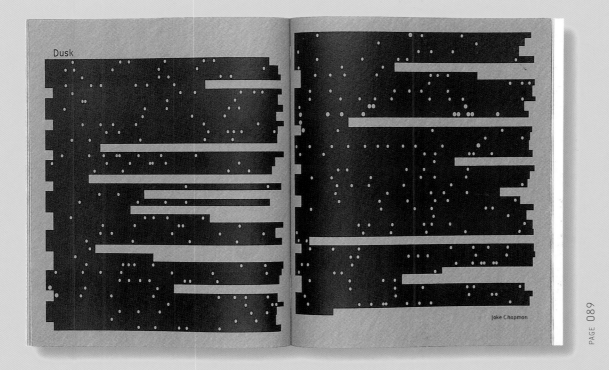

Dusk

Jake Chapman

PAGE 089

frequently when explaining a little theory to a group of designers is, 'Well, I knew that anyway.' In a way that is exactly right. That is the whole point of theory – theory explains phenomena and dynamics that exist out there. You might have known instinctively that a piece of graphic design is successful, but theory helps to explain why it is successful – and hopefully the theory can also translate into some sort of guiding strategy as well."

>THE CAUTION EXHIBITED BY SOME GRAPHIC DESIGNERS WITH REGARD TO A MORE INTELLECTUAL OR THEORETICAL APPROACH TO THE PROCESS OF VISUAL COMMUNICATION REVEALS NOTHING MORE THAN THE IMMATURITY OF A DEVELOPING DISCIPLINE, WHICH EVOLVED METEORICALLY OVER A RELATIVELY SHORT PERIOD OF TIME DURING THE LAST CENTURY.

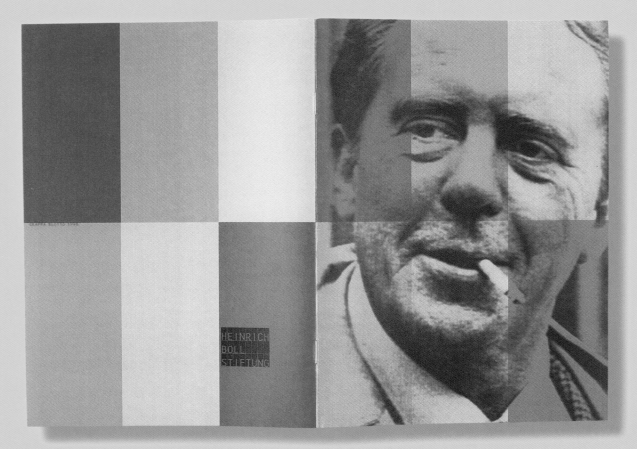

OFTEN THE DEBATES OF OTHER RELATED AREAS HAVE SEEMED MORE CONVINCING, AND DESIGNERS HAVE BEGUN TO APPROPRIATE NOT ONLY THE DESCRIPTIVE LANGUAGES BUT ALSO SOME OF THE METHODOLOGIES EMPLOYED. AS A NATURAL PROCESS OF DEVELOPMENT, THIS HAS ALLOWED DESIGNERS TO VIEW THE INTENTIONS AND CONCERNS OF THEIR PROFESSION IN A DIFFERENT LIGHT, AND HAS LED TO A DEBATE WITHIN GRAPHIC DESIGN ITSELF CENTRED ON A CRITICAL REFLECTION AND ANALYSIS OF THE ACTIVITY, ASSESSING IT AS AN INTELLECTUAL APPROACH AND AS PRACTICE. THIS BOOK UTILISES THAT DEVELOPMENT AS ITS STARTING POINT, AND ATTEMPTS TO ENGAGE WITH A SERIES OF EXAMPLES OF WORK BY CONTEMPORARY DESIGNERS WHICH DEMONSTRATE A RANGE OF INSIGHTS BEYOND THEIR FORMAL STRUCTURE, IN TURN REFLECTING ON THE ACTIVITY OF GRAPHIC DESIGN PRACTICE ITSELF.

words and pictures

PAGE 040

>THE DISCUSSION OF THE WORK CONTAINED IN THIS BOOK IS AN ATTEMPT TO EXPLAIN THE DIFFERENT APPROACHES ADOPTED BY THE DESIGNERS FEATURED. NOT ONLY THE STRUCTURE OR PROCESSES EMPLOYED ARE EXPLORED BUT ALSO THE CONTEXT OF THE WORK — ITS RELATIONSHIP TO THE CONTENT AND MESSAGE AND TO ITS INTENDED AUDIENCE. DESIGN DOES NOT EXIST IN A VACUUM OF ITS OWN MAKING; IT RESPONDS NOT ONLY TO THE CLIENT AND PRODUCT BUT ALSO TO THE SITUATION WITHIN WHICH IT EXISTS. THE DESIGNER WORKS SYSTEMATICALLY TO SYNTHESISE A RANGE OF FACTORS; FROM THE TECHNICAL AND THE FINANCIAL, TO THE SOCIAL, THE POLITICAL AND THE PERSONAL. THIS FUSING TOGETHER OF ELEMENTS, BOTH IN A PRACTICAL, FORMAL SENSE AND THROUGH THE INTERMEDIARY ROLE PLAYED IN THE DIALOGUE BETWEEN CLIENT AND (INTENDED) AUDIENCE, IS AT THE CORE OF THE DESIGNER'S ACTIVITY.

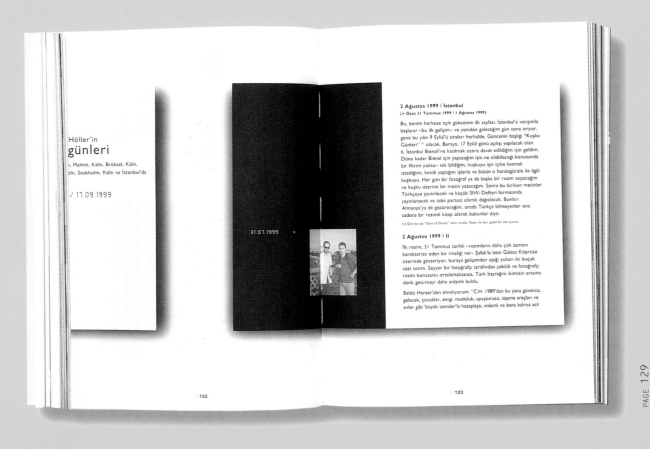

>Often the effects of graphic design can be underestimated by those responsible for its production, and it remains largely unnoticed by those that consume it. Yet its influence is far-reaching — the very invisibility of design allows it to inform and persuade on a level denied to many other media. From the moment we awake we are exposed to the effects of graphic design, from the layout of our morning newspaper or the title sequence of a breakfast TV programme, to the shop fronts and signage systems we pass on the way to work, and the supermarket packages that fill the spaces in our cupboards. At times intrusive, informative, seemingly essential or downright superficial, design surrounds us and we spend our lives immersed in the environment it creates — documenting the layout of our world.

Intelligent Systems

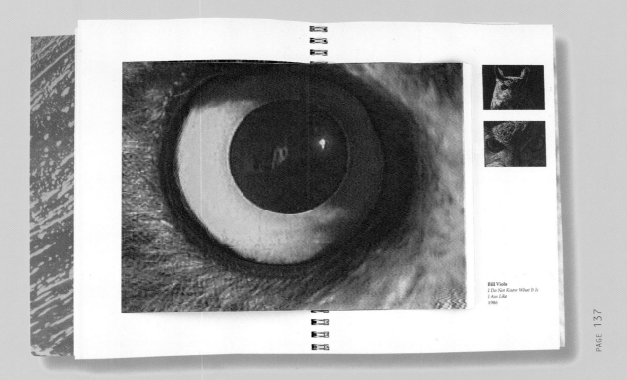

Bill Viola
*I Do Not Know What It Is
I Am Like*
1986

>Design also functions as a mirror of our culture, subtly reflecting the moods and changes of attitude within each generation. How many of the artefacts that we surround ourselves with might be considered as graphic design? If the non-trained observer were asked to name the items that reminded them of a previous generation or their own youth, they probably would not mention a logotype or bus timetable but might well remember a record sleeve, poster or magazine that had assumed some iconic or personally resonant meaning. Design is also influenced by the culture it purports to represent. The designer and writer Michael Worthington has argued that graphic design is more than a mirror of culture; that "it refracts culture and that design itself is altered by this process of refraction".

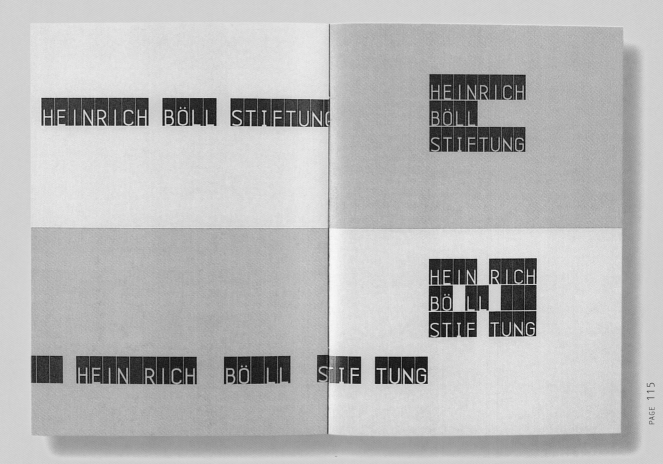

THIS SYMBIOTIC RELATIONSHIP, OR INTERDEPENDENCE, BETWEEN CULTURAL PRODUCTION AND SOCIETY CREATES THE INTELLECTUAL SYNTHESIS THAT DETERMINES THE PROCESS OF GRAPHIC DESIGN.

Experimental Layout

>THIS BOOK IS CONCERNED WITH ONE OF THE FUNDAMENTAL AND CENTRAL CONCERNS OF GRAPHIC DESIGN ACTIVITY — THE ART OF LAYOUT. THE SELECTION OF EXAMPLES WITHIN THIS VOLUME IS FOCUSED UPON WORK DESIGNED FOR PRINTED MEDIA. THE EMERGENCE OF A WHOLLY NEW DISCIPLINE WITHIN THE PROFESSION CONCERNED WITH DESIGN FOR THE SCREEN AND ENGAGED IN THE PRODUCTION OF INTERACTIVE, DYNAMIC AND IMMERSIVE ENVIRONMENTS IS WORTHY OF A BOOK IN ITS OWN RIGHT RATHER THAN

alternative practice

PAGE 045

RELEGATION TO A CHAPTER OR AN OCCASIONAL REFERENCE. THIS IS NOT TO SUGGEST THAT THERE IS NO RELATIONSHIP BETWEEN 'OLD' AND 'NEW' MEDIA; RATHER, THAT THE SUBJECT OF LAYOUT WITHIN PRINT DESERVES TO BE EXPLORED FURTHER, AND IN A DIFFERENT MANNER, REFLECTING THE RECENT CHANGES WITHIN THE PROFESSION. HOPEFULLY, THE READER WILL MAKE THE CONNECTIONS BETWEEN IDEAS EXPLORED IN THE PRINTED WORK SHOWN HERE AND ITS INFLUENCE ON, AND INFLUENCE BY, THIS NEW DEPARTURE IN GRAPHIC DESIGN. WE ARE UNDOUBTEDLY EXPERIENCING, AND IN LARGE PART BENEFITING FROM, THIS TWO-WAY PROCESS, AND MORE WORK REMAINS TO BE UNDERTAKEN TO FULLY EXPLORE THE CROSS-FERTILISATION THAT OBVIOUSLY EXISTS BETWEEN TRADITIONAL LINEAR SEQUENTIAL DESIGN FOR PRINT AND DESIGN'S WIDER PARTICIPATION IN FILMIC AND NON-LINEAR ENVIRONMENTS.

>THE DISCUSSION OF LAYOUT WITHIN GRAPHIC DESIGN HAS TRADITIONALLY BEEN ASSOCIATED WITH THE CONSIDERATION OF THE SINGLE PAGE OR SPACE, SUCH AS A POSTER OR A SEQUENCE OF PAGES. THIS TITLE DOES NOT ATTEMPT TO PRESENT AN OVERVIEW OF THE HISTORY OF THAT ACTIVITY BUT IS CONCERNED WITH CONTEMPORARY WORK THAT CHALLENGES THE HISTORY AND TRADITIONS OF LAYOUT. THERE IS NO HIERARCHY OF IMPORTANCE HERE, NEWNESS IS NOT IN ITSELF A VIRTUE: THIS WORK COULD NOT HAVE OCCURRED WITHOUT AN AWARENESS OF PAST PRECEDENTS AND AN UNDERSTANDING OF THE VALUE OF WORK UNDERTAKEN BY PREVIOUS GENERATIONS. IT COULD ALSO NOT HAVE OCCURRED WITHOUT THE SAME LEVEL OF UNDERSTANDING OF THE ACTIVITIES CONCERNED WITH NEW MEDIA AND IS ITSELF, IN MANY CASES, A PRODUCT OF THE DIGITAL AGE.

graphic authorship

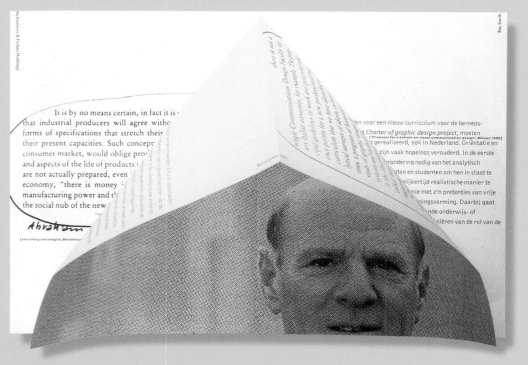

>THE FAMILIARITY OF THE PRINTED FORM, A COMFORTING REMINDER OF A LONG TRADITION OF CULTURAL PRODUCTION, ALLOWS THE DESIGNER TO BUILD ON, AND EXTEND, THE POSSIBILITIES PRESENTED BY OUR CONNECTION TO THE PHYSICAL OBJECT. PERHAPS THE ALLURE OF, FOR INSTANCE, A TANGIBLE BOOK IS HEIGHTENED BY THE INCREASING 'VIRTUALNESS' OF CONTEMPORARY LIFE. THE DEMISE OF THE PRINTED FORM HAS BEEN PREDICTED AS FREQUENTLY AS THE VOLUME AND CHOICE OF PRINT HAS INCREASED. WE MAY BE COMING TO RELY ON MORE AND MORE 'INTELLIGENT' SYSTEMS THAT TAKE A DIGITAL FORM, BUT EACH NEW ARRIVAL ALSO HAS A RELATED PRINTED MANUAL. THIS IS USUALLY DELIVERED IN A PACKAGE WITH GRAPHIC INSTRUCTIONS, LOGO OR IDENTITY AND OFTEN ACCOMPANIED BY A VARIETY OF PRINTED TITLES THAT INDEX THE RANGE OF PRODUCTS AVAILABLE OR OFFER FURTHER GUIDANCE ON 'HOW TO'.

Tom Hunter

Tom Hunter photographs people in their homes, surrounded by their belongings. His earlier pictures, of squatters and travellers, may be seen as a personal account of the communities in which he has lived and of which he is still very much a part – the London Fields squatting community, where he has lived for the past eight years, and the travelling community, which he joined some six years ago. Hunter is now involved in photographing the inhabitants of a tower block in Holly Street, Hackney. This is part of a larger project for which Hunter will be exhibiting his work in one of the flats. The estate is due to be demolished later this year.

Through their composition and lighting, Hunter's photographs of the squatters consciously referenced the paintings of Vermeer. The Travellers series also had a strong painterly quality, but Hunter's recent work has a much more formal appearance, concentrating on the documentary aspects of photography, while still focusing upon the diversity of the individual. Hunter uses a large format camera and slow colour film, which allows great depth of detail and richness of colour, in contrast to the grainy black and white images produced by the film stock which is often used in documentary photography.

Holly Street Series, 1998
C-type print
183 × 213 cm
courtesy of the artist

Hunter considers himself a community photographer, and an element of collaboration between the photographer and the sitter is fundamental to his work. He is concerned to present what the subject wants, not the stolen moment characteristic of photojournalism. All his sitters are given the opportunity to arrange their homes, and he spends an hour with his subjects before taking the final photograph, allowing them to feel comfortable with their environment and the camera. Hunter goes through every process with his subjects, taking preliminary polaroids so that they can consider the image they are portraying to the outside world, and play a part in the creative process.

Hunter's work within this exhibition consists of three colour photographs and a video projection. The photographs occupy three walls to form an open cube, whilst the projection is situated

58

**The Art of Squatting:
Persons unknown**, 1997
R-type print
102 × 76 cm
courtesy of the artist

in an adjoining room. Each depicts an interior shot of an occupied room which fills the whole frame, the very large format giving the viewer the impression of actually sharing the resident's space.

Hunter focuses on the richness of colours and textures, portraying the beautiful and the dignified and contesting the often unflattering light in which the media tend to represent tower blocks and the people who inhabit them. He also plays on the fragility of these carefully constructed environments, the realisation that all these homes, which people have taken pride in, will soon be destroyed. His choice of an emphatically documentary approach recalls the role of photography as a medium of record, often used to capture that which is about to be lost. We are reminded that these domestic interiors will soon be shattered, that the residents ultimately have no control over the homes they have made.

Lee Riley

59

EVEN THE MOST RECENT TREND IN COMPUTER MANUALS DELIVERED VIA CD ROM OR ON-LINE DEMONSTRATES THE NEED FOR A SIMPLE, EASILY NAVIGABLE, PRINTED VERSION. DELIBERATELY DESIGNED FOR EASE OF REPRODUCTION VIA HOME COMPUTER AND PRINTER SET-UPS, THESE HAVE MORE TO DO WITH EXPEDIENCY AND A REDUCTION IN MANUFACTURING COSTS THAN THE PROVISION OF INFORMATION FOR THE CONSUMER.

>THE CHEAPNESS AND EASE OF USE OF THE PRINTED FORM ALLOWS IT TO CONTINUE AS SUPPORTING MATERIAL WHILST PROVIDING AVAILABILITY BEYOND THE LIMITATIONS OF, OR ACCESS TO, ELECTRONIC MEDIA (STILL A NEW PHENOMENON IN MANY PLACES). CLEARLY PRINT IS NOT AS AILING AS MANY COMMENTATORS WOULD SUGGEST AND ITS FUTURE WELL-BEING APPEARS INEXTRICABLY LINKED TO THE GROWTH OF THE NEW MEDIA.

visual contrariness

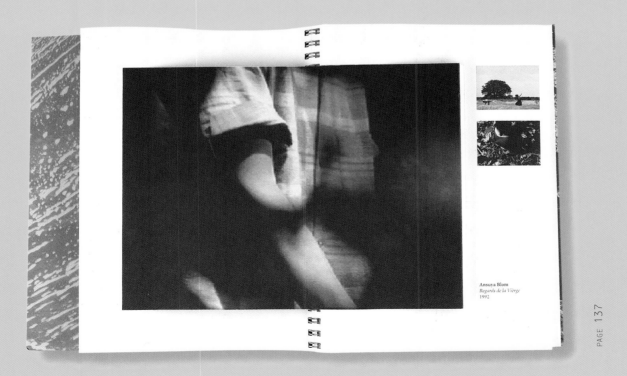

Ansuya Blom
Regards de la Vièrge
1992

PAGE 137

>THE FORTHCOMING PAGES HAVE BEEN ORGANISED INTO CHAPTERS THAT ARE INTENDED TO PROVIDE NOT ONLY AN INSIGHT INTO THE PRACTICAL WORKING METHODS, INTENTIONS AND MOTIVATIONS OF THE DESIGNERS FEATURED, BUT ALSO THE WIDER CONTEXT AND DEBATES WITHIN WHICH THE WORK COULD BE CONSIDERED. THE LAYOUT OF THIS BOOK EMPLOYS THREE NARRATIVE STRUCTURES THAT OPERATE AS DISTINCT BUT RELATED ELEMENTS: THE TEXT PROVIDES A COMMENTARY AND DISCUSSION OF THE ASPECT OF LAYOUT EXPLORED IN EACH CHAPTER — ENCAPSULATING, WHERE RELEVANT, CURRENT PROFESSIONAL DEBATES; THE INTERVIEWS WITHIN EACH SECTION ALLOW A UNIQUE UNDERSTANDING OF THE INDIVIDUAL APPROACHES OF THE DESIGNERS FEATURED; AND THE CAPTIONS OFFER FURTHER AND EXTENDED DETAIL OF PROJECTS, INDIVIDUAL PIECES OF WORK AND THEMATIC COLLECTIONS OF DESIGN.

>THE RESEARCH AND PRODUCTION OF THIS BOOK WOULD NOT HAVE BEEN POSSIBLE WITHOUT THE GENEROUS COOPERATION AND TIME GIVEN BY THE FEATURED DESIGNERS. THEIR ELABORATION ON THE WORKING METHODS AND PRINCIPLES BEHIND EACH OF THE PROJECTS SHOWN HAS BEEN INVALUABLE, EXTENDING OUR ANALYSIS OF THE WORK AND DEMONSTRATING THE CRITICAL UNDERSTANDING OF DESIGN PRACTICE WHICH IS PART OF THEIR EVERYDAY WORKING PROCESSES. WE WOULD LIKE TO THANK THEM FOR ALLOWING ACCESS TO PROJECT WORK NOT WIDELY SEEN BEFORE, AND IN THE PROCESS PROVIDING US WITH A FURTHER EDUCATION IN THE SUBJECT OF DESIGN. WE HOPE THAT THIS SPIRIT IS CONTINUED IN THE COLLECTION OF WORK WE HAVE BEEN ABLE TO PROVIDE.

IAN NOBLE AND RUSSELL BESTLEY

Miles Coolidge

Safetyville is both a real place in California and a town embedded in our imagination. Miles Coolidge makes documentary photographs of the ordinary, the vernacular, and the familiar in American urban life. *Safetyville* is clearly a brand new town, but appears to have no inhabitants. The buildings, still pristine white or pastel-hued, shine and reflect the brilliant Californian light. Everything is quiet and comfortable there. Sedate, even. Anyone staying in this town would, surely, have a nice day.

Coolidge's iconography of the everyday, and *Safetyville*'s ordinariness are both uncannily close to our own world. But not quite. Coolidge is driven by a desire to make strange the familiar, and

make familiar the strange. Indeed, as he has observed, the town of *Safetyville* does indeed 'make the everyday strange'.

Every denomination of building, and all the activities of modern urban life are here. All, that is, except one: there are few visible signs of retail commerce. Yet the town is situated in one of the wealthiest states in the biggest economy in the world. Inexplicably, more, logic and proportion appear to be up for grabs. Inexplicably, trees loom over shrunken corporate façades. Each element of the city is seemingly animate, imbued with a life-force of its own: roadways threaten to engulf sidewalks, curbs push out onto perfectly manicured lawns. Streets, buildings, even roadsigns compete for territory, squeezing each other's breathing space. This urban

Safetyville: Schoolhouse, Office Buildings, Storefronts
1994
C-type print
78 × 96 cm
ACME, Los Angeles, USA

jungle surges and swells, in spite of its missing inhabitants.

But, as the saying goes, it's a small world: *Safetyville* is in fact an exact one-third scale version of middle-class Middle America. Built in Sacramento, California, the town was created for the sole purpose of teaching schoolchildren 'how to cross roads. Coolidge comments that *Safetyville* is 'a theme park of the normal or everyday'. The rules of work and play are reversed and interchangable here. Yet our sense of reality is not depleted but heightened and intensified by Coolidge's images; *Safetyville* is not merely child's play.

Although a gigantic, absurd, and astonishing contemporary folly, the town is not just a surrogate for our own cityscape. On the contrary, *Safetyville* exposes the world around us as less solid, and less certain than any we might know from images. Possibly, on

Safetyville: Regional Transit Restaurant
1994
C-type print
78 × 42 cm
ACME, Los Angeles, USA

reflection, our world is a more ingenuous, more captivating, and more crudely mechanical stage-set than that seen in Coolidge's work. If so, maybe *Safetyville* really is the ideal preparation for the bigger adult theme park outside. And just maybe, the cityscapes that we think we know are no less precarious, and our lives no more vicarious, than those played out in this beautiful, bizarre, deeply foreign, and deeply familiar town.

Alistair Robinson

52 53

PAGE 079

spatial dynamics

MEANING, IN SHORT, RESIDES I

The Familiar Form

>WHY DO WE FIND THE PRINTED FORM SO FAMILIAR? IN AN AGE WHERE THE MEDIA AVAILABLE TO US HAVE BECOME MORE AND MORE INTANGIBLE — IN TELEVISION, THE INTERNET AND VOICE MAIL FOR EXAMPLE — OUR DESIRE OR NEED FOR A PHYSICAL RELATIONSHIP WITH AN OBJECT IS HEIGHTENED. FROM EARLY CHILDHOOD WE ARE INTRODUCED TO THE LINEAR STRUCTURES OF WORDS AND THEIR RELATIONSHIP TO IMAGES IN LAYOUT AND BOOK FORM. EVEN THE MOST UBIQUITOUS TECHNOLOGY OF THE DAY, THE COMPUTER, IS PROVIDED WITH A MANUAL IN 'HARD-COPY' FORM — AND HOW OFTEN HAVE USERS OF EMAIL FELT COMPELLED TO PRINT OUT A PAPER COPY OF THEIR ELECTRONIC MESSAGE?

>THESE CONDITIONED PATTERNS OF READING, FROM LEFT TO RIGHT OR TOP TO BOTTOM FOR EXAMPLE, ALLOW US TO APPROACH ANY FORM OF PRINTED MATERIAL WITH SOME EXPECTATION OF HOW WE WILL NAVIGATE THROUGH IT. THIS, THEN, IS THE STARTING POINT FOR THE DESIGNER, WHO IS ABLE TO BUILD UPON THIS FAMILIARITY WITHIN THE LAYOUT AND FORMAT OF A PROJECT, OFTEN UTILISING THE ELEMENT OF SURPRISE OR DIFFERENCE TO CONFOUND THE READER OR USER'S EXPECTATIONS. THE DESIGNER IS ABLE TO EMPLOY A RANGE OF STRATEGIES AND KEY ELEMENTS SUCH AS TYPEFACE, SCALE, ARRANGEMENT AND COLOUR WITHIN THE PAGE/S TO EMPHASISE EITHER THE CONTENT IN GENERAL OR A SIGNIFICANT ASPECT OF A PROJECT.

Intention and Approach

>THE WORK FEATURED HERE HAS BEEN SELECTED BECAUSE IT EXPLORES PARTICULAR EXPERIMENTAL APPROACHES TO BOTH LAYOUT AND FORMAT; THE EXAMPLES OF WORK, TOGETHER WITH THE DETAILED CAPTIONS AND ANNOTATION, ARE DESIGNED TO EXTEND OUR UNDERSTANDING OF THE INTENTION BEHIND THE DESIGNERS' PARTICULAR APPROACHES TO ELEMENTS SUCH AS STRUCTURE AND SCALE, AND THEIR

HE TOTAL ACT OF COMMUNICATION

RELATIONSHIP TO THE USE OF COLOUR, PHOTOGRAPHY OR ILLUSTRATION AND TYPOGRAPHY. THE PROJECTS RANGE FROM THE COMPLEXITY OF UNA DESIGNERS' MILLENNIAL TWO-YEAR DIARY AND THE CAREFUL EMPLOYMENT OF FOLDING BY JUSTY PHILLIPS FOR THE POV LECTURE SERIES PUBLICITY AT THE ROYAL COLLEGE OF ART IN LONDON THROUGH TO THE SMALLER SCALE AND INTIMACY OF SELF-AUTHORED PROJECTS BY MARK PAWSON, SUCH AS HIS DIE-CUT PLUG WIRING DIAGRAM BOOK, AND JAN VAN TOORN'S USE OF LAYOUT TO EMPHASISE A POLITICAL MESSAGE AND PERSONAL POSITION. IN MANY CASES THE DESIGNERS HAVE PRESENTED THE WORK IN A MANNER DESIGNED TO ENGAGE THE READER IN A PROCESS OF INTERPRETATION. THIS SEEMINGLY INDIRECT APPROACH TO THE COMMUNICATION OF A MESSAGE WITHIN DESIGN IS NOT IN OPPOSITION TO THE MORE SINGULAR AND DIRECT APPROACHES TO LAYOUT THAT ALSO EXIST, BUT IS INTENDED TO ALLOW A RANGE OF MEANINGS TO EMERGE AND A PERSONAL UNDERSTANDING TO BE ARRIVED AT. THE LAYOUT OF THE WORK MAY OFTEN, FOR EXAMPLE, BE DESIGNED IN SUCH A MANNER AS TO CREATE A SENSE OF 'OPENNESS', BUT IMPORTANTLY STILL COMMUNICATE AND FUNCTION AS A PRODUCT.

Identity and Audience

>THE FORMAT OF EACH PROJECT HAS BEEN CAREFULLY SELECTED BY THE DESIGNER, THROUGH THEIR CONSIDERATION OF THE RELATIONSHIP BETWEEN THE CONTENT OR UNDERLYING MESSAGE AND ITS INTENDED AUDIENCE. HOWEVER IN MANY CASES THE BRIEF, OR THE LIMITATIONS OF THE BRIEF BROUGHT ABOUT BY COMMERCIAL, FINANCIAL OR TECHNICAL CONSTRAINTS, DEMANDS THAT THE PERSONAL INTENTIONS OF THE DESIGNER EMERGE THROUGH THE CLIENT'S NEED TO COMMUNICATE IN A SPECIFIC MANNER AND TO A SPECIFIC READERSHIP. IT IS STILL POSSIBLE FOR THE DESIGNER'S IDENTITY TO EXIST WITHIN THE FINISHED PRODUCT THROUGH THEIR UNDERSTANDING AND STRATEGIC EMPLOYMENT OF SCALE, MATERIALS, BINDING AND NARRATIVE DEVICES WITHIN THE OVERALL STRUCTURE.

Foundation and Structure

>The layout of the key elements within each individual page of a project is related to the sequence of pages, and is used to create hierarchies and structures which guide the reader, indicating ways in which to navigate the information presented. Drawing upon the reader's expectation of the familiar, this can take the form of repetition, the designer creating an overall structure built around recurring and similar themes. These key foundations may include the use of the same weight and sized typeface/s organised within a regularised grid, images — photographed or illustrated in a particular manner or style, — and a limited range of colours, paper stock and print finish. The designer employs these elements within a range of formats and sizes related directly to the grid.

Historical Context

>Throughout the history of the discipline, graphic designers have utilised these elements, making use of various strategies to create a sequential or narrative structure within layout. Earlier experimental European approaches focused on the use of white space and sans-serif typography to create a simplicity of form and communication that utilised asymmetrical typography and layout. This was driven by an adherence to the grid as a controlling device based upon either geometry and the proportion of the page, or — following the standardisation of typefaces and paper sizes — on the basic units of typographic measurement (such as point scales, picas, ems etc).

>The maxim of graphic design at this time, that visual communication must appear in the 'shortest, simplest, most penetrating form', drew upon the investigation of internal organisation within page layouts and of ordered content. The embracing of the idea that design itself could both empower and act as an agent of social change is documented in the optimism and spirit of the early manifestos produced by designers associated with movements such as the Bauhaus in Germany, which celebrated the new methods of mass production and technology of the day.

> It is worth noting that political events in Europe at that time brought an early close to the Bauhaus as a central location for these progenitors of the discipline, forcing many to seek homes further afield, the US in particular, and creating an influence which was to dominate international design for a considerable period. It could also be argued that the basic foundations of graphic design practice — the tools, vocabulary and visual

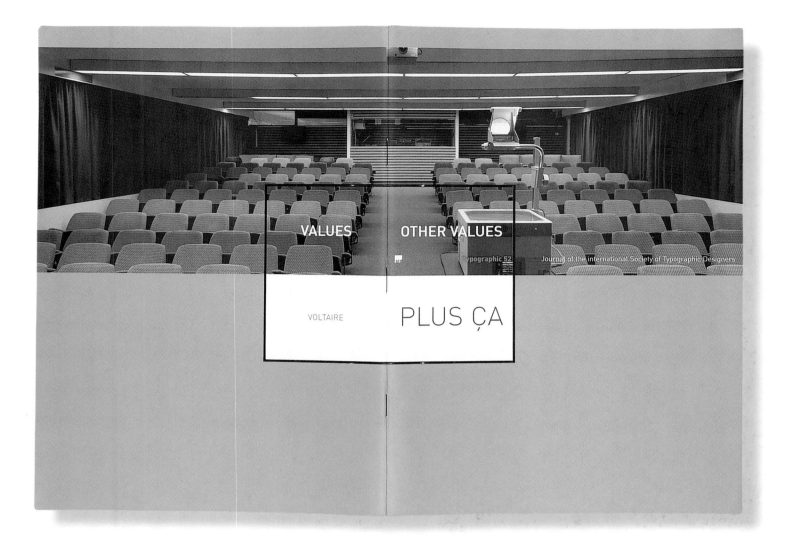

VALUES OTHER VALUES

Typographic 52 Journal of the international Society of Typographic Designers

VOLTAIRE PLUS ÇA

Nick Bell	210 x 297mm
Plus ça Change Typographic Journal edition	1999

>Above and overleaf: This edition of the Society of Typographic Designers' Journal, entitled **Plus ça Change** (everything changes), deals with the history of European typographic education and contemporary approaches to teaching the subject. Bell interpreted the collection of articles and visual examples as a series of interrelating layers; each article is treated individually, with pages cut at different sizes and printed in one or two colours from a limited palette on different stocks, bound commonly at the centre. Layout, colour and typographic treatment are specific to each section, allowing for a continuous flow of information across each writer's piece but giving a sense of punctuation between them. The reader is encouraged to explore relationships between the articles and ideas, and the design allows the possibility of individual readings and interpretations. When folded out, the cover (above) includes a die-cut perforated rectangle across the binding, which can be taken off by the reader and folded to construct further narratives and word-games on the theme **Plus ça Change**.

GRAMMAR, TOGETHER WITH ITS RELATIONSHIP TO MANUFACTURE AND TECHNOLOGY — WERE ESTABLISHED DURING THIS PERIOD. MANY OF THESE DEVELOPMENTS WITHIN THE DISCIPLINE ALSO SERVED AS AN EARLY INDICATOR OF THE POTENTIAL FOR GRAPHIC DESIGN WITHIN THE WIDER COMMUNITY. WHILE ROOTED IN AVANT-GARDE THINKING AND VISUAL EXPERIMENTATION, AND BASED UPON THE ACCEPTANCE OF A GENUINE SOCIAL ENGAGEMENT BY DESIGNERS, THIS SUBTRACTIVE VISUAL MODEL PROPAGATED BY DESIGNERS SUBSEQUENTLY GREW TO BECOME A DOGMATIC AND FIXED PERSPECTIVE ON COMMUNICATION. THE INTEGRITY OF THE UTOPIAN IDEAL OF A UNIVERSALITY OF FORM AND VISUAL LANGUAGE — WHITE SPACE, ASYMMETRICAL LAYOUT, SANS-SERIF TYPOGRAPHY AND LIMITED COLOUR PALETTE — WAS PROGRESSIVELY DILUTED AS IT BECAME MORE WIDELY ADOPTED, EVENTUALLY BECOMING LITTLE MORE THAN A VISUAL STYLE, SYNONYMOUS WITH LARGE CORPORATE AND INDUSTRIAL CONCERNS AND HAVING LITTLE CONNECTION TO THE VALUES OF ITS INITIAL CONCEPTION.

Contemporary Context

>SUBSEQUENT DEVELOPMENTS WITHIN GRAPHIC DESIGN HAVE SEEN A DIVERGENCE FROM THESE EARLIER APPROACHES AND BELIEFS. CHANGES WITHIN THE PROFESSION HAVE BROUGHT ABOUT A PROGRESSIVE SUBDIVISION OF THE ACTIVITY INTO VARIOUS BRANCHES OF PRACTICE OR DEFINED DISCIPLINES SUCH AS CORPORATE DESIGN, EDITORIAL DESIGN, WEB DESIGN OR PACKAGING. AT LEAST ONE — INFORMATION DESIGN — CONTINUES TO ADHERE TO MANY OF THE VALUES OF EARLIER THINKING, SUCH AS CLARITY AND LEGIBILITY, AS CENTRAL TO GOOD DESIGN. THIS REDEFINITION OF THE ACTIVITY HAS ALSO ALLOWED PRACTITIONERS TO CHALLENGE EARLIER IDEALS OR METHODS OF WORKING, BASING THEIR APPROACH NOT UPON AN ABSOLUTE FORM OF COMMUNICATION BUT IN THE EXPLORATION OF A VARIETY OF VISUAL VOICES AND METHODS. THIS THINKING COULD BE SEEN AS BEING BASED UPON THE ACCEPTANCE THAT 'GOOD' OR 'EFFECTIVE' DESIGN IS NOT ONLY DRIVEN BY ISSUES SUCH AS CLARITY OR LEGIBILITY BUT ALSO UPON A PROCESS THAT IS BUILT AROUND THE INTERPRETATION OF MESSAGES AND A VISUAL DIALOGUE OR EXCHANGE BETWEEN DESIGNER AND AUDIENCE.

Readability and Legibility

>THIS NEWER APPROACH HAS BEEN USED TO VERY DIFFERENT EFFECT FROM EARLIER VERSIONS OF GRAPHIC DESIGN, TO ALTER OR DENY THE READER'S ANTICIPATION OF THE FORM THE WORK WILL TAKE. INSTEAD OF THE COMFORTING FAMILIARITY OF REPETITION AND A CONTROLLING GRID, DESIGNERS HAVE BEGUN TO EMPLOY STRATEGIES OF APPARENTLY 'DISORGANISED' VISUAL ORGANISATION. THE DISCUSSION OF READABILITY RATHER THAN LEGIBILITY HAS BECOME THE CENTRAL ISSUE; DEBATE FOCUSES ON THE APPROPRIATENESS OF A PARTICULAR APPROACH WHICH IN TURN EMPLOYS A PARTICULAR STYLE OR VISUAL LANGUAGE RELEVANT TO A PARTICULAR AUDIENCE.

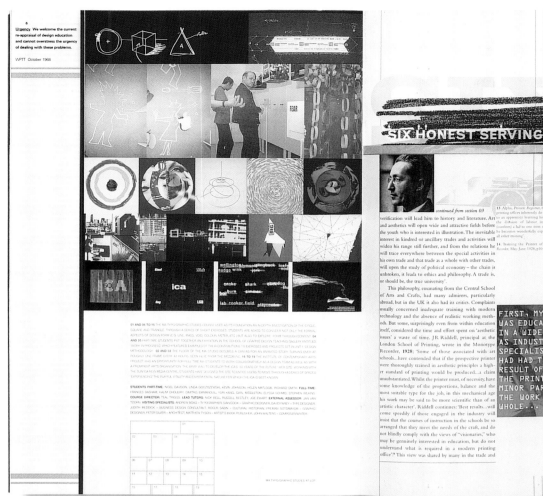

CLIVE CHIZLETT

SIX HONEST SERVING MEN

continued from section 03

verification will lead him to history and literature. Art and aesthetics will open wide and attractive fields before the youth who is interested in illustration. The inevitable interest in kindred or ancillary trades and activities will widen his range still further, and from the relations he will trace everywhere between the special activities in his own trade and that trade as a whole with other trades, will open the study of political economy – the chain it unbroken, it leads to ethics and philosophy. A trade is, or should be, the true university'.

This philosophy, emanating from the Central School of Arts and Crafts, had many admirers, particularly abroad, but in the UK it also had its critics. Complaints usually concerned inadequate training with modern technology and the absence of realistic working methods. But some, surprisingly even from within education itself, considered the time and effort spent on 'aesthetic issues' a waste of time. J R Riddell, principal at the London School of Printing, wrote in the Monotype Recorder, 1928; 'Some of those associated with art schools...have contended that if the prospective printer were thoroughly trained in aesthetic principles a higher standard of printing would be produced...a claim unsubstantiated. Whilst the printer must, of necessity, have some knowledge of the proportions, balance and the most suitable type for the job, in this mechanical age his work may be said to be more scientific than of an artistic character'. Riddell continues: 'Best results...will come speedily if those engaged in the industry will insist that the courses of instruction in the schools be so arranged that they meet the needs of the craft, and do not blindly comply with the views of "visionaries," who may be genuinely interested in education, but do not understand what is required in a modern printing office'.[14] This view was shared by many in the trade and

13. Alpha, *Printers Register*, 6 October 1880. 'Many printing offices informedi do not afford a fair chance to an apprentice learning his trade in its entirety, the division of labour in large establishments [confines] a lad to one item of his business in which he becomes wonderfully expert to the exclusion of all other training'.

14. Training the Printer of the Future, *Monotype Recorder*, May-June 1928, p10-11.

was fuelled perhaps, by Mason's criticisms of commercial printing standards in The Imprint.

The first issue of The Imprint was published in January 1913. Mason, along with Gerard Meynell, a pioneer in the revival of printing, and two of Mason's colleagues from the Central School of Arts and Crafts, Edward Johnston, who taught calligraphy, and F E Jackson, who taught lithography, shared the role of editor of this new monthly typographic journal. It was aimed principally at the trade, with the offer of genuine exchanges of knowledge and experience within its pages. Mason certainly made full use of The Imprint as a mouth-piece; his critical views of the typographic skills and working practices of the contemporary printing trade became a regular feature and he was never less than brutally frank. In his review of The Mask, a quarterly journal of the Art of the Theatre, Mason, having criticised the choice of type, the layout and poor press work concludes, 'The whole thing typographically looks to me like the untrained piecemeal conception of the amateur printer. I haven't the patience to go over it in detail; for there is a matter of excellent printing, and it drives me wild to see it fooled about in this way'. On the use of type itself, Mason gave the following critique of 'The American Printer'; 'So printers and advertisers aren't content to use print as God Almighty meant it to be used – quietly and honestly – but strain the beautiful instrument into discordant forms that repel all finer minds, and bring the craft into contempt. What regard or dignity has the printer nowadays? The craft has become an industry, and the industry one of the least esteemed'.

His criticism did not always go unanswered although Mason's resolve remained absolute. His review of 'The Fellowship Books'; 'A rather pretty series of priggish

> FIRST, MY AIM WAS EDUCATIVE IN A WIDE SENSE AS INDUSTRIAL SPECIALISATION HAD HAD THE RESULT OF GIVING THE PRINTER A MINOR PART IN THE WORK AS A WHOLE...

09

Nick Bell <

Typographic Journal <

1999 <

example spread <

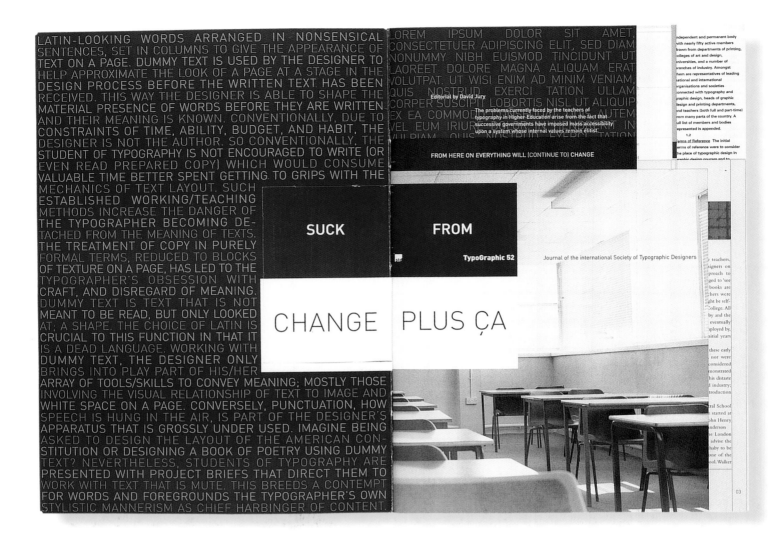

LATIN-LOOKING WORDS ARRANGED IN NONSENSICAL SENTENCES, SET IN COLUMNS TO GIVE THE APPEARANCE OF TEXT ON A PAGE. DUMMY TEXT IS USED BY THE DESIGNER TO HELP APPROXIMATE THE LOOK OF A PAGE AT A STAGE IN THE DESIGN PROCESS BEFORE THE WRITTEN TEXT HAS BEEN RECEIVED. THIS WAY THE DESIGNER IS ABLE TO SHAPE THE MATERIAL PRESENCE OF WORDS BEFORE THEY ARE WRITTEN AND THEIR MEANING IS KNOWN. CONVENTIONALLY, DUE TO CONSTRAINTS OF TIME, ABILITY, BUDGET, AND HABIT, THE DESIGNER IS NOT THE AUTHOR. SO CONVENTIONALLY, THE STUDENT OF TYPOGRAPHY IS NOT ENCOURAGED TO WRITE (OR EVEN READ PREPARED COPY) WHICH WOULD CONSUME VALUABLE TIME BETTER SPENT GETTING TO GRIPS WITH THE MECHANICS OF TEXT LAYOUT. SUCH ESTABLISHED WORKING/TEACHING METHODS INCREASE THE DANGER OF THE TYPOGRAPHER BECOMING DE-TACHED FROM THE MEANING OF TEXTS. THE TREATMENT OF COPY IN PURELY FORMAL TERMS, REDUCED TO BLOCKS OF TEXTURE ON A PAGE, HAS LED TO THE TYPOGRAPHER'S OBSESSION WITH CRAFT, AND DISREGARD OF MEANING. DUMMY TEXT IS TEXT THAT IS NOT MEANT TO BE READ, BUT ONLY LOOKED AT; A SHAPE. THE CHOICE OF LATIN IS CRUCIAL TO THIS FUNCTION IN THAT IT IS A DEAD LANGUAGE. WORKING WITH DUMMY TEXT, THE DESIGNER ONLY BRINGS INTO PLAY PART OF HIS/HER ARRAY OF TOOLS/SKILLS TO CONVEY MEANING; MOSTLY THOSE INVOLVING THE VISUAL RELATIONSHIP OF TEXT TO IMAGE AND WHITE SPACE ON A PAGE. CONVERSELY, PUNCTUATION, HOW SPEECH IS HUNG IN THE AIR, IS PART OF THE DESIGNER'S APPARATUS THAT IS GROSSLY UNDER USED. IMAGINE BEING ASKED TO DESIGN THE LAYOUT OF THE AMERICAN CON-STITUTION OR DESIGNING A BOOK OF POETRY USING DUMMY TEXT? NEVERTHELESS, STUDENTS OF TYPOGRAPHY ARE PRESENTED WITH PROJECT BRIEFS THAT DIRECT THEM TO WORK WITH TEXT THAT IS MUTE. THIS BREEDS A CONTEMPT FOR WORDS AND FOREGROUNDS THE TYPOGRAPHER'S OWN STYLISTIC MANNERISM AS CHIEF HARBINGER OF CONTENT.

LOREM IPSUM DOLOR SIT AMET, CONSECTETUER ADIPISCING ELIT, SED DIAM NONUMMY NIBH EUISMOD TINCIDUNT UT LAOREET DOLORE MAGNA ALIQUAM ERAT VOLUTPAT. UT WISI ENIM AD MINIM VENIAM, QUIS NOSTRUD EXERCI TATION ULLAM CORPER SUSCIPIT LOBORTIS NISL UT ALIQUIP EX EA COMMOD VEL EUM IRIUR IN VULPIAM QUIS AUTE TATION

Editorial by David Jury

The problems currently faced by the teachers of typography in Higher Education arise from the fact that successive governments have imposed mass accessibility upon a system whose internal values remain elitist.

FROM HERE ON EVERYTHING WILL (CONTINUE TO) CHANGE

SUCK

FROM

TypoGraphic 52

Journal of the international Society of Typographic Designers

CHANGE PLUS ÇA

> **Nick Bell**
> Typographic Journal
> 1999
> end pages (above)
> example spreads (right)

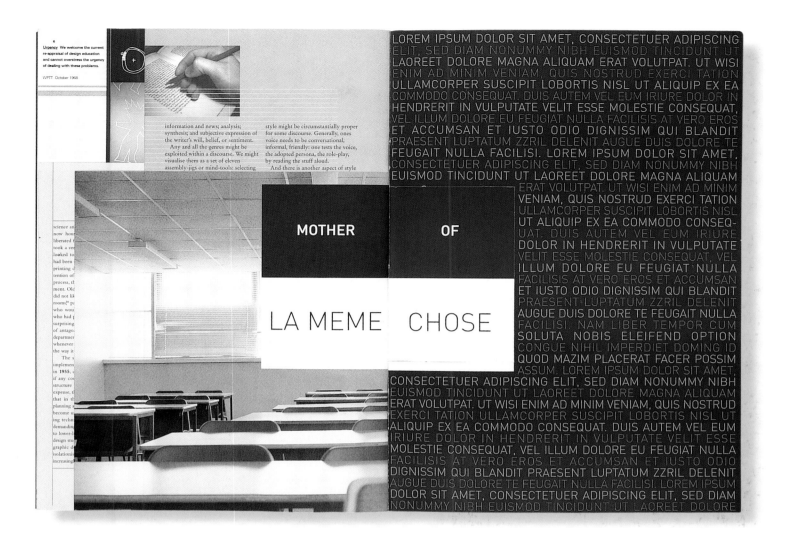

Urgency We welcome the current re-appraisal of design education and cannot overstress the urgency of dealing with these problems.

WPTT. October 1968

information and news; analysis; synthesis; and subjective expression of the writer's will, belief, or sentiment.

Any and all the genres might be exploited within a discourse. We might visualise them as a set of eleven assembly-jigs or mind-tools: selecting

style might be circumstantially proper for some discourse. Generally, ones voice needs to be conversational; informal, friendly: one tests the voice, the adopted persona, the role-play, by reading the stuff aloud.

And there is another aspect of style

MOTHER OF

LA MEME CHOSE

LOREM IPSUM DOLOR SIT AMET, CONSECTETUER ADIPISCING ELIT, SED DIAM NONUMMY NIBH EUISMOD TINCIDUNT UT LAOREET DOLORE MAGNA ALIQUAM ERAT VOLUTPAT. UT WISI ENIM AD MINIM VENIAM QUIS NOSTRUD EXERCI TATION ULLAMCORPER SUSCIPIT LOBORTIS NISL UT ALIQUIP EX EA COMMODO CONSEQUAT. DUIS AUTEM VEL EUM IRIURE DOLOR IN HENDRERIT IN VULPUTATE VELIT ESSE MOLESTIE CONSEQUAT, VEL ILLUM DOLORE EU FEUGIAT NULLA FACILISIS AT VERO EROS ET ACCUMSAN ET IUSTO ODIO DIGNISSIM QUI BLANDIT PRAESENT LUPTATUM ZZRIL DELENIT AUGUE DUIS DOLORE TE FEUGAIT NULLA FACILISI. LOREM IPSUM DOLOR SIT AMET, CONSECTETUER ADIPISCING ELIT, SED DIAM NONUMMY NIBH EUISMOD TINCIDUNT UT LAOREET DOLORE MAGNA ALIQUAM ERAT VOLUTPAT. UT WISI ENIM AD MINIM VENIAM, QUIS NOSTRUD EXERCI TATION ULLAMCORPER SUSCIPIT LOBORTIS NISL UT ALIQUIP EX EA COMMODO CONSEQUAT. DUIS AUTEM VEL EUM IRIURE DOLOR IN HENDRERIT IN VULPUTATE VELIT ESSE MOLESTIE CONSEQUAT, VEL ILLUM DOLORE EU FEUGIAT NULLA FACILISIS AT VERO EROS ET ACCUMSAN ET IUSTO ODIO DIGNISSIM QUI BLANDIT PRAESENT LUPTATUM ZZRIL DELENIT AUGUE DUIS DOLORE TE FEUGAIT NULLA FACILISI. NAM LIBER TEMPOR CUM SOLUTA NOBIS ELEIFEND OPTION CONGUE NIHIL IMPERDIET DOMING ID QUOD MAZIM PLACERAT FACER POSSIM ASSUM. LOREM IPSUM DOLOR SIT AMET, CONSECTETUER ADIPISCING ELIT, SED DIAM NONUMMY NIBH EUISMOD TINCIDUNT UT LAOREET DOLORE MAGNA ALIQUAM ERAT VOLUTPAT. UT WISI ENIM AD MINIM VENIAM, QUIS NOSTRUD EXERCI TATION ULLAMCORPER SUSCIPIT LOBORTIS NISL UT ALIQUIP EX EA COMMODO CONSEQUAT. DUIS AUTEM VEL EUM IRIURE DOLOR IN HENDRERIT IN VULPUTATE VELIT ESSE MOLESTIE CONSEQUAT, VEL ILLUM DOLORE EU FEUGIAT NULLA FACILISIS AT VERO EROS ET ACCUMSAN ET IUSTO ODIO DIGNISSIM QUI BLANDIT PRAESENT LUPTATUM ZZRIL DELENIT AUGUE DUIS DOLORE TE FEUGAIT NULLA FACILISI. LOREM IPSUM DOLOR SIT AMET, CONSECTETUER ADIPISCING ELIT, SED DIAM NONUMMY NIBH EUISMOD TINCIDUNT UT LAOREET DOLORE

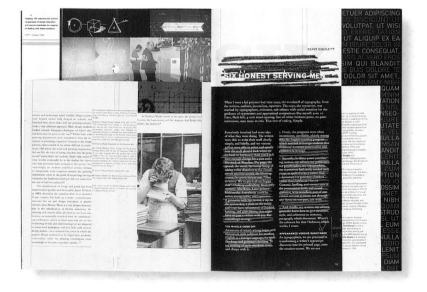

CLIVE CHIZLETT

SIX HONEST SERVING MEN

>Designers have begun to explore how a message can be read in different ways. Employing key visual devices, this has taken the form of a layering of information — an additive rather than a subtractive model. In a similar fashion to earlier versions of the profession, this has undoubtedly been influenced by the technologies which now dominate the production of graphic design. Designers have been able to develop new methods of working which challenge some of the established or previously accepted 'rules' of design. This breaking down of the traditional rule-book for design and layout in particular has been developed to a notorious level of extremity. Certain schools of thought within graphic design have been concerned with developing an almost anti-narrative approach. While experimental design can challenge preconceptions of the sequential nature of how we read, designers may become less concerned with the content and its communication, in the process neglecting the needs of the reader in the act of experimentation.

>This approach to the design of printed material has been called 'visual noise', and is often more focused on the visual possibilities presented by new technology than truly alternative or more genuinely experimental forms of communication. The effect of this has been to mask the real value of initial explorations driven by a more fundamental thinking about the relationship of graphic design to subjects such as language, semiotics and communication theory.

Design Discourse

>New approaches by designers, underpinned by these theoretical considerations drawn from outside of graphic design, have become part of the development of a genuine and specific design discourse. The wider impact of such experimentation presents a useful development within graphic design. It has allowed designers to consider, for instance, the relationship between the approach to printed (linear) form and emerging screen-based disciplines in interactive and web design. Much of this work is concerned with non-linear approaches to layout and has introduced issues of the non-sequential and non-hierarchical — pointing to future developments and a new visual lexicon for design.

>The discussion of the relationship between the designer and their audience allows for a more complex understanding of the communication process itself. The acceptance (by designers) that visual messages can be analysed through impacting levels of meaning rather than one single interpretation, and the recognition that the users of this

INFORMATION CAN BE ACTIVE PARTICIPANTS IN THE CONSTRUCTION OF A MESSAGE, HAS OPENED UP NEW AVENUES FOR THE GRAPHIC DESIGNER. DESIGN, RATHER THAN BEING POSITIONED WITHIN THE TIGHT CONSTRAINTS OF A TRANSMITTER-RECEIVER ROLE, IS ABLE TO TAKE ON MORE OF A NEGOTIATING OR MEDIATING STANCE BETWEEN CLIENT OR MESSAGE AND AUDIENCE. THE DESIGNER IS ABLE TO UTILISE THIS POSITION, OFFERING CLUES TO A RANGE OF INTERPRETATIONS WITHIN A WIDER FIELD OF POSSIBLE READINGS.

The Featured Designers

>THE DESIGNERS FEATURED IN THIS CHAPTER HAVE EMPLOYED KEY STRATEGIES TO ACHIEVE THESE ENDS. THE PROJECTS BY BOTH NICK BELL AND JUSTY PHILLIPS UTILISE THE READER'S ENGAGEMENT TO ALLOW COMPLEX MEANINGS AND INTERPRETATIONS TO BE ARRIVED AT. THE UNA DIARY FUNCTIONS ACROSS TWO YEARS SIMULTANEOUSLY; THE FOLDING AND INTERLEAVING OF PAGES AND TEXT HEADINGS PRESENTS A SERIES OF MESSAGES IN A STATE OF FLUX. THE DELIBERATE USE OF A NARRATIVE STRUCTURE WHICH ALLOWS THE DESIGNER TO CONTROL AND DIRECT IS ALSO INTENDED TO ENCOURAGE AND ALLOW THE USER TO RENEGOTIATE THE PIECE AS BOTH A WORKING DIARY AND AS AN OBJECT IN ITS OWN RIGHT.

>PHILLIPS, IN HER PUBLICITY DESIGN FOR THE POV LECTURE PROGRAMME, PERMITS THE READER TO REVEAL AND OBSCURE INFORMATION BY THE FOLDING OF A SINGLE A2 SHEET PRINTED ON BOTH SIDES. WHILST POSSIBLE PERMUTATIONS ARE PRESCRIBED AND LIMITED, THE FOLDING ALLOWS THE PRODUCT TO FUNCTION AS BOTH A MAILER AND POSTER. THE WORK OF JAN VAN TOORN AND MARK PAWSON CHALLENGES THE ACCEPTED DEFINITIONS OF GRAPHIC DESIGN; BOTH WORK WITH GRAPHIC PROCESSES AND MATERIALS, OFTEN 'LOWER-TECH', TO ACHIEVE PARTICULAR AND HIGHLY PERSONAL AIMS. FOR MARK PAWSON, THE RECYCLING OF EXISTING MATERIALS, SUCH AS UNUSED BILLBOARD POSTERS, AND THE EMPLOYMENT OF THE PHOTOCOPIER AS PRODUCTION TOOL IS PART OF THE PROCESS OF CELEBRATING THE OFTEN UNNOTICED, VERNACULAR AND 'THROW-AWAY' DESIGN OF PRINTED EPHEMERA WITHIN CONTEMPORARY CULTURE. PAWSON USES A STRATEGY OF REPETITION TO EMPHASISE AND RE-EMPHASISE THE BEAUTY AND SUBTLE DIFFERENCES OF OBJECTS SUCH AS PLUG WIRING DIAGRAMS OR CHEAP TOY ASSEMBLY INSTRUCTIONS. DELIBERATELY NON-SPECIFIC IN ITS PRESENTATION, VAN TOORN'S WORK RECYCLES IMAGES AND TEXT (OFTEN QUOTING DIRECTLY FROM THE WORK OF OTHERS) TO ARRIVE AT A POSITION OF VISUAL AWKWARDNESS. THE DISCORDANT CROPPING AND EDITING OF IMAGES IS INCORPORATED INTO AN OVERALL APPROACH TO LAYOUT THAT PRIORITISES OPENNESS AND INTERPRETATION AS ITS PRIMARY OBJECTIVE BUT IS ALWAYS UNDERPINNED BY VAN TOORN'S COMMITMENT TO A SOCIAL AGENDA FOR DESIGN.

> **UNA Design**

> Millennial Diary 1999/2000

> example spreads

> see details overleaf

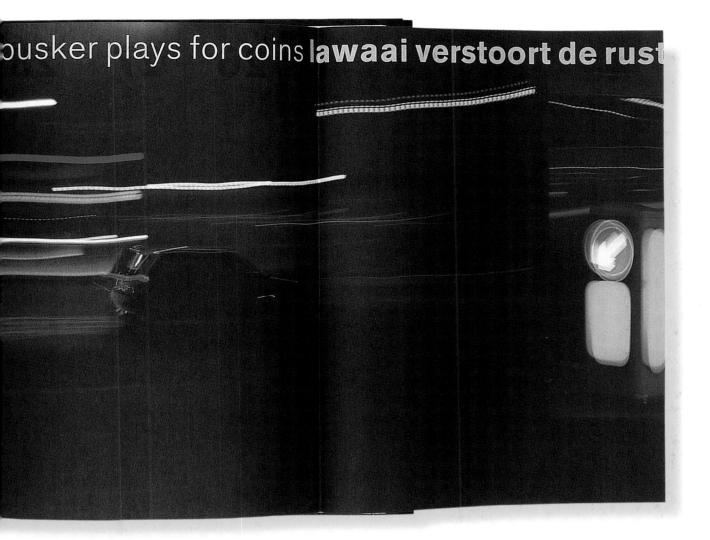

busker plays for coins **lawaai verstoort de rust**

1999 **1.18** ...oet muses **muziek is hoopaar** noise shatters the silence in an empty room **ee**

1 2 3

UNA Design	225 x 255mm (99/00) and 200 x 245mm (01)
UNA Millennial Diary 1999–2000, UNA Diary 2001	1999/2001

>Previous pages and above left: Designed by the UNA Design partnership in London and Amsterdam, the **UNA Millennial Diary** works across a two year period, utilising a careful series of folds and enclosed hidden pages which can be rearranged at the end of the first year. Folded inside each section, a series of interrelating photographic images by Anthony Oliver work in sequence throughout the length of the book, each image overlapping the next. Printed on uncoated stock, the photographs depict scenes from agricultural and farm buildings, together with night-time images of roads and traffic, blended to present the reader with the ambiguous feeling of a travelogue through an autumnal European landscape. Running parallel to the images, across the top of each page of the diary, a series of quotes in dual languages (English and Dutch) appear like out-takes from an accompanying story. Set in Berthold Akzidenz Grotesk in a range of weights, a subtle

distinction is made between the two translations, with a limited colour palette of natural greens, yellows and browns reflecting the atmosphere of the accompanying photographs. The theme of the diary is 'time' as a figurative abstraction; the mechanics of the clock and the rationalising of the human mind being often in conflict with the gradual evolution of natural processes. At the end of the millennium the designers suggest a period of reflection in the knowledge that, in the words of the diary's introduction, "At the turn of the century, nature will be unastonished. Life will proceed as usual."

> Above and right: The **UNA Diary 2001** utilises Chinese binding, with lightweight semi-opaque pages folded and bound at the loose edge. A complicated information system of strongly-coloured, overprinted concentric circles indicating particular days in each month is printed on the reverse, so as to show through the page and relate to the typographic grid system of the diary.

UNA Design<

UNA Diary 2001 <

example spreads <

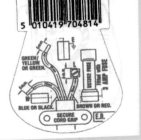

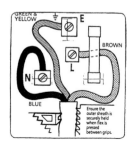

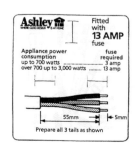

> **Mark Pawson**

> Die-Cut Plug Wiring Diagram Book

> 1999

> example spreads (above)

> end pages (far right)

> see details overleaf

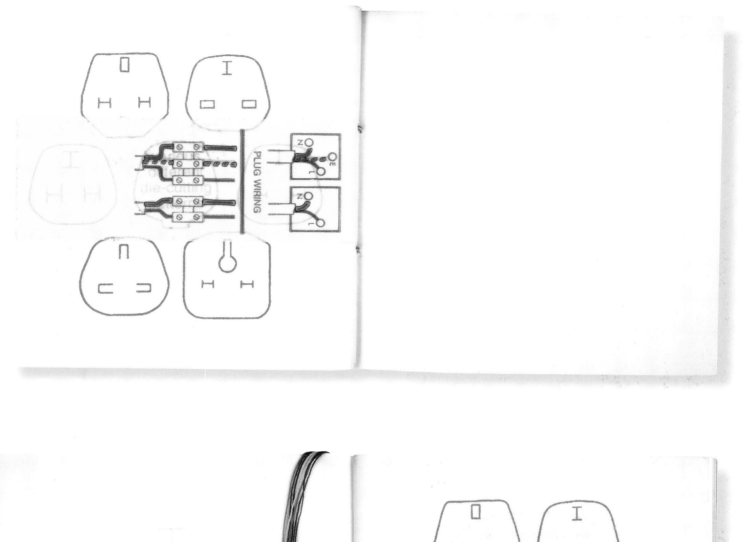

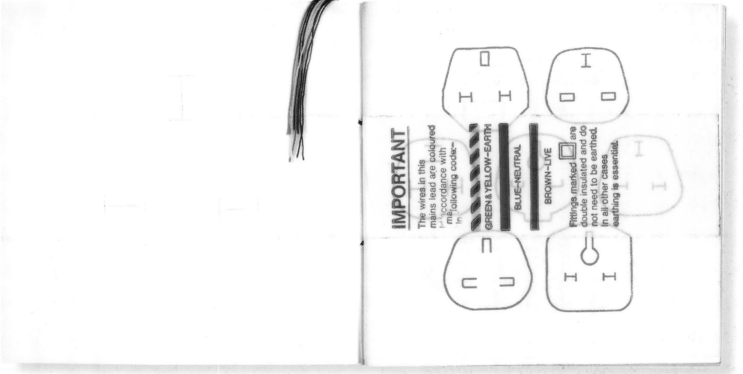

PLUG WIRING

IMPORTANT

The wires in this mains lead are coloured in accordance with the following code:—

GREEN & YELLOW—EARTH

BLUE—NEUTRAL

BROWN—LIVE

Fittings marked ☐ are double insulated and do not need to be earthed. In all other cases earthing is essential.

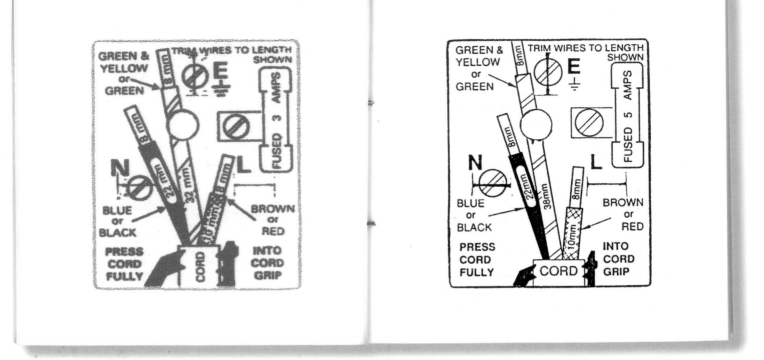

> **Mark Pawson**

> Die-Cut Plug Wiring Diagram Book

> 1999

> example spreads

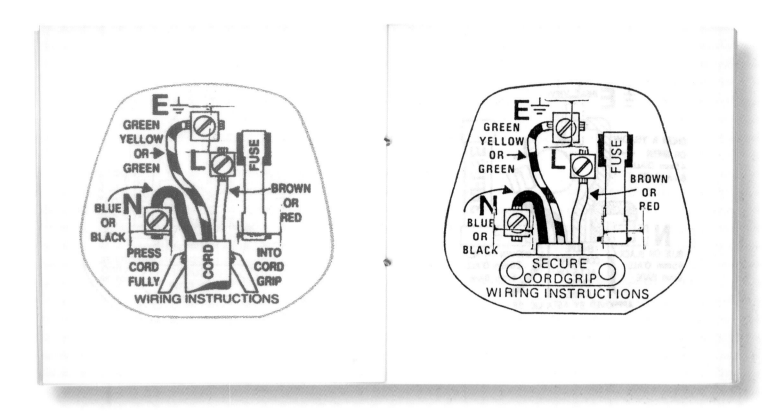

Mark Pawson		68 x 72mm
Die-Cut Plug Wiring Diagram Book		1999

>Previous pages and above: A selection of spreads from the **Die-Cut Plug Wiring Diagram Book** by Mark Pawson. Forty specimens, taken from the die-cut card safety diagrams slotted over the pins on British Standard electrical plugs attached to appliances in the UK, are reproduced in their original form and actual size via simple colour or monochrome photocopy processes.

Produced entirely by hand, the book includes leader pages containing examples of the plastic wiring code which is normally attached to the apparatus flex. The book jacket is cut by hand to replicate the die-cut on the originals, and each book is hand-stitched using four coloured threads matching the wiring colours. Pawson has since produced button badges and T-shirts on the theme.

726

RES PLASTIC S.p.A Milano (Italy)

CORONADO

211

had an elephant and gorilla that are built in the same way.Last week I found in the street some parts of a similar toy,but this time in blue,maybe a sea creature,dolphin?seal?whale? 12.saturday.Aeroplane,same as on thursday,but this time in silver,whoppee,and this one has got a right wing,and a LEFT wing.Usually if I get two toys the same/different colours I will mix them up,but theres not much point here,one is still gonna have two right wings! 13.SundayAaaarggghh,another jeep,very slight variation on previous one,with different windscreen,bonnet,mudguards and roll-bar. 14.monday.Pink Panther,the second one,and about time,the policeman version,blue coppers tunic and hat,smaller scale than the previous one,but because of the policemans hat,its the

.Wednesday,Sports Car,red,black,beige,the
feature on this is the sunroof which can be
flipped over and hidden in the boot.Unusual
split windscreen,so maybe it is a replica of
an actual car,but I've no idea what kind.
Some previous cars were alfa-romeos. REF 726
0.Thursday,Aeroplane,moss green with black
wheels and engines,real boring,I'm sure I got
exactly the same one previously,in white,this
ne is identified as a 'CORONADO'and as a
ovelty comes with two right wings.REF 211
ow about a plane that somersaults on impact?
1.Friday,Kangaroo,Grey,multi-jointed,poseabl
odel,ball & socket joints,comes with sticker
to put on the head and feet,but I didn't use
hem as they'd detract from the graphic
implicity of the kangaroo!I've previously

MARK'S
LITTLE BOOK
ABOUT
KINDER EGGS.

PRO. GEST. s.r.l. VERONA - ITALY

SCAME - MASTAF S.p.A.
PONTIDA (BG) ITALY

> **Mark Pawson**

> Mark's Little Book About Kinder Eggs.

> 1989

> example spreads

with a friend I bought a whole box,and ended
up with 3 each of 20 toys!!The boxes are
bigger these days,and theres about 24 or 30
on each layer,so I could have gone totally
over the top and bought a whole layer....
 I got a written receipt for them.
 I opened 4 of them straight away,and put
the rest into the egg compartment of the
fridge .

4.Space Station,white and light blue,with
solar panels,radar dish and astronaut on a
line,floating outside.Leaflet shows two vari-
ations.I'd seen this toy previously,a friend
had one,but could not be persuaded to trade
(he likes astronauts,and has done paintings

Mark Pawson	100 x 70mm
Mark's Little Book About Kinder Eggs.	1989

>Previous pages and above: Described in Mark Pawson's catalogue as "A monumental classic and a deserving bestseller (over 7,000 copies in circulation). Obsessive, meticulous and altogether brilliant." Pawson's biggest selling title is a monochrome photocopied book based on a painstaking personal exploration of around 500 'surprise' toys which he collected from Kinder Egg children's sweets over a period of six years. The book includes diagrams from the original instructions set alongside Pawson's detailed personal notes and reflections on the toy itself. The text is typewritten on a manual typewriter and the book assembled by cut-and-paste methods prior to photocopying onto standard cartridge copy paper, then trimmed by hand, the spine stitched by one metal staple.

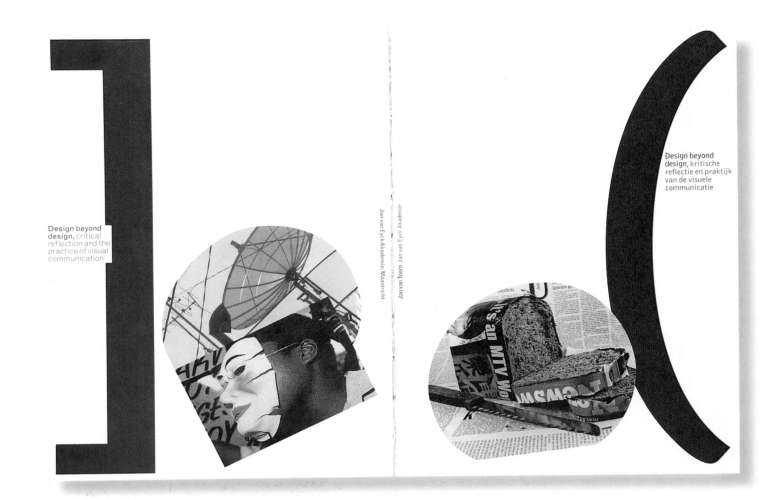

Design beyond
design, critical
reflection and the
practice of visual
communication

Design beyond
design, kritische
reflectie en praktijk
van de visuele
communicatie

Jan van Toorn Jan van Toorn

Jan van Eyck Akademie, Maastricht

Jan van Toorn		158 x 211mm
Design beyond design		1998

>Above and overleaf: The underlying themes of the **Design beyond design** symposium, exploring the potential for design strategies to move toward a more active role in public space, are reflected within a series of quotations from designers, design educators and social commentators and a text by van Toorn reproduced in both Dutch and English languages. Presented as cut-outs from original publications, crudely circled to infer personal highlights or a marking of importance, the quotes are juxtaposed with images of heads of financial and government institutions, corporations and advertising agencies. Images are printed on the reverse of the pages, which are then bound at a right angle to the fold. The images can only be viewed by folding out the pages from the bottom edge (as shown), or by tearing the top edge of the folded sheets, thus effectively destroying the book. Images are cropped deliberately awkwardly, and reproduced as a very heavy colour halftone similar to cut-down billboard sheets; they are also labelled by hand in a similar fashion to the circled quotations on the 'external' face of the pages.

It is by no means certain, in fact it is
that industrial producers will agree with
forms of specifications that stretch their
their present capacities. Such concept
consumer market, would oblige pro
and aspects of the life of products
are not actually prepared, even
economy, "there is money
manufacturing power and t
the social nub of the new

Abraham

[socioloog/sociologist, Strasbour

len voor een nieuw curriculum voor de beroeps-
t *Charter of graphic design project*, moeten
['Proposal for a debate on visual communication design', Milaan 1990]
n gerealiseerd, ook in Nederland. Oriëntatie en
zijn vaak hopeloos verouderd. In de eerste
randering nodig van het analytisch
nten en studenten om hen in staat te
elijkertijd realistische manier te
mie met z'n pretenties van vrije
ningsvorming. Daarbij gaat
nde onderwijs- of
niëren van de rol van de

Jan van Toorn <

Design beyond design <

1998 <

cover/example spreads <

Everything that is not virgin nature then is understood as having been touched by transformative cultural intervention, i.e. design. (YOU LOOK UP AND IN A FLASH YOU REALIZE THAT EVERYTHING—YES, EVERYTHING—AROUND YOU HAS BEEN DESIGNED!) Thought of in these terms, designers are, in the basest of terms, the mediators of reality.

Louise Sandhaus, 1994

[ontwerper/designer, Los Angeles]

Like all other forms of professional mediation, design owes its success to the economic and technologico-scientific development promoted by industry and government. This is connected with its share in the planning of production, but even more with the production of images and visual stimuli in the media which is essential to the retail of products, information and entertainment. Communication design thereby coordinates an important part of the virtual integration of the consumer in the social regulatory mechanisms of the market, services and politics.

Het ontwerpen dankt zijn succes net als andere vormen van professionele bemiddeling, aan de door overheden en bedrijfsleven gestimuleerde economische en technisch-wetenschappelijke ontwikkeling. Dat heeft alles te maken met het aandeel in de planning van de produktie, maar meer nog met de beeldvorming en visuele stimuli in de media, onmisbaar voor de afzet van produkten, informatie en amusement. Het communicatief ontwerpen coördineert daarmee een belangrijk deel van de virtuele integratie van de consument in de maatschappelijk regulerende mechanismen van markt, dienstverlening en politiek.

8 9

> **Jan van Toorn**

> Design beyond design

> 1998

> example spreads

> see also overleaf

At the same time design is in the fragile r
a profession that has not yet reached m
whose relations with its partners in t
process have not been fully mastered
in search of its identity.
Today the world of design is exr
expansion for which it is ill prep
is at a crossroads.[4] Ann

matische routine van ontwerpers leidt in de werkelijkheid
rmatie-economie tot legitimatie van het bestaande
lijk systeem, dat zij inmiddels als een natuurlijke
r hun werk. Gevolg daarvan is dat de ideeën van
er de communicatieve betekenis van het vak,
delen vernauwen tot een institutionele
ld. Het is een vorm van zelfcensuur die
rganisatorische, technologische en
een taalgebruik oplevert dat van de
maakt. [Marc Augé, antropoloog, Parijs]

Ted Turner CNN

De eerste dag van de conferentie 'Design beyond design'
zal worden besteed aan de discrepantie tussen de sociaal-
economische en symbolische werkelijkheid van de mondiale
informatie- en consumptiecultuur, aan de perspectieven
voor het democratiseren van de media en de rol van visuele
producenten en theoretici daarbij. De tweede dag gaat
over het ontwerpen dat bewust 'de opheffing nastreeft van
de grenzen tussen alledaagse en esthetische ervaring' en
behandelt de strategieën en uitdrukkingsvormen van de
operationele en reflexieve tradities. Aan de orde komen
initiatieven op gebieden buiten het blikveld van het
officiële design evenals dialogische vormen van visuele
bemiddeling binnen het ontwerpen gericht op
onafhankelijke oordeelsvorming en participatie.

The first day of the conference 'Design
beyond design' will be devoted to the dis-
crepancy between the socio-economic
and symbolic reality of the worldwide
information and consumer culture, the
prospects for a democratisation of the
media, and the role of visual producers
and theoreticians in this development.
The second day will be devoted to design
that deliberately aims at 'abolishing the
boundaries between everyday and
aesthetic experience' and will deal with
the strategies and forms of expression of
the operational and reflexive traditions.
Initiatives in areas outside the realm of
official design will be discussed, as well
as dialogic forms of visual mediation
within design aimed at the forming of
independent opinion and participation.

I think it
is symbolic that the Netherlands has set up a
centre of research of this kind in the city of
Maastricht. Dutch graphic design is highly
developed yet many professionals are asking
where it is heading, and question in particu-
lar the paradox of 'happy' graphic design,
with its great formal success. Could this
perhaps represent the best advertising atti-
tude for the future, the best way of passing
on dominant values? It is a fundamental
question, and one which I am following
very closely." Pierre Bernard 1993

72 73

Everything that is not virgin nature then is understood as having
transformative cultural intervention, i.e. design. (YOU LOOK UP /
REALIZE THAT EVERYTHING—YES, EVERYTHING—AROUND YOU H
Thought of in these terms, designers are, in t'
terms, the mediators of reality.

Louise Sandl

Bill Gate

italistische media-maatschappij zijn ook informatie en
opwaar geworden. De monopolies van de cultuur- en
industrie hebben door toenemende commercia-
lering, wereldwijd een publieke sfeer gecreëerd
voor discussie over de sociale en culturele
r hen georganiseerde 'free flow of
r democratische controle op hun
een wereld waarin de realiteit
tie wordt gecamoufleerd door
+ onvermijdelijke.'
!haas, architect, Rotterdam en Londen]

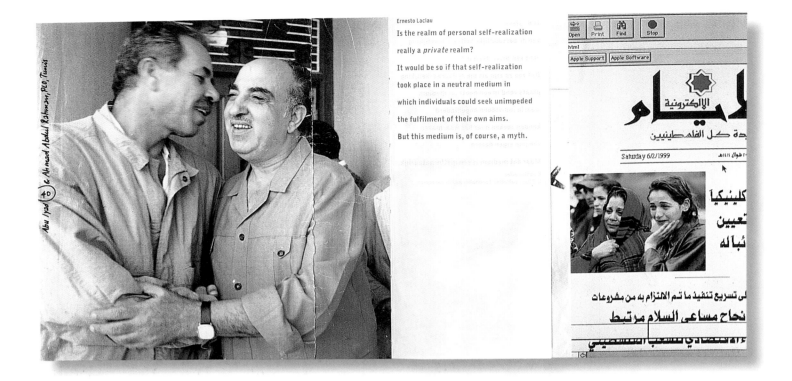

Ernesto Laclau

Is the realm of personal self-realization really a *private* realm? It would be so if that self-realization took place in a neutral medium in which individuals could seek unimpeded the fulfilment of their own aims. But this medium is, of course, a myth.

Jan van Toorn		200 x 200mm
Cultiver Notre Jardin		1999

>Above and overleaf: Jan van Toorn continues themes explored in the **Design beyond design** publication in this 'goodwill publication' produced for the Dutch printers Rosbeek. The theme of the book represents an analogy between the diversity of world cultures and a metaphorical garden. Monochrome images are printed on the reverse of folded sheets, which are then bound along one edge at 90 degrees to the fold. Full-colour images from around the world, sourced from news media and the designer's own archive, are labelled by hand, detailing the location depicted and page number – both the 'internal' and 'external' pages are numbered in this way. Also bound into the book between several spreads are trimmed pages of around one-third the width of the book, incorporating quotes from writers and design theorists relating to the 'private' and the 'public'. Translated in both Dutch and English languages, these are printed in magenta and cyan on each side of a translucent material. These partial pages act to obscure a part of the image which, when revealed, can present a different interpretation to the reader, or offer an alternative juxtaposition of images. Van Toorn has worked with the client for a number of years; his work reflects an 'open' brief to the designer to produce a publication which could be used to publicise the work of the printers but with few other parameters specified. This degree of relative freedom allows van Toorn to pursue the issues raised in his previous work and possibly to reach a different audience in the process.

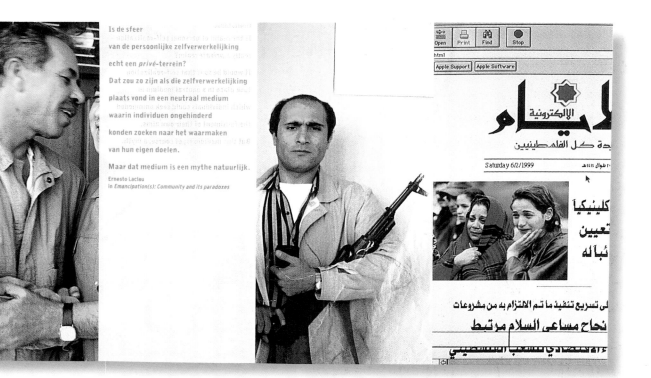

Is de sfeer
van de persoonlijke zelfverwerkelijking
echt een *privé-terrein*?
Dat zou zo zijn als die zelfverwerkelijking
plaats vond in een neutraal medium
waarin individuen ongehinderd
konden zoeken naar het waarmaken
van hun eigen doelen.

Maar dat medium is een mythe natuurlijk.

Ernesto Laclau
in *Emancipation(s): Community and its paradoxes*

cultiver notre jardin

Humanity emerged from a garden, and has
been living since the Fall in an imperfect
landscape. That is why Voltaire exhorted
us to cultivate our own garden in order to
survive during uncertain times. But it is
often no easy task to grow and cultivate
what is peculiarly ours there, particularly
at a time when the 'gardening vision' of
conglomerates of institutes and systems
operating at a global scale leaves less and
less room for gardens with other seedlings
then their own. What is more, the dominant
climate still has a great influence on how
the crop grows. So ever since the Garden of
Eden we have little choice but to keep on
bargaining with the grand design of the
surrounding estates. The free space thus
always remains half finished, incomplete.
It is a lived paradox, and we have to get
out of it what we can.

Jan van Toorn

notre jardin cultiver

1999

Rosbeek 45

Jan van Toorn <
Cultiver Notre Jardin <
1999 <
example spreads <

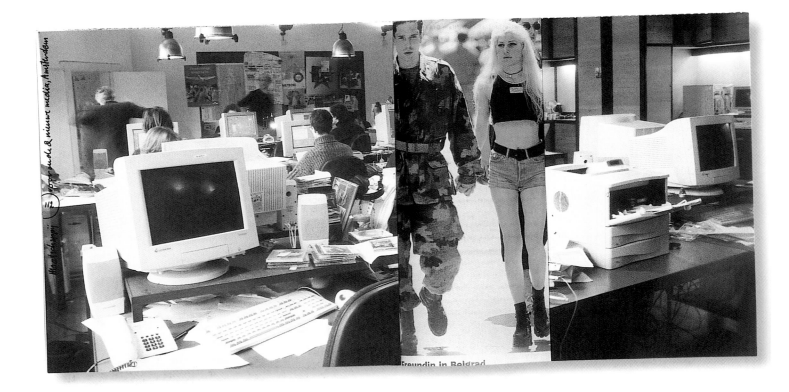

> **Jan van Toorn**

> Cultiver Notre Jardin

> 1999

> example spreads

Initiatief/initiative **William Graatsma**

Samenstelling, ontwerp, fotografie/
editing, design, photography

Jan van Toorn, Amsterdam

Foto's/photographs

Carl Amman, Amsterdam, p 82

Associated press, Amsterdam, p 31, 100

Juan Ramon López, New York, p 26, 32

MVRD, 010 Publishers, Rotterdam, p 7

Reuters, p 30

Roemer van Toorn, Amsterdam, pp 15, 18, 36, 68, 75, 76, 79, 80, 82, 83, 87, 88, 95, 99, 119

G. Shönharting/OstKreutz, p 4

Engelse vertaling/english translations

Peter Mason, Amsterdam, Heiner Müller
& p 120

Drukken, binden/printing, binding

Drukkerij Rosbeek bv, Nuth

De uitgevers hebben hun uiterste best gedaan
contact op te nemen met copyrighthouders. Degene
die we niet hebben bereikt vragen we contact met
ons op te nemen/The publishers have made every
effort to contact holders of copyrights. All copyright
holders we have been unable to reach are invited to
contact us.

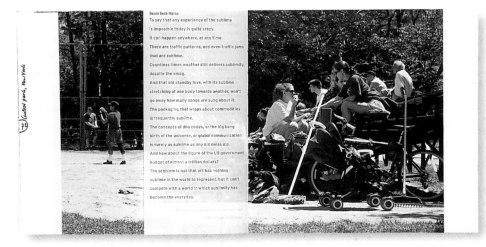

Susan Buck-Morss
To say that any experience of the sublime
is impossible today is quite crazy.
It can happen anywhere, at any time.
There are traffic patterns, and even traffic jams
that are sublime.
Countless times weather still delivers sublimity,
despite the smog.
And that old standby love, with its sublime
stretching of one body towards another, won't
go away how many songs are sung about it.
The packaging that wraps about commodities
is frequently sublime.
The concepts of dna codes, or the big bang
birth of the universe, or global communication
is surely as sublime as any old swiss alp.
And how about the figure of the US government
budget of almost a trillion dollars?
The problem is not that art has nothing
sublime in the world to represent, but it can't
compete with a world in which sublimity has
become the everyday.

P.O.V.

A series of lectures 1999 | Royal College of Art School of Communications

The idea that visual communication might be used as a medium of personal 'authorship' is taken for granted by many designers and image-makers, but there has been little discussion of the motivations that might underlie such interventions. Authorship requires a point of view – an identifiable position.

P.O.V. turns raw data and vague sense impressions into usable information. This series of college-wide lectures addresses the problems and possibilities of communication art and design as a critical practice.

All lectures take place in Lecture Theatre One, and start at 6.30 pm sharp.
Call Liz Ruth on 0171 590 4302 for free tickets and further details.
Royal College of Art, Kensington Gore, London SW7 2EU.

design | justy phillips

21	01	Rick Poynor
11	02	Ken Garland
02	03	Adbusters
23	03	Lorraine Wild
14	04	WD+RU
05	05	Steven Heller
02	06	David Crow

> **Justy Phillips**

> P.O.V. publicity brochure

> 1999

> unfolding spreads

P.O.V.

A series of lectures 1999 | Royal College of Art School of Communications

The idea that visual communication might be used as a medium of personal 'authorship' is taken for granted by many designers and image-makers, but there has been little discussion of the motivations that might underlie such interventions. Authorship requires a point of view – an identifiable position.

23 March | Lorraine Wild

Lorraine Wild has a design office in Los Angeles, where her practice includes collaborations with artists, curators, publishers and cultural institutions. She teaches at the California Institute of the Arts in the graphic design programme, which she directed from 1985 to 1992. Her writings on design education and practice have been published in *Emigre* and *I.D. Magazine*.

14 April | Women's Design Research Unit – Teal Triggs & Siân Cook
Pantone no. 223: WD+RU and women in design

WD+RU was formed in 1995 to raise awareness and empower women working professionally in the field of typo/graphic design. Projects have ranged from typeface and screensaver design to community-based activities helping to encourage school girls to consider graphic design as a career option.
Siân Cook is a graphic designer and teaches at Ravensbourne College of Design and Communication, and at the London College of Printing.
Teal Triggs is a design historian and course director of the MA Typo/graphic Studies programme at the London College of Printing.

5 May | Steven Heller
Imaging subversion/subverting the image

Steven Heller is a senior art director at the *New York Times* and the chair of the MFA design department at the School of Visual Arts, New York. Editor of the *AIGA Journal of Graphic Design*, he is author and editor of more than 60 books, including *Innovators of American Illustration*, *Design Literacy*, *Looking Closer: Critical Writings on Graphic Design*, and *The Education of a Graphic Designer*.

2 June | David Crow
Rituals of resistance

David Crow worked as a designer at Assorted Images and Island Records before setting up his own studio in 1989. He is the founder of *Trouble* magazine, which took a critical view of contemporary consumer culture, and a contributor to the typography publishing project *Fuse*. Since 1995, he has been head of the graphic arts department at Liverpool Art School, Liverpool John Moores University.

21 January | Rick Poynor
The hall of mirrors and the empty chair

Rick Poynor founded *Eye*, the international review of graphic design, and edited it from 1990 to 1997. His books include the critical surveys *Typography Now: The Next Wave*, *The Graphic Edge*, and *Typography Now Two: Implosion*, and *Design Without Boundaries*, a collection of his journalism and criticism. He is a visiting professor in the School of Communications at the Royal College of Art.

11 February | Ken Garland
Here are some things we should have done

Ken Garland is a graphic designer and design educator. He was art editor of *Design* magazine from 1956 to 1962, before establishing Ken Garland & Associates in London. In 1964, he published the manifesto *First things first*, also signed by 21 other designers and photographers, expressing concern at the wasteful misdirection of talent into advertising. *A Word in Your Eye*, his collected writings, was published in 1996.

2 March | Adbusters – Kalle Lasn & Chris Dixon
Culture jamming and Media Carta

Kalle Lasn is co-founder and president of the Media Foundation, based in Vancouver, Canada, and editor/publisher of *Adbusters*. His documentary films have been broadcast on PBS, CBC, and around the world. He sits on the advisory boards of the Center for the Study of Commercialism, the Cultural Envionmental Movement, and TV Free America.
Chris Dixon holds degrees in psychology and graphic design. He has worked on projects for Amnesty International and the World Health Organisation. He is art director for *Adbusters* and the Media Foundation.

P.O.V. turns raw data and vague sense impressions into usable information. This series of college-wide lectures addresses the problems and possibilities of communication art and design as a critical practice.

All lectures take place in Lecture Theatre One, and start at 6.30 pm sharp.
Call Liz Ruth on 0171 590 4302 for free tickets and further details.
Royal College of Art, Kensington Gore, London SW7 2EU.

design | justy phillips

Justy Phillips		420 x 594mm
P.O.V. publicity brochure		1999

>Above and overleaf: Publicity brochure for a lecture series at the Royal College of Art, London, organised by Rick Poynor, at that time Visiting Professor in the School of Communications. The brochure is folded down to 255 x 148mm, and folds out in stages to reveal further information about the series of events, with a poster for the lecture series on the reverse. Printed in two colours on a cream-coloured uncoated stock, the careful use of folding allows for texts to be revealed in alternate configurations as the work is opened out. Phillips makes bold use of space and sans-serif typography, employing elements of repetition, bathos and asymmetry to achieve a finished product that allows the reader to reconfigure the information in multiple formats.

P.O.V. turns raw data and vague sense impressions into usable information. This series of college-wide lectures addresses the problems and possibilities of communication art and design as a critical practice.

All lectures take place in Lecture Theatre One, and start at 6.30 pm sharp.
Call Liz Ruth on 0171 590 4302 for free tickets and further details.
Royal College of Art, Kensington Gore, London SW7 2EU.

design | justy phillips

21\|01	Rick Poynor
11\|02	Ken Garland
02\|03	Adbusters
23\|03	Lorraine Wild
14\|04	WD+RU
05\|05	Steven Heller
02\|06	David Crow

P.O.V.

P.O.V.

A series of lectures 1999 | Royal College of Art School of Communications

The idea that visual communication might be used as a medium of personal 'authorship' is taken for granted by many designers and image-makers, but there has been little discussion of the motivations that might underlie such interventions. Authorship requires a point of view – an identifiable position.

21 January | Rick Poynor
The hall of mirrors and the empty chair

Rick Poynor founded *Eye*, the international review of graphic design, and edited it from 1990 to 1997. His books include the critical surveys *Typography Now: The Next Wave*, *The Graphic Edge*, and *Typography Now Two: Implosion*, and *Design Without Boundaries*, a collection of his journalism and criticism. He is a visiting professor in the School of Communications at the Royal College of Art.

11 February | Ken Garland
Here are some things we should have done

Ken Garland is a graphic designer and design educator. He was art editor of *Design* magazine from 1956 to 1962, before establishing Ken Garland & Associates in London. In 1964, he published the manifesto *First things first*, also signed by 21 other designers and photographers, expressing concern at the wasteful misdirection of talent into advertising. *A Word in Your Eye*, his collected writings, was published in 1996.

2 March | Adbusters – Kalle Lasn & Chris Dixon
Culture jamming and Media Carta

Kalle Lasn is co-founder and president of the Media Foundation, based in Vancouver, Canada, and editor/publisher of *Adbusters*. His documentary films have been broadcast on PBS, CBC, and around the world. He sits on the advisory boards of the Center for the Study of Commercialism, the Cultural Enviornmental Movement, and TV Free America.
Chris Dixon holds degrees in psychology and graphic design. He has worked on projects for Amnesty International and the World Health Organisation. He is art director for *Adbusters* and the Media Foundation.

23 March | Lorraine Wild

Lorraine Wild has a design office in Los Angeles, where her practice includes collaborations with artists, curators, publishers and cultural institutions. She teaches at the California Institute of the Arts in the graphic design programme, which she directed from 1985 to 1992. Her writings on design education and practice have been published in *Emigre* and *I.D. Magazine*.

14 April | Women's Design Research Unit – Teal Triggs & Siân Cook
Pantone no. 223: WD+RU and women in design

WD+RU was formed in 1995 to raise awareness and empower women working professionally in the field of typo/graphic design. Projects have ranged from typeface and screensaver design to community-based activities helping to encourage school girls to consider graphic design as a career option.
Siân Cook is a graphic designer and teaches at Ravensbourne College of Design and Communication, and at the London College of Printing.
Teal Triggs is a design historian and course director of the MA Typo/graphic Studies programme at the London College of Printing.

5 May | Steven Heller
Imaging subversion/subverting the image

Steven Heller is a senior art director at the *New York Times* and the chair of the MFA design department at the School of Visual Arts, New York. Editor of the *AIGA Journal of Graphic Design*, he is author and editor of more than 60 books, including *Innovators of American Illustration*, *Design Literacy*, *Looking Closer: Critical Writings on Graphic Design*, and *The Education of a Graphic Designer*.

2 June | David Crow
Rituals of resistance

David Crow worked as a designer at Assorted Images and Island Records before setting up his own studio in 1989. He is the founder of *Trouble* magazine, which took a critical view of contemporary consumer culture, and a contributor to the typography publishing project *Fuse*. Since 1995, he has been head of the graphic arts department at Liverpool Art School, Liverpool John Moores University.

> **Justy Phillips**
> P.O.V. publicity brochure, 1999
> unfolding spreads

21|01 Rick Poynor
11|02 Ken Garland
02|03 Adbusters
23|03 Lorraine Wild
14|04 WD+RU
05|05 Steven Heller
02|06 David Crow

P.O.V.

point(s) of view

A series of lectures | Royal College of Art School of Communications

Tickets and details 0171 590 4302

A PRACTICAL DREAMER: THE PHOTOGRAPHS OF
Man Ray

> **Walker Arts Centre**

> Man Ray exhibition brochure

> 2000

> cover/unfolding spreads

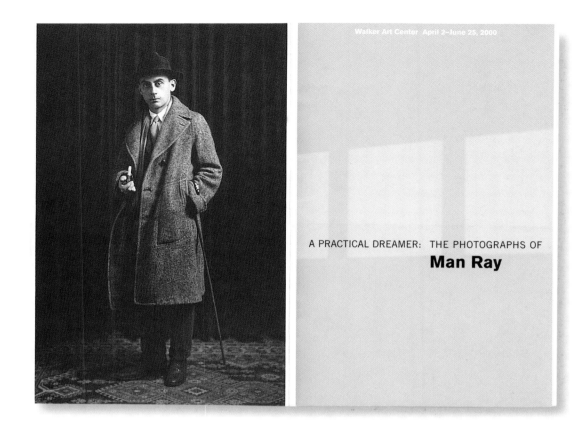

Walker Art Center April 2–June 25, 2000

A PRACTICAL DREAMER: THE PHOTOGRAPHS OF
Man Ray

Joan Miró, *Tête et Oiseau*, 1967, bronze, Collection Walker Art Center; Gift of the T. B. Walker Foundation, 1970

A Practical Dreamer: The Photographs of Man Ray is organized by the J. Paul Getty Museum, Los Angeles. The Minneapolis presentation is made possible by generous support from Dayton's community-giving initiative, Project Imagine; Goldman, Sachs & Co.; Alliance Capital Management Corporation; Ingrid and Alfred Harrison; and Beverly and John Rollwagen.

We would like to extend our gratitude to the following lenders for their generosity: Timothy Baum, Rosemary Furtak, Fay Gallus and Richard Sweet, Evan M. Maurer, Martin and Lora Weinstein, Jane Westerlund, the Minneapolis Institute of Arts, the Getty Research Institute, The University of Minnesota Library Special Collections and Rare Books, and an anonymous lender. We also received valuable assistance from Ted Hartwell, Dennis Jon, and Hal Peterson at the Minneapolis Institute of Arts; Tim Johnson at the University of Minnesota; Julian Cox at the J. Paul Getty Museum; Walter Gegner at the Minneapolis Public Library; Roger Browner, Erik Browner, and Stephanie Browner at the Man Ray Trust; and Jean-Michel Bouhours at the Centre Georges Pompidou.

©2000 Walker Art Center
www.walkerart.org

Unless otherwise noted, the following are gelatin silver prints by Man Ray, Collection The J. Paul Getty Museum, Los Angeles. © The Man Ray Trust ARS-ADAGP.

Inside, top, left to right:
Profile and Hands 1932 gelatin silver print, solarized 7 1/16 x 9 in.
Larmes (Tears) 1930–1933 9 x 11 3/4 in.
Florence Homolka *Double Wedding Portrait* (Man Ray, Juliet Man Ray, Max Ernst, and Dorothea Tanning) 1946 8 1/2 x 10 in.

1. *Fire Escape and Umbrellas* 1917 6 7/8 x 4 15/16 in.
2. Berenice Abbott negative, 1921; printed later 7 15/16 x 6 1/2 in.
3. *Augustabernard Gown* negative, 1934; print 1936 11 1/4 x 8 15/16 in.
4. *Untitled Rayograph (Paper Spiral)* from the portfolio *Les champs délicieux (The Delicious Fields)* 1922 8 15/16 x 6 7/8 in.
5. *Le violin d'Ingres (Ingres' Violin)* 1924 11 5/8 x 9 in.
6. *Self-Portrait with Camera* 1932 gelatin silver print, solarized 11 1/2 x 9 in.
7. *Juliet with Headdress* circa 1945 6 1/2 x 4 5/8 in.
8. *Ruth, Roses, and Revolvers* 1942–1944 9 13/16 x 7 15/16 in.

Back:
Self-Portrait with Pipe, Paris 1921 5 7/16 x 3 1/4 in.

Figs. 9–11 are frame enlargements from films by Man Ray, Collection Centre Georges Pompidou, Musée national d'art moderne, Paris; © The Man Ray Trust, ARS-ADAGP.

9. *Le retour à la raison (The Return to Reason)* 1923
10. *Emak Bakia* 1926
11. *L'Étoile de mer (The Star of the Sea)* 1928

Société Man Ray

From the very beginning of his artistic career, Man Ray situated himself near the developing cultural avant-garde. He regularly visited Alfred Steiglitz's New York gallery, 291, an important center of international modernism and a focal point of New York Dada in its infancy. At about that time, he saw the very modern works of Pablo Picasso, Georges Braque, Marcel Duchamp, and Francis Picabia at the 1913 *Armory Show*, a seminal exhibition in the history of the European and American avant-garde. Man Ray met Marcel Duchamp, who was to become one of his closest associates, shortly after they both moved to New York in 1915. Both were involved with the Arensberg Circle, a group of writers and artists who gathered at the home of collectors Walter and Louise Arensberg.

Duchamp introduced Man Ray to European Dada activities, and both incorporated Dada's sense of iconoclasm and experimentation in their work. Their many collaborations included the publication of the only issue of *New York Dada* in 1921. Man Ray visited Duchamp's studio often—the photograph *Dust Breeding* (1920) (included in Duchamp's *Boîte-en-Valise*) was made when Man Ray observed that Duchamp's famous *The Large Glass*, in a state of partial completion, looked like "some strange landscape from a bird's-eye view." When Duchamp returned to Paris in 1921, Man Ray soon followed and found himself in the company of European Dadaists Tristan Tzara, Jean (Hans) Arp, and poet Paul Éluard on the day of his arrival: "I felt at ease with these strangers who seemed to accept me as one of themselves." Man Ray flourished in Europe, exhibiting not only in Paris, but also in Cologne with the help of German artist Max Ernst.

After the final dissolution of the Dada movement in Paris in 1922, Ernst, Man Ray, and Picabia joined André Breton in discussions about the potential of the irrational, marvelous, and unconscious in artistic practice—ideas that would later surface in Breton's 1924 *Manifesto of Surrealism*. Although Man Ray's best-known works are photographs, he and his friends Ernst, Picabia, and the younger Yves Tanguy explored painting and collage in order to express fantastical Surrealist imagery. Man Ray remained in Paris throughout the 1920s and 1930s ensconced in the artistic community. Before leaving war-torn Europe in 1940, he designed the lighting for the important *International Surrealist Exhibition* of 1938—on opening night some 1,000 viewers were given flashlights and had to find their way to the artworks through the dark. In addition to the paintings and other "attractions or distractions" on view, Arp, Salvador Dalí, Duchamp, Ernst, Joan Miró, and Man Ray fashioned mannequins into artworks for this "climax of Surrealist activity."

Dada, and later Surrealism, were movements marked by an active theorization of artistic practice and a network of artists, writers, collectors, and personalities who came together often in exhibitions, performances, happenings, and salons. In consideration of this high level of interaction and collaboration surrounding Man Ray's work in Paris and New York, this exhibition includes an adjunct group of works by many of his friends and contemporaries, including Duchamp, Picabia, Ernst, Miró, and others. These associations and relationships are also documented through period exhibition catalogues and photographs.

Elizabeth Thomas, Walker Art Center

EXPERIMENTAL LAYOUT: SPATIAL DYNAMICS 065

> **Walker Arts Centre**
> Man Ray exhibition brochure
> 2000
> unfolding spreads

Man Ray (American, 1890–1976) delighted in astounding viewers by juxtaposing familiar elements in incongruous ways, his intent nothing less than the transcendence of normal thought patterns. "The experiment lies with the spectator in his willingness to accept what his eye conveys to him," he wrote in 1921. "The success of the experiment is in proportion to the desire to discover and enjoy." Throughout his long career he made photographs, paintings, assemblages, drawings, sculptures, and films. Though he resisted classification as a photographer, his no-rules approach tested the boundaries of the medium and resulted in some of his most innovative and enduring work. Man Ray's efforts to redefine what we consider beautiful have shaped the way we see the world today and have been tremendously influential on the artists who followed him.

As a young artist in New York in the 1910s, Man Ray initially took up photography to record his work in other media. He was aware of the medium's potential for creative expression from his visits to photographer Alfred Stieglitz's gallery of modern art at 291 Fifth Avenue, where he saw the latest art from Europe and sought advice. Man Ray soon trained his lens on other subjects, making portraits, self-portraits, and nude studies. Not satisfied with these conventional uses of photography, he began working in 1917 with the cliché-verre (glass-negative) process, which involves scratching a design into a layer of emulsion or pigment on glass, then using the resulting plate as a negative. The technique was used among artists of the French Barbizon school in the late 1800s as a method of printmaking. *Fine Escape and Umbrellas* (inside, fig. 1) may look like a sketch but is actually a photographic print made with such a negative, allowing Man Ray to subvert the uniqueness of a drawing by making it reproducible, while also subverting photography by drawing the image by hand rather than using a camera.

Abandoning New York for the adventure of Paris in 1921, Man Ray established a portrait studio whose profits allowed him the freedom to pursue painting unconstrained by any concern for its marketability. His photographs of friends and acquaintances in Paris—a catalogue of creative luminaries of the 1920s and 1930s—demonstrate a skilful economy of means and stand among his best work (fig. 2). Another of Man Ray's accomplishments was his fashion photography (fig. 3), which reached its apex in the late 1930s. His imaginative approach to assignments enhanced the glamour of designers' garments in periodicals such as *Harper's Bazaar* and *Vogue*.

Concurrent with this commercial work, Man Ray was exploring the outer limits of photography's boundaries. In 1922 he began making cameraless photographs he called Rayographs. The process can be traced to the inception of photography in the 1830s, when William Henry Fox Talbot and others placed nature specimens on chemically treated paper and exposed them to light, producing a silhouette of the objects. *Untitled Rayograph (Paper Spiral)* (fig. 4) was included in Man Ray's *Les champs délicieux (The Delicious Fields)*, a portfolio of 12 Rayographs published in Paris in December 1922. Like the cliché verre pictures, Rayographs allowed the artist to make photographic images without a camera. With this technique, Man Ray imbued the most ordinary materials—scissors, a curl of paper, a gyroscope—with great mystery and import, suspended against a backdrop of limitless black. Since they were also made without a negative, Rayographs were—like paintings and drawings—one-of-a-kind objects. In a further twist, however, Man Ray used a camera to photograph the Rayographs in the portfolio so that multiple copies could be made and sold.

The Rayographs are infused with the spirit of Dadaism, a movement with which Man Ray was associated even before leaving New York. The adherents of Dadaism staged rebellious, chaotic performances throughout Europe and embraced chance elements and randomness in their work as a reaction against the "sensible" society that had permitted the horrors of World War I. The group lost momentum just after Man Ray arrived in Paris, but many of its members aligned themselves with the French writer André Breton, who joined the tenets of Dadaism with the dream theory of Viennese psychoanalyst Sigmund Freud to inaugurate Surrealism in 1924. Man Ray used his camera not only to document the members, works, and activities of these two groups but also as a means of exploring their ideas with photography. The nature of the medium was particularly well suited to their interest in accident, chance, and the decontextualization of objects of the ordinary world.

The spontaneous, disruptive humor of Dadaism is also evident in Man Ray's un-retouched photograph. In *Violon d'Ingres (Ingres' painter Jean Auguste Dominique Ingres, Man Ray made a series of photographs of his mistress, Kiki, wearing a turban. He then altered a picture of Kiki's back by painting the F-holes of a violin onto the print and then rephotographing the whole. The picture maintains a tension between objectification and appreciation of the female form. The transformation of Kiki's body into a musical instrument with the subtle addition of a few brushstrokes is amusing, but her animistic form is also disturbing. As a finishing touch, the artist added the title, a French idiom that means "hobby," perhaps suggesting that while playing the violin was Ingres' hobby, playing with Kiki was a pastime of Man Ray's. The piece implies Man Ray's mastery of the history of French painting as well as his ability to "improve" on it.

Another photographic technique closely associated with Man Ray is the Solarization effect, more commonly known as solarization. Named for the man who discovered it in 1862, the effect involves exposing a photographic print or negative to light during the development process to create an unpredictable reversal of tones in some areas, as in Man Ray's *Self-Portrait with Camera* (fig. 6). He used solarization to give an otherworldly quality to his subjects and as a method of suggesting a gratifying self-portrait of a softer alongside the physical likeness. "The technique allowed me to get away from photography, to get away from banality... and there was a chance to produce a photograph that would not look like a photograph," he told an interviewer in 1961. In the picture Man Ray shows himself intently adjusting the focal range on his view camera as if for a portrait session with the viewer. The touch of his hand on the focusing ring emphasizes Man Ray's artistry in the making of his photographs, a departure from his more accidental approach to the medium. The corona of solarization emanating from his profile suggests a mystique for the artist on a par with that of his famous subjects from the worlds of art, fashion, and society.

After having lived abroad for nearly two decades, Man Ray moved back to the United States in the summer of 1940, after Nazi troops occupied Paris. With its thriving film industry, temperate climate, and swelling population of expatriate artists, writers, and musicians, Hollywood seemed like a good place to wait out the war. In his first few days in Los Angeles, Man Ray found a studio and met his future wife, Juliet Browner (fig. 7). Despite this auspicious beginning, Man Ray did not flourish during his 10 years in Southern California. Although he entertained the idea of working in the film industry, he quickly realized that he would have to collaborate, and he rejected offers to serve as a cameraman. However, a piece of short fiction he published in the December 1944 issue of the arts magazine *View* was used as the basis for a cinematic scenario in the movie *Dreams That Money Can Buy* (1946), directed by German filmmaker and former Dadaist Hans Richter. In the photograph *Ruth, Roses, and Revolvers* (fig. 8), which accompanied the original story, a film noir atmosphere provides evidence of Hollywood's impact on Man Ray's photographs of the 1940s. The melancholy of the blowzy plucked rose is undercut by the toy cowboy pistol, which adds a ridiculous and melodramatic air to the scene. Due to his reputation in America primarily as a fashion photographer, in this writings of this period the artist distanced himself from photography, though he continued to work with the medium throughout the decade. After his return to Paris in 1951, his wife, Juliet, was his primary photographic subject until his death in 1976.

For Man Ray, photography was ultimately just one tool of many in the service of his ideas, but he demonstrated a remarkable facility for manipulating the medium in the creation of art. During his seven decades as an artist he never seemed to waver from the philosophy that his work was "designed to amuse, bewilder, annoy, or to inspire reflection, but not to arouse admiration for any technical excellence usually sought for in works of art. The streets are full of admirable craftsmen, but so few practical dreamers."

—Katherine Ware, Exhibition Curator

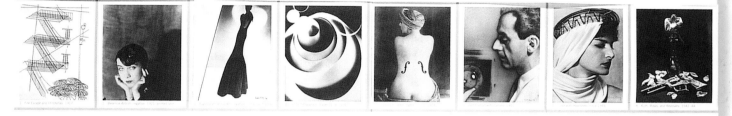

Walker Arts Centre	610 x 515mm
A Practical Dreamer: The Photographs of Man Ray exhibition brochure	2000

>Previous spread, above and overleaf: Publicity brochure designed by the in-house design team at the Walker Art Centre to accompany the exhibition **A Practical Dreamer: The Photographs of Man Ray**. Printed in a subtle range of flat colours on a matt stock, the brochure is folded to 155 x 230mm, initially appearing to take a standard 'magazine' format. However, as the brochure folds out in a series of unusual and unexpected stages, it reveals hidden rows of images and blocks of text. In some instances, images are partially revealed in the stages of unfolding, or are juxtaposed with footnotes and rows of still images which are taken from cinematic experiments by Man Ray. These take the form of story-boards, running across the entire width of the brochure, set against time details for each frame and reference numbers which are annotated in the accompanying text. The reader is confronted with more and more complex levels of information, the brochure presenting a deeper and more detailed reflection on the exhibition than might be expected in gallery publicity material of this nature.

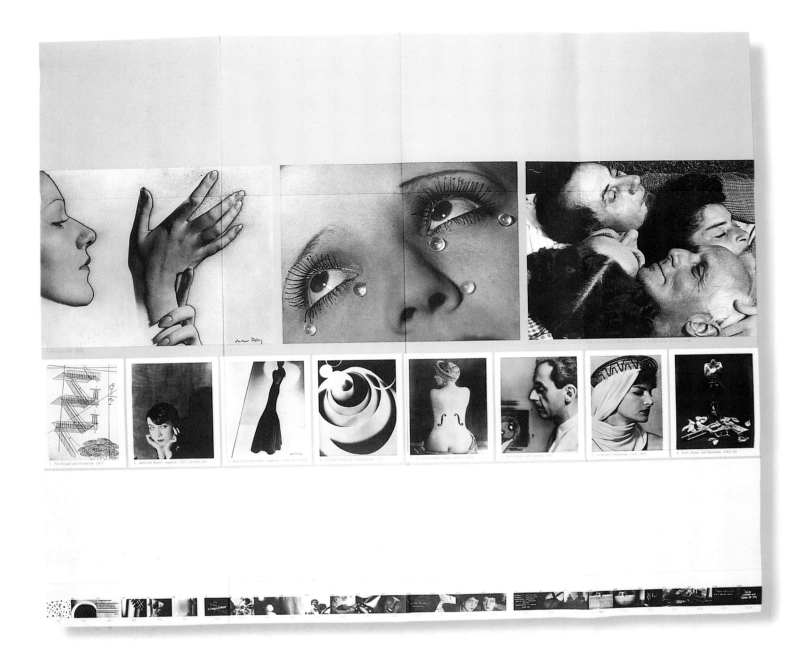

> **Walker Arts Centre**

> Man Ray exhibition brochure

> 2000

> unfolding spreads

Cinema Man Ray

A PRACTICAL DREAMER: THE PHOTOGRAPHS OF Man Ray

Walker Art Center April 2–June 25, 2000

A Practical Dreamer: The Photographs of Man Ray

Man Ray (American, 1890–1976) delighted in astounding viewers by juxtaposing familiar elements in incongruous ways, his intent nothing less than the transcendence of normal thought patterns. "The experiment lies with the spectator in his willingness to accept what his eye conveys to him," he wrote in 1945. "The success of the experiment is in proportion to the desire to discover and enjoy." Throughout his long career he made photographs, paintings, assemblages, drawings, sculptures, and films. Though he resisted classification as a photographer, his no-rules approach tested the boundaries of the medium and resulted in some of his most innovative and enduring work. Man Ray's efforts to redefine what we consider beautiful have shaped the way we see the world today and have been tremendously influential on the artists who followed him.

As a young artist in New York in the 1910s, Man Ray initially took up photography to record his work in other media. He was aware of the medium's potential for creative expression from his visits to photographer Alfred Stieglitz's gallery of modern art at 291 Fifth Avenue, where he saw the latest art from Europe and sought advice. Man Ray soon trained his lens on other subjects, making portraits, self-portraits, and nude studies. Not satisfied with these conventional uses of photography, he began working in 1917 with the cliché-verre (glass-negative) process, which involves scratching a design into a layer of emulsion or pigment on glass, then using the resulting plate as a negative. The technique was used among artists of the French Barbizon school in the late 1800s as a method of printmaking. Fire Escape and Umbrellas (inside, fig. 1) may look like a sketch but is actually a photographic print made with such a negative, allowing Man Ray to subvert the uniqueness of a drawing by making it reproducible, while also subverting photography by drawing the image by hand rather than using a camera.

Abandoning New York for the adventure of Paris in 1921, Man Ray established a portrait studio whose profits allowed him the freedom to pursue painting unconstrained by other concern for its marketability. His photographs of friends and acquaintances in Paris — a catalogue of creative luminaries of the 1920s and 1930s — demonstrate a skillful economy of means and stand among his best work (fig. 2). Another of Man Ray's accomplishments was his fashion photography (fig. 3), which reached its apex in the late 1930s. His imaginative approach enhanced the glamour of designers' garments in periodicals such as Harper's Bazaar and Vogue.

Concurrent with this commercial work, Man Ray was exploring the outer limits of photography's boundaries. In 1922 he began making cameraless photographs he called Rayographs. The process can be traced to the inception of photography in the 1830s, when William Henry Fox Talbot and others placed nature specimens on chemically treated paper and exposed them to light, producing a silhouette of the objects. Untitled Rayograph (Paper Spiral) (fig. 4) was included in Man Ray's Les champs délicieux (The Delicious Fields), a portfolio of 12 Rayographs published in Paris in December 1922. Like the cliché-verre pictures, Rayographs allowed the artist to make photographic images without a camera. With this technique, Man Ray imbued the most ordinary materials — scissors, a curl of paper, a gyroscope — with great mystery and import, suspended against a backdrop of limitless black. Since they were also made without a negative, Rayographs were — like paintings and drawings — one-of-a-kind objects. In a further twist, however, Man Ray used a camera to photograph the Rayographs in the portfolio so that multiple copies could be made and sold.

The Rayographs are infused with the spirit of Dadaism, a movement with which Man Ray was associated even before leaving New York. The adherents of Dadaism staged rebellious, chaotic performances throughout Europe and embraced chance elements and randomness in their work as a reaction against the "sensible" society that had permitted the horrors of World War I. The group lost momentum just after Man Ray arrived in Paris, but many of its members aligned themselves with the French writer André Breton, who joined the tenets of Dadaism with the dream theory of Viennese psychoanalyst Sigmund Freud to inaugurate Surrealism in 1924. Man Ray used his camera not only to document the members, works, and activities of these two groups but also as a means of exploring their ideas with photography. The nature of the medium was particularly well suited to their interest in accident, chance, and the decontextualization of objects of the ordinary world.

The spontaneous, disruptive humor of Dadaism is also evident in Man Ray's quintessential photograph Le violon d'Ingres (Ingres's Violin) (fig. 5). Inspired by the languorous nudes of 19th-century painter Jean-Auguste-Dominique Ingres, Man Ray made a series of photographs of his mistress, Kiki, wearing a turban. He then altered a picture of Kiki's back by painting the F-holes of a violin onto the print and then rephotographing the work. The picture maintains a tension between objectification and appreciation of the female form. The transformation of Kiki's body into a musical instrument with the crude addition of a few brushstrokes is amusing, but her armless form is also disturbing. As a finishing touch, the artist added the title, a French idiom that means "hobby," perhaps suggesting that while playing the violin was Ingres's hobby, playing with Kiki was a pastime of Man Ray's. The piece implies Man Ray's mastery of the history of French painting as well as his ability to "improve" on it.

Another photographic technique closely associated with Man Ray is the Sabattier effect, more commonly known as solarization. Named for the man who discovered it in 1862, the effect involves exposing a photographic print or negative to light during the development process to create an unpredictable reversal of tones in some areas, as in Man Ray's Self-Portrait with Camera (fig. 6). He used solarization to give an otherworldly quality to his subjects and as a method of suggesting a psychological portrait of a sitter alongside the physical likeness. "The technique allowed me to get away from photography, to get away from banality . . . and here was a chance to produce a photograph that would not look like a photograph," he told an interviewer in 1944. In this picture Man Ray shows himself intently adjusting the focal range on his view camera as if for a portrait session with the viewer. The touch of his hand on the focusing ring emphasizes Man Ray's artistry in the making of his photographs, a departure from his more accidental approach to the medium. The corona of solarization emanating from his profile suggests a mystique for the artist on a par with that of his famous subjects from the worlds of art, fashion, and society.

After having lived abroad for nearly two decades, Man Ray moved back to the United States in the summer of 1940, after Nazi troops occupied Paris. With its thriving film industry, temperate climate, and swelling population of expatriate artists, enters, and musicians, Hollywood seemed like a good place to wait out the war. In his first few days in Los Angeles, Man Ray found a studio and met his future wife, Juliet Browner (fig. 7). Despite this auspicious beginning, Man Ray did not flourish during his 10 years in Southern California. Although he entertained the idea of working in the film industry, he quickly realized that he would have to collaborate, and he rejected offers to serve as a cameraman. However, a piece of short fiction he published in the December 1944 issue of the arts magazine View was used as the basis for a cinematic scenario in the movie Dreams That Money Can Buy (1946), directed by German filmmaker and former Dadaist Hans Richter. In the photograph Ruth, Roses, and Revolvers (fig. 8), which accompanied the original story, a film noir atmosphere provides evidence of Hollywood's impact on Man Ray's photographs of the 1940s. The melancholy of the blowzy plucked rose is undercut by the toy cowboy pistol, which adds a ridiculous and melodramatic air to the scene. Due to his reputation in America primarily as a fashion photographer, in his workings of this period the artist distanced himself from photography, though he continued to work with the medium throughout the decade. After his return to Paris in 1951, his wife, Juliet, was his primary photographic subject until his death in 1976.

For Man Ray, photography was ultimately just one tool of many in the service of his ideas, but he demonstrated a remarkable facility for manipulating the medium in the creation of art. During his seven decades as an artist he never seemed to waver from the philosophy that his work was "designed to amuse, bewilder, annoy, or to inspire reflection, but not to arouse admiration for any technical excellence usually sought for in works of art. The streets are full of admirable craftsmen, but so few practical dreamers."

Katherine Ware, Exhibition Curator

Interview Mark Pawson

Where do you think your work might be placed in relation to other art and design practice and what is your main area of employment?

I support myself largely through the sale of my work, some bits of teaching and writing and I also run a mail order catalogue selling other artists' books and small press zines. In the past I've done exhibition and installation projects, but since then I have decided to focus more on bookworks which I almost always manufacture, distribute and sell myself. It's very important to me that the work is accessible and affordable, sold through diverse outlets — from record shops to clothes shops and artists' book stores, so that people can decide for themselves where it fits into the continuum of art, or design, or fashion.

How is the work produced?

Very little of my work has been screenprinted or commercially reproduced: all my books are photocopied, sometimes onto old magazine or poster stock, or rubber-stamped, and some have been reproduced on Roneo and Gestetner stencil machines. I did recently undertake a brief commissioned by Levi's Vintage, to produce a large one-off piece which was screenprinted directly onto a 15 ft long strip of blue denim. This was then photographed and reproduced as a limited edition printed poster. Quite a few of my books also have a matching T-shirt, which I design and then have commercially screenprinted, and I also manufacture button badges by hand.

With the rubber stamp and photocopy books, do you produce them in this way because it is cheaper than commercial printing?

It is probably cheaper to produce the books that way, but I mainly choose to produce by hand because I can have full control of the process; stamping in the living room and binding on the kitchen table — you could say it's the original desktop publishing. Also I enjoy labour-intensive processes, and the satisfaction of having a stack of new books after a day's work. The downside of this way of working is that I'm currently reaching the limit of the number of books I can produce.

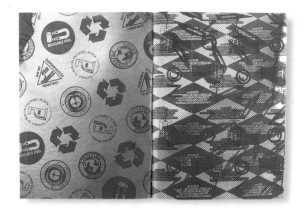

Which was the first book you created?

Postcard-sized books of photocopier-generated patterns and textures, which were blank on the reverse and could be used as notebooks, in 1983/4 when I was at University studying sociology. I just kept making things ever since I was a kid, and when I was 17 discovered the international mail-art network, which was my art education really, a ready-made, worldwide group of artists enthusiastically exchanging work. When I made **Mark's Little Book About Kinder Eggs.** (pages 46–49), I didn't really anticipate that it would become a bestseller. I have sold around 7,000 of those at around 75 pence each. The original idea was to produce a book which was roughly the same size and price as a Kinder Surprise chocolate egg. Produced on a manual typewriter (I didn't have a computer), it was done as a diary. I wrote it in one day, then typed it up and made 200 photocopied books; it was spontaneously put together in three days. I was just personally interested in the subject, I collected hundreds of the toys and wanted to write about them in a factual documentary style.

Have you updated the book over the last ten years?

Not really. I intended to, and there is one additional spread of several newspaper clippings about Kinder Eggs which wasn't in the first edition, but I soon realised that I needed to do a completely new version rather than just keep updating the existing one. I do try to keep as much as possible of my work in print, to make them available for several years. With a few exceptions, I'm not interested in doing small limited editions of expensive books, although obviously sometimes they do have a place.

How do you come about ideas for your books – is it a process of research and development, or personal inspiration?

Definitely a chaotic mix of inspiration and constant experimentation. I always have lots of ideas – too many ideas – which I keep in notebooks. If an idea stays with me for a while I will make it into a book, or a postcard, T-shirt or badge, wherever it belongs.

I don't really think about the audience for my work too much; I know from experience that it will sell. I think it is interesting work produced mainly for my own satisfaction and over several years I've found markets for it, and figured out things like how many copies to make and how much to sell it for. The work isn't produced for serious collectors of artists' books, who often look for expensive limited editions. My work doesn't fit into those categories: it's cheap, it's usually still in production, and often small in size.

I can imagine you're always picking things up in the street, always collecting.
I'm an image junkie, constantly picking up bits of image material, trying to categorise images, filing them for the future, some of which ends up being used in my work. For instance, when I was sorting through a box of printed ephemera, I found four or five different plug wiring diagrams, which fit over the prongs on British three-pin plugs. This collection had started to come together by chance, and I wondered why there are so many different variations of the diagrams. I asked people to send me any wiring diagrams that they found and ended up with about 60 different ones, all using different colours and shapes. The book presents them very straightforwardly, with just a short accompanying essay. The colours in the book are true to the original diagrams, and each book is bound by hand with thread the same colours as the wires in the plug.

You use a lot of found imagery; how is that affected by copyright laws?
As I said, I'm an image junkie. There's enough images in the world already, why create more? Of course, there are questions of copyright, but I think I take images far enough away from the original source, and re-contextualise them, making something new from them.

Much of your work appears to be concerned with the process of manufacture; the reader can sense a feeling of real enjoyment in the methods of production.
For the **MaPK naBCoH** photocopy book (pages 85–87), I got hold of a large amount of unused, printed billboard paper from eight-sheet advertising posters. This was a wonderful stock to work with. On the front are very large colour halftone images, intended to be viewed from about 20 feet away, and on the back a flat grey tone. I had been producing black and white photocopy mail art for some time, and I decided to use this material in the production of a new book. I cut the poster sheets down to A3 and photocopied a range of my artwork – intricately detailed collages, patterns and textures – onto them, doing multiple passes on the copier, enlarging and reducing between passes. Every page is photocopied up to four times, you can see and feel the build-up of dense black toner on the page. Each copy of these books is unique, because I was playing around so much with my stack of images, and the photocopier. I also had access to single colour red, blue, green and brown photocopiers, where you change the colour of the toner cartridge between print runs. Through time the books have changed with the different copiers I had access to, particularly because now you don't often see the

single colour machines. I made this book continuously for ten years, and round about the same time I finally ran out of the billboard poster paper, I'd just taught myself bookbinding, so producing a hardback version seemed an ideal conclusion to the project. For the cover, I used my name, and a portrait – kind of vain, but both are hard-to-recognise: MaPK naBCoH is my name translated into Russian, and the picture is a blown-up photobooth picture of me side-on with dreadlocks flying everywhere.

How did the Life has Meaning book come about?

That book was created after I met KNUST, a group of Dutch artists who run a print studio in Nijmegen using Roneo and Gestetner stencil printers (duplicators). They saw my work, and invited me to go and produce something there. Stencil printers use wet inks and photo-stencils in what is basically a screenprinting process. These machines were used quite widely up to 20 years ago, but have been replaced entirely by photocopiers. It is possible to do colour separations with them, and to reproduce full-colour work. **Life has Meaning** is the successor to **MaPK naBCoH**, expanding and building on what I had done with photocopiers. The originals were created on black and white or full-colour copiers, and then translated to the other technology. I invented special effects on the photocopier by, for instance, enlarging to various percentages from an original and overlaying through multiple passes.

Does the technology lead you or do you have a brief in mind for which you then seek the technology to produce?

A lot of the work is produced through play, through experiments with simple processes. I like to push the boundaries of the machinery. The photocopier is probably the ideal tool for me; sometimes I find myself spending an hour on the computer to create something which I could do in seconds on the photocopier. I don't do anything that would be termed digital work, I still work in a very manual, hands-on way and I think my work always will be like that.

form follows content

WHY MAKE A STUPID

Content, Form and Negotiation

>WHEN ACCEPTING A BRIEF FROM A CLIENT, THE GRAPHIC DESIGNER IS ALWAYS INVOLVED IN SOME LEVEL OF NEGOTIATION. THIS PROCESS MIGHT BEGIN AT THE POINT OF CLARIFICATION OF THE CLIENT'S NEEDS OR WISHES, WHICH MAY BE SET AGAINST THE DESIGNER'S PROFESSIONAL EXPERTISE REGARDING THE BEST APPROACH TO REACH A PARTICULAR OUTCOME. THE FORM THAT THE RESULTING DESIGN WILL TAKE IS DIRECTLY RELATED TO THE CONTENT OF THE MESSAGE, THE INTENTION OF THE CLIENT AND THE UNDERSTANDING OF THE AUDIENCE.

>THE ROLE OF THE DESIGNER CAN BE DEFINED IN A NUMBER OF WAYS. THE TRADITIONAL PERCEPTION OF THE PROFESSION IS LARGELY CONCERNED WITH FACILITATION. THAT IS TO SAY THAT THE DESIGNER IS LARGELY INVOLVED IN THE ACTIVITY OF PROBLEM-SOLVING AND AESTHETIC CONSIDERATION DIRECTED TOWARDS THE NEEDS OR WISHES OF THE CLIENT. THIS CAN BE ALSO BE DESCRIBED IN HIERARCHICAL TERMS; THE DESIGNER FULFILS A PRESCRIBED ROLE SET BY THE CLIENT AND OPERATES TOWARDS SPECIFIC AND DEFINED OUTCOMES. AT TIMES, OTHER VOICES PLAY A PART IN THIS DIALOGUE — ARTISTS OR AUTHORS FOR INSTANCE, OR EDITORS WHO SHAPE THE CONTENT OF THE WORK. SUCH A PROCESS OF COLLABORATION TENDS TO CENTRE UPON THE CRAFT SKILLS OF THE DESIGNER, WHO THEN UTILISES HIS OR HER KNOWLEDGE OF KEY FACTORS CONCERNED WITH PRODUCTION TO ARRIVE AT MEANINGFUL AND APPROPRIATE SOLUTIONS.

>ALTHOUGH THE DESIGNER IN THIS INSTANCE MIGHT BE VIEWED AS PLAYING A LESSER ROLE IN THE CREATION OF THE MESSAGE OR THE INTENTION OF THE WORK, HE OR SHE WOULD USUALLY BE CONCERNED WITH WHAT PETER WILLBERG DESCRIBES AS 'also creating something worthwhile...'

HING BEAUTIFUL?

THIS IMPLIES THAT THE DESIGNER'S OWN AGENDA HAS AT LEAST SOME PART TO PLAY IN THE NEGOTIATION OF THE BRIEF. THOSE AREAS WHERE THE GRAPHIC DESIGNER HAS A MORE IMPORTANT ROLE TO PLAY IN THESE PRELIMINARY STAGES OF THE PROJECT MIGHT INCLUDE THE DISCUSSION OF THE PURPOSE OF THE WORK, TOGETHER WITH POTENTIAL STRATEGIES WITH WHICH TO PROJECT THE DESIRED MESSAGE. OF COURSE, THE DESIGNER ALSO HAS A MAJOR INFLUENCE ON THE FORM THAT THE RESULTING LAYOUT WILL TAKE.

Graphic Authorship

>THE DESIGNER USUALLY RESPONDS TO A BRIEF GIVEN BY A CLIENT. HOWEVER, CONTEMPORARY DISCOURSE ON THE SUBJECT OF GRAPHIC DESIGN PLACES A GOOD DEAL OF EMPHASIS ON THE POSSIBILITIES OF INTERVENTION BY THE DESIGNER AND THE NOTION OF WHAT MIGHT BE TERMED 'AUTHORSHIP'. THIS EXTENSION OF THE DESIGNER'S ROLE IMPLIES A WIDER AND MORE SIGNIFICANT FORM OF COLLABORATION, WHEREIN THE EMPHASIS IS PLACED UPON HOW AND WHY THE DESIGNER OPERATES TO MEDIATE THE WORK THEY ARE PRODUCING. SUCH AN ALTERNATIVE VIEW OF DESIGN ACTIVITY COULD BE CONSIDERED A MORE INCLUSIVE MODEL WHICH RECOGNISES THAT DESIGN HAS A ROLE TO PLAY BEYOND ITS PRIMARY FUNCTION AS AN APPLIED ARTFORM.

>THE DEBATE SURROUNDING THE NOTION OF GRAPHIC AUTHORSHIP HAS BEEN CONCERNED WITH HOW DESIGN CAN CONSTRUCT CHALLENGING FORMS THAT EXTEND OUR UNDERSTANDING AS WELL AS REPRESENT THAT WHICH ALREADY EXISTS. THE DESIGNER AND WRITER MICHAEL ROCK HAS DESCRIBED THIS ACTIVITY AS, 'Suggesting new approaches to the issue of design process in a profession traditionally associated more with the communication than the origination of messages.'

The Designer as Facilitator

>THE DESIGNER COULD THEN ALSO BE CONSIDERED AS A CONTENT PROVIDER, TO A GREATER OR LESSER EXTENT. IN SOME INSTANCES, FOR EXAMPLE THE FINE ART CATALOGUES DESIGNED BY PETER WILLBERG, THE DESIGNER MAY ACTIVELY FACILITATE A DIALOGUE BETWEEN HIMSELF, THE CLIENT (GALLERY) AND THE ARTIST WHOSE WORK IS FEATURED. OFTEN THIS CAN MEAN THE ESTABLISHMENT OF LONGER-TERM RELATIONSHIPS BETWEEN THE PARTIES INVOLVED, TO ALLOW COLLABORATIONS TO GROW NATURALLY TOWARDS A MUTUALLY BENEFICIAL OUTCOME.

>WILLBERG OFTEN VISITS THE FEATURED ARTIST ON A REGULAR BASIS, ENCOURAGING THEM TO SHOW HIM DEVELOPMENTAL WORK OR BACKGROUND SKETCHES AND PHOTOGRAPHS WHICH HE THEN INCLUDES AS DESIGN ELEMENTS, CREATING A CLOSER LINK BETWEEN THE ORIGINAL ARTWORK AND THE READER. VISUAL AND TEXTUAL ESSAYS IN ART CATALOGUES BECOME IMPORTANT MILESTONES IN ART HISTORY AND GIVE THE ARTIST/AUTHOR AND DESIGNER THE OPPORTUNITY TO CONVEY A FURTHER INSIGHT INTO THE WORK. A PUBLICATION IS ALSO OF IMMENSE IMPORTANCE TO AN ARTIST IN THE WAY HE OR SHE IS PERCEIVED, BOTH IN THE 'ART WORLD' AND BY PROSPECTIVE AUDIENCES. VERY OFTEN IT IS ALL THAT REMAINS OF AN EXHIBITION BY THE TIME THE WORK HAS BEEN RETURNED TO THE VARIOUS LENDERS AROUND THE GLOBE. A CATALOGUE THEREFORE HAS TO BE CORRECT IN DETAIL WHILST IMAGINATIVE IN APPEARANCE. ALTHOUGH THE WORK MAY BE COMMISSIONED AND, AS WILLBERG SAYS, '...is very often about solving the problems and needs of the client', THE DESIGNER HAS A VERY EVIDENT CONTRIBUTION TO MAKE AS AN EQUAL PARTY IN BOTH THE MEDIATION AND THE WAY IN WHICH THE WORK IS REVEALED.

>THE QUALITY OF THE PRESENTATION OR REPRODUCTION OF THE ORIGINAL ARTWORKS IN BOOK FORM IS CRUCIAL AND OFTEN BECOMES THE KEY ISSUE ONCE THE DESIGN PROCESS IS OVER. THIS COMING TOGETHER OF WORDS, IMAGES AND DESIGN IS A SOPHISTICATED PROCESS WHICH NOT ONLY DOCUMENTS THE WORK OF THE ARTIST BUT ACTUALLY CREATES ANOTHER SPACE IN WHICH TO EXPERIENCE AND ENJOY ARTWORKS. THE DESIGNER IS CENTRAL TO THIS ACTIVITY: NEGOTIATING WITH THE ARTIST, WRITER AND OFTEN THE CURATOR TO PRODUCE A CONJUNCTION OF IDEAS THAT EXTENDS OUR UNDERSTANDING OF THE ORIGINAL WORK. THROUGH THIS PROCESS THE BOOK BECOMES ANOTHER SPACE ALONGSIDE THE GALLERY, MUSEUM OR PUBLIC LOCATION. THE DESIGNER, IN USING HIS SKILL AND TRAINING, IS ABLE TO CREATE AN OBJECT WITH WHICH WE ARE ABLE TO HAVE A PHYSICAL AND EMOTIONAL RELATIONSHIP. USING SENSITIVE AND APPROPRIATE DESIGN AND INCORPORATING TYPOGRAPHY AND LAYOUT, THE DESIGNER HAS ALSO TO ENSURE THAT THE CONSIDERATION OF PRODUCTION — FORMAT, PAPER AND BINDING — IS RELEVANT TO THE WORK AND HOW AN AUDIENCE MIGHT REACT TO IT.

Miles Coolidge

Safetyville is both a real place in California and a town embedded in our imagination. Miles Coolidge makes documentary photographs of the ordinary, the vernacular, and the familiar in American urban life. *Safetyville* is clearly a brand new town, but appears to have no inhabitants. The buildings, still pristine white or pastel-hued, shine and reflect the brilliant Californian light. Everything is quiet and comfortable there. Sedate, even. Anyone staying in this town would, surely, have a nice day.

Coolidge's iconography of the everyday, and *Safetyville's* ordinariness are both uncannily close to our own world. But not quite. Coolidge is driven by a desire to make strange the familiar, and

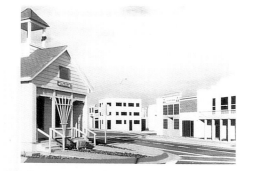

make familiar the strange. Indeed, as he has observed, the town of *Safetyville* does indeed 'make the everyday strange'.

Every denomination of building, and all the activities of modern urban life are here. All, that is, except one: there are few visible signs of retail commerce. Yet the town is situated in one of the wealthiest states in the biggest economy in the world. And what is more, logic and proportion appear to be up for grabs. Inexplicably, trees loom over shrunken corporate façades. Each element of the city is seemingly animate, imbued with a life-force of its own: roadways threaten to engulf sidewalks, curbs push out onto perfectly manicured lawns. Streets, buildings, even roadsigns compete for territory, squeezing each other's breathing space. This urban

Safetyville: Schoolhouse, Office Buildings, Storefronts
1994
C-type print
78 × 96 cm
ACME, Los Angeles, USA

jungle surges and swells, in spite of its missing inhabitants.

But, as the saying goes, it's a small world: *Safetyville* is in fact an exact one-third scale version of middle-class Middle America. Built in Sacramento, California, the town was created for the sole purpose of teaching schoolchildren how to cross roads. Coolidge comments that *Safetyville* is 'a theme park of the normal or everyday'. The rules of work and play are reversed and interchangable here. Yet *our* sense of reality is not depleted but heightened and intensified by Coolidge's images; *Safetyville* is not merely child's play.

Although a gigantic, absurd, and astonishing contemporary folly, the town is not just a surrogate for our own cityscape. On the contrary, *Safetyville* exposes the world around us as less solid, and less certain than any we might know from images. Possibly, on

Safetyville: Regional Transit Restaurant
1994
C-type print
78 × 42 cm
ACME, Los Angeles, USA

reflection, our world is a more ingeneous, more captivating, and more crudely mechanical stage-set than that seen in Coolidge's work. If so, maybe *Safetyville* really is the ideal preparation for the bigger adult theme park outside. And just maybe, the cityscapes that we think we know are no less precarious, and our lives no more vicarious, than those played out in this beautiful, bizarre, deeply foreign, and deeply familiar town.

Alistair Robinson

52

53

Peter Willberg		170 x 235mm
The Campaign Against Living Miserably exhibition catalogue		1998

>Above and overleaf: The catalogue designed by Peter Willberg to accompany the **Campaign Against Living Miserably** exhibition at the Royal College of Art, London, was designed and produced on a limited budget. The designer chose to print the book on two different paper stocks. One section is reproduced in full colour on a heavy uncoated paper, whilst the second section is printed on a very lightweight coated stock. Willberg utilised a clever

colour device on the reverse of each image in order to limit any show-through on the verso page. This use of colour is an innovative development from his other work using opacified papers. The coloured blocks feature as a strong visual device throughout the book, exposing the grid system behind the page layout while offering another level of colour and texture which both accompanies and interrupts the regular pattern of the page.

Civil Engineering, 1997
fencing wire, aluminium
soft drink cans
dimensions variable
Otjiruze, Namibia

Escape Vehicle No. 5, 1996
helium balloon, chair, cable,
scissors
dimensions variable

Simon Faithfull

Simon Faithfull's work hovers on the boundary between sense and nonsense. Material from the world of the commonplace or everyday undergoes a process of puzzling modification as its meaning slips and twists. Throughout the work there emerges a sense of the proximity of the mundane to the absurd.

Escape Vehicle No. 5 is the latest in a series of works produced over the past two years. These works have evolved along a line of thought common to all of us: the desire to substitute one reality for another. The world over, there are very few who can claim to be totally content with their lot. The contradictions inherent in this predicament have presented themselves in other works by Faithfull. A computer programme has provided him with an exhaustive list of aliases of his name such as 'Linus Half-Motif', 'Tim Full-Fashion' and 'Naomi Flush-Flit'. He has presented these *alter egos* as a platoon of Plasticine people with passport photographs of himself for heads, but their hastily improvised disguises point to something harder to crack – the pathos and failure of trying to be all things to all men. A similar impossibility lies at the heart of each *Escape Vehicle*. The first consisted of a rocket chair, disintegrating in the process of lift-off. Others have included a matchstick chair tethered to a trio of dead flies and an angel contrived from a fold-up mackintosh. A parallel has emerged between these and other works which describe a return to earth and reality, perhaps most notable of which are photographs of a jet aircraft falling out of the sky, albeit a travel agent's model of one.

The physical purpose of *Escape Vehicle No. 5* is in contradiction to its physical circumstance – a quixotic blend of utopian, impoverished and improvised means. The balloon is a perfect means of escape, yet it cannot sustain a passenger in flight. How exactly do you sit in the chair prepared for release and simultaneously stand on the ground and cut the cable holding the balloon in place? Where would you go to? Whilst the work begs these questions, its makeshift and yet poised fixity presents them as unanswerables. This leaves us with an object that invites us to balance our equations, both those about the personal and those about the nature of art practice.

Anders Pleass

54

55

> **Peter Willberg**

> The Campaign Against Living Miserably
 exhibition catalogue

> 1998

> example spreads

Tom Hunter

Tom Hunter photographs people in their homes, surrounded by their belongings. His earlier pictures, of squatters and travellers, may be seen as a personal account of the communities in which he has lived and of which he is still very much a part – the London Fields squatting community, where he has lived for the past eight years, and the travelling community, which he joined some six years ago. Hunter is now involved in photographing the inhabitants of a tower block in Holly Street, Hackney. This is part of a larger project for which Hunter will be exhibiting his work in one of the flats. The estate is due to be demolished later this year.

Through their composition and lighting, Hunter's photographs of the squatters consciously referenced the paintings of Vermeer. The Travellers series also had a strong painterly quality, but Hunter's recent work has a much more formal appearance, concentrating on the documentary aspects of photography, while still focusing upon the diversity of the individual. Hunter uses a large format camera and slow colour film, which allows great depth of detail and richness of colour, in contrast to the grainy black and white images produced by the film stock which is often used in documentary photography.

Holly Street Series, 1998
C-type print
183 × 213 cm
courtesy of the artist

Hunter considers himself a community photographer, and an element of collaboration between the photographer and the sitter is fundamental to his work. He is concerned to present what the subject wants, not the stolen moment characteristic of photojournalism. All his sitters are given the opportunity to arrange their homes, and he spends an hour with his subjects before taking the final photograph, allowing them to feel comfortable with their environment and the camera. Hunter goes through every process with his subjects, taking preliminary polaroids so that they can consider the image they are portraying to the outside world, and play a part in the creative process.

Hunter's work within this exhibition consists of three colour photographs and a video projection. The photographs occupy three walls to form an open cube, whilst the projection is situated

**The Art of Squatting:
Persons unknown**, 1997
R-type print
102 × 76 cm
courtesy of the artist

in an adjoining room. Each depicts an interior shot of an occupied room which fills the whole frame, the very large format giving the viewer the impression of actually sharing the resident's space.

Hunter focuses on the richness of colours and textures, portraying the beautiful and the dignified and contesting the often unflattering light in which the media tend to represent tower blocks and the people who inhabit them. He also plays on the fragility of these carefully constructed environments, the realisation that all these homes, which people have taken pride in, will soon be destroyed. His choice of an emphatically documentary approach recalls the role of photography as a medium of record, often used to capture that which is about to be lost. We are reminded that these domestic interiors will soon be shattered, that the residents ultimately have no control over the homes they have made.

Lee Riley

The Designer as Artist

>MARK PAWSON MIGHT BE SEEN AS AN EXTREME EXAMPLE OF THE DESIGNER AS AUTHOR, AS ALL HIS WORK IS SELF-AUTHORED. HE COULD THEREFORE BE TERMED BOTH DESIGNER AND CLIENT, AND COULD BE SAID TO OCCUPY THE ILL-DEFINED AREA BETWEEN ART PRACTICE AND GRAPHIC DESIGN. THOUGH OCCASIONALLY WORKING TO A COMMERCIAL BRIEF, MUCH OF HIS WORK IS SELF-AUTHORED AND MANUFACTURED BY HAND; WHERE CLIENTS HAVE CHOSEN TO BUY INTO HIS DIY METHODS, FOR INSTANCE LEVI'S COMMISSION TO DESIGN A PUBLICITY POSTER, THEY HAVE LEFT IT TO PAWSON HIMSELF TO CREATE HIS OWN CONTENT.

>PAWSON DEALS DIRECTLY WITH HIS CHOSEN AUDIENCE, UTILISING DESIGN TOOLS AND MARKETING STRATEGIES WITHIN WORK WHICH BLURS THE EDGES BETWEEN ART, DESIGN AND FASHION. MUCH OF HIS WORK DISPLAYS A FASCINATION WITH GRAPHIC EPHEMERA AND THE DETRITUS OF EVERYDAY LIFE WITHIN CONTEMPORARY CULTURE. A SELF-CONFESSED 'IMAGE JUNKIE', PAWSON DRAWS ON HIS AUDIENCE'S FAMILIARITY WITH SUCH DISPOSABLE ITEMS AS PLASTIC CLIP-ON MOUSTACHES FROM JOKE SHOPS AND CHRISTMAS CRACKERS, FREE TOYS FROM CHILDREN'S SWEETS AND CEREAL PACKETS, AND CARD WIRING DIAGRAMS FROM THE THREE-PIN PLUGS ON ELECTRICAL APPLIANCES.

>BY DRAWING FAMILIAR, BUT OFTEN UNNOTICED OR INSIGNIFICANT, GRAPHIC OUTPUT TO THE ATTENTION OF HIS AUDIENCE, PAWSON'S WORK OFFERS A SOBERING AND REFLECTIVE COMMENT ON SUCH ISSUES AS THE DISPOSABILITY OF PRODUCTS WITHIN THE MODERN ECONOMY, ENVIRONMENTAL ISSUES, POPULAR CULTURE, ADVERTISING AND THE DIY OR 'DO IT YOURSELF' TRADITION. THE CENTRAL THEMES HE REVISITS SHOW AN AWARENESS OF THE CULTURAL TRADITION OF ALTERNATIVE VISUAL STYLES, PARTICULARLY IN THE USE OF COLLAGE AND LO-TECH, HAND-MADE PRODUCTION PROCESSES. THE KNOWING IRONY SHOWN BY HIS INCLUSION OF HUNDREDS OF SCALPEL BLADES AS VISUAL DEVICES IN HIS PHOTOCOPY BOOKS REVEALS BOTH A HUMOUR ON THE PART OF THE DESIGNER AS WELL AS A DIRECT REFLECTION ON WHAT PAWSON TERMS 'the tools of the trade'.

Design in Context

>THE COLLABORATION BETWEEN AUTHOR OR ARTIST, CLIENT AND DESIGNER ALLOWS EACH TO FUNCTION ON AN EQUAL LEVEL. A MODEL OF THE DESIGN PROCESS AS A TRIANGULAR RELATIONSHIP BETWEEN CLIENT, DESIGNER AND AUDIENCE MIGHT BE BETTER EMPLOYED TO DESCRIBE THIS SITUATION, RATHER THAN A MORE TRADITIONAL HIERARCHY WHEREBY THE CLIENT INSTRUCTS THE DESIGNER, WHO THEN IN TURN GIVES FORM TO THE MESSAGE IN ORDER TO DELIVER IT CLEARLY AND CONCISELY TO AN AUDIENCE. THE GRAPHIC DESIGNER, AS AN INTERMEDIARY BETWEEN CLIENT OR AUTHOR AND AUDIENCE, IS NOT A

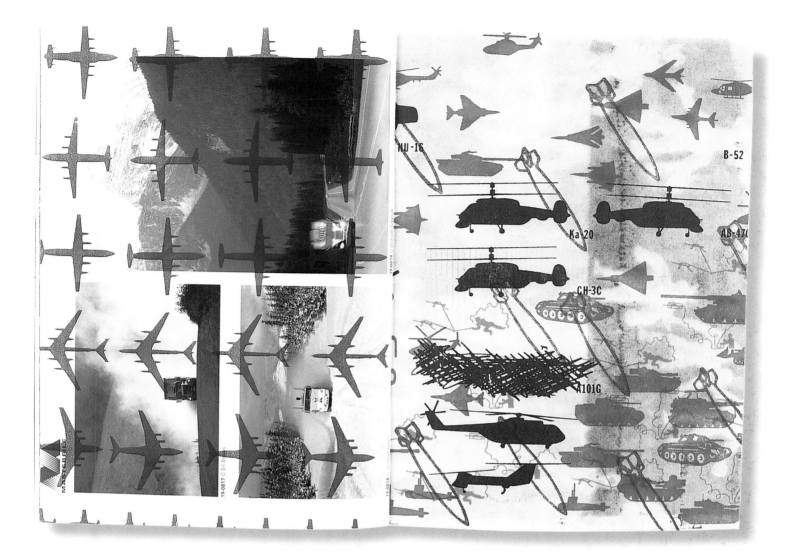

Mark Pawson		148 x 210mm
MaPK naBCoH photocopy book		1988–1998

>Above and following pages: Mark Pawson produced this book on a range of different paper stocks, including cut-down pages of unused, printed billboard paper taken originally from eight-sheet advertising posters. Some pages feature details from large colour halftone images, overprinted by multiple passes on a standard office photocopier. Other paper stocks include pages from magazines, or waste run-off sheets from Pawson's other manufacturing processes (such as other photocopy or rubber stamp books and badge-making materials). Each page is photocopied up to four times, resulting in a build up of dense black toner on the page. In early editions, Pawson also utilised single colour red, blue, green and brown photocopiers, changing the colour of the toner cartridge between print runs to create rudimentary 'full-colour' work.

SIMPLE MESSENGER. WHETHER INTENTIONALLY OR UNINTENTIONALLY, CONSCIOUSLY RECOGNISED OR NOT, THE DESIGNER AS AN INDIVIDUAL TRANSLATES THE MESSAGE WITHIN A WIDER IDEOLOGICAL FRAMEWORK. AS SUCH, THE MESSAGE IS INFORMED BY ITS ORIGINATOR, BY ITS AUDIENCE, BY THE DESIGNER AS AN ACTIVE (NOT IMPARTIAL) GO-BETWEEN, AND BY THE SOCIAL STRUCTURES SURROUNDING ALL THREE WHICH DETERMINE NOT JUST THE CONTENT, BUT THE NATURE OF THE MESSAGE.

>GRAPHIC DESIGN THEREFORE OPERATES AS A META-LANGUAGE, CONTRIBUTING TO THE SYSTEMS OF REPRESENTATION THROUGH WHICH THE INDIVIDUAL IS FORCED TO MAKE SENSE OF THE WORLD. AT THE SAME TIME HOWEVER, ITS PRODUCTION PROCESSES AND VISIBLE FORM ARE DETERMINED BY HISTORIC, SOCIAL AND MATERIAL FACTORS BEYOND THE CONTROL OF THE DESIGNER. AS A FORM OF VISUAL COMMUNICATION, GRAPHIC DESIGN OPERATES WITHIN A SET OF BOUNDARIES THAT ARE ALREADY GIVEN AND UNDERSTOOD, THOUGH OFTEN UNACKNOWLEDGED, BY BOTH DESIGNER AND AUDIENCE. THESE INCLUDE THE TECHNICAL AND ECONOMIC RESTRICTIONS WHICH ARE AN ACCEPTED PART OF ANY DESIGN BRIEF, BUT PERHAPS LESS OBVIOUSLY ALSO THOSE INVISIBLE FACTORS WHICH DETERMINE THE FORM THAT THE WORK MIGHT TAKE: WHAT THE AUDIENCE, AND THE DESIGNER, WOULD ASSUME TO BE ACCEPTABLE AS GENERIC TO A PARTICULAR MESSAGE — IN OTHER WORDS, THAT WHICH DETERMINES WHAT CONSTITUTES A BOOK, A POSTER, AN ADVERTISEMENT ETC. THESE FACTORS INCLUDE BOTH WRITTEN AND VISUAL LANGUAGE, TYPOGRAPHIC AND ILLUSTRATIVE STYLES, AND HISTORIC PRECEDENTS FAMILIAR TO EACH OF THOSE CONCERNED.

Revolt Into Style

>FOR DESIGNERS INTERESTED IN EITHER 'INTERVENTION' IN THE CULTURAL OR POLITICAL SPHERE, OR IN OPPOSING AN ESTABLISHED DOMINANT IDEOLOGY, THESE BOUNDARIES TO THE COMMUNICATION PROCESS, AND THOSE METHODS WHICH MAY BE EFFECTIVELY EMPLOYED BY THE DESIGNER TO NEGOTIATE THEM, ARE EVEN MORE SIGNIFICANT. JAN VAN TOORN, A DESIGNER WHO HAS SET A VERY RADICAL PUBLIC AGENDA FOR MANY YEARS, ASSERTS THAT SOLUTIONS FOR ALTERNATIVE COMMUNICATION SYSTEMS ARE GENERALLY PUT FORWARD BY DESIGNERS ON A PURELY AESTHETIC LEVEL — THEY DEAL WITH THE FORM OF THE MESSAGE BUT NOT THE CONTENT. IN HIS OWN WORK, HE AIMS TO PRESENT THE MESSAGE AS AN ARGUMENT OR OPINION. BY DISPLAYING THE PRODUCTION PROCESS, BOTH ON THE PART OF THE DESIGNER AND THE PRODUCER, HIS WORK EXHIBITS A DUALITY WITHIN THE MESSAGE WHICH AIMS TO EVOKE A QUESTIONING OF ITS CONTENT BY THE AUDIENCE. THE SPECTATOR IS ENCOURAGED TO ENGAGE IN AN ACTIVE INTERPRETATION OF THE ARGUMENT, AND THE MESSAGE IS PRESENTED AS AN OPEN DIALOGUE BETWEEN OBJECTIVE REPRESENTATION AND THE SUBJECTIVE INTERVENTION ON THE PART OF THE DESIGNER. AS VAN TOORN ASSERTS, 'the introduction of the mediator's view in the

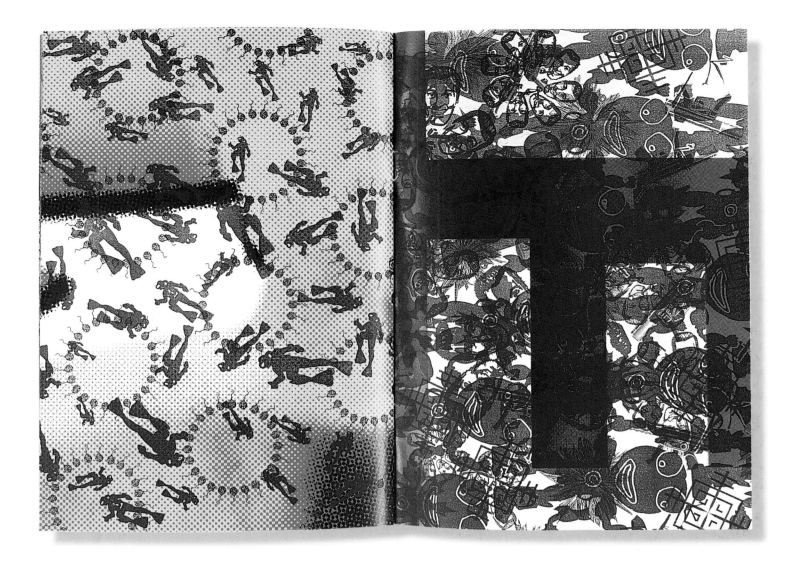

Mark Pawson <

MaPK naBCoH photocopy book <

1988–1998 <

example spread <

message has consequences for both form and content. As another perspective becomes visible, the (traditionally hidden) agenda of the client is revealed in relation to a broader communicative context, thereby inviting interpretation by the recipients.'

>VAN TOORN'S WORK MAY BE READ BY A WIDE AUDIENCE ON A STRICTLY AESTHETIC LEVEL, AND MAY REQUIRE SOME FURTHER EXPLANATION IF THE DESIGNER'S INTENDED MESSAGES ARE TO BE UNDERSTOOD. ONCE AGAIN THIS HIGHLIGHTS A PARTICULAR PROBLEM REGARDING GRAPHIC DESIGN'S CONCEPTION OF ITSELF; THE FINE ARTS, FILM, LITERATURE AND OTHER CULTURAL PRACTICES HAVE LONG-ESTABLISHED ROLES FOR CRITICS WHO COAX MEANINGS FROM TEXTS WHICH MIGHT OTHERWISE REMAIN UNAPPARENT TO THE READER. THE TRADITIONAL VIEW OF DESIGN AS REMOVED FROM THE 'SERIOUS' ARTS, TOGETHER WITH THE MODERNIST SENSE OF DESIGN PRACTICE AS A TRANSPARENT MEDIUM, HAS LED TO A STATE OF AFFAIRS WHERE THIS CULTURAL CRITICISM (AS OPPOSED TO A STRICTLY PROFESSIONAL CRITICISM OF CLARITY AND FORM) HAS NOT BEEN APPLIED TO GRAPHIC DESIGN, AND HIDDEN MEANINGS WITHIN TEXTS ARE LARGELY DEEMED UNWELCOME.

>ANNE BUSH, A DESIGN WRITER AND ACADEMIC, DESCRIBED THIS SITUATION IN AN ARTICLE IN EMIGRÉ MAGAZINE CHARTING THE DEVELOPMENT OF PROFESSIONAL CRITICISM AND ITS APPLICATION WITHIN THE APPLIED ARTS: "Evaluations of graphic design have avoided the contextual strategies employed by other disciplines in favour of a criticism that is professionally internal and unique to its product. Continuing to believe in the possibility of untainted judgements, the field has supported a dialogue based on graphic design's essential qualities, and on the reality shaped by its practical applications. As confirmation, this mode of criticism not only stymies analytical discourse, but reveals a disturbing separation between the act of designing and the circumstances within which this act takes place."

>GRAPHIC DESIGN, THEREFORE, SUFFERS FROM A LACK OF CRITICAL ENGAGEMENT BEYOND THOSE TECHNICAL DESCRIPTIONS RELATING TO CRAFT OR SUITABILITY FOR PURPOSE. THIS WOULD APPEAR TO OMIT THOSE AREAS OF THE SUBJECT WHICH MIGHT ALLOW FOR SUBJECTIVE EXPLORATION OF CULTURAL THEMES, OR EXPERIMENTATION AND INNOVATION WITH REGARD TO CONTEXT, LOCATION AND THE CHANGING NATURE OF BOTH THE DISCIPLINE AND THE PROSPECTIVE AUDIENCE.

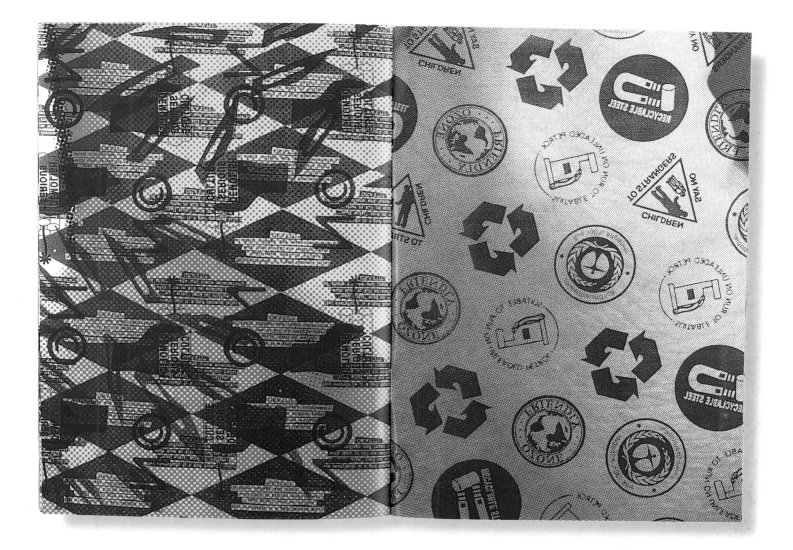

From Dawn till Dusk: Peter Doig and Udomsak Krisanamis

Dawn

Hundreds of effervescent mitochondria flick across the surface of Doig-space like Wilhelm Reich's orgones sailing across the membrane of an eye that closes after staring at the morning sun. Squint into these teeming blizzards and your optical nerve might cloud over with silken egg-white, forming two snow-blind glaucoma omelettes for breakfast.

Hush now, little faun, insincerity drifts silently as snow, snow, quick, quick snow. Horror hibernates under-foot, pulsing beneath a stained seasonal duvet. Yet the feint tell of lingering interpretations hangs brittle in the air like frosty halitosis – vehement affirmations of beauty and ugliness chirped by timid squirrel-critics hoarding their nuts before they're frost-b-b-b-b-b-b-itten.

'The sleep of reason produces monsters', mumbles languid Goya in 1797, but the monsters are awake in 1972: 'The unconscious has its nightmares but they are not anthropomorphic. It is not the sleep of reason that engenders monsters but vigilant and insomniac rationality' snap nasty Deleuze and Guattari.

Knowing the forest only too well, Yogi Bear loves Deputy-Doig's imaginary wilderness, spawned from an inhuman taste for spite; for the blood-sport in disarming enlightened sophisticates by delivering them into the dark forest and watching them aestheticize their own hypothermia. Chatter, chatter.

'Whips and furs are merely the means by which I terrorize myself' cracks Sacher-Masoch as he sashays naked into the snow-escape.

Even without fun-fur, Sacher-Masoch's bare cockles would be warmed by the glacial chill refrigerating this barren scenery.

Why does culture exhibit a predilection for its own victimisation?

Critical art spills from the wake of fallen Jesuit theology. Guilt and redemption have been transubstantiated in the form of 'critique'. Chant 'shit' for 'shit's sake and you'll be kindly escorted by psychiatric police. Smear 'shit' for 'critique's sake and you might even get to shake hands with a museum director.

There you have it in a squirrel's nutshell.

Ever since God's creative monopoly fell to Human hands there lacked the resounding solidarity amongst us mortals to calm Modernity's ensuing Brownian decline: Lost in space-time discontinuum we are presently drifting on collision course with Zero, only we've lost faith in the belief that 'O' is in fact an orifice and we'll pass right through it.

Only the sore-eyed insomniac first-person-singular presides in echoing isolation; and no big surprise that painting was charged with the task of dramatizing this existential solitude in colour. BUT, because pure beauty is often scoffed at for being an asinine superfluity that glosses over deeper human natures, Modern art became ugly and blessed with a nice personality to match.

Anyway, certain rewards await those who decide not to play fair – not least the infantile pleasure in spoiling the entire game – which is just ONE of infinite types of undesirable human characteristics seething malignant below beautified surfaces. The sticky end for liberated culture comes when it meets sadistic, anal, degenerate, monstrous, devious and virulently fatalistic adults who are very happy to find expression for their nasty habits within the parameters of their host incumbent's progressive generosity.

And so we come to the white noise and phase inversion of Doig's autism.

There is a clear advantage in reversing *the artistic for the autistic*. Such willful deterioration of head-to-hand competence invades the motive force of the *auteur* and sends any explicitly *sensible* intention wildly in counter-orbit to the holistic integrity of the work's over-all appearance. In other words, IF THESE PICTURES LOOKED LIKE THEY WERE INTENDED TO BE INSINCERE, THEY WOULDN'T WORK. ON THE OTHER HAND, IF THEY APPEARED TOO 'FOOT AND MOUTH' THEY WOULDN'T STAND UP.

Only the functional misfirings and variable permutations drive them successfully off the beaten track – are they naively beautiful, beautifully naive, critically naive, cynical or sincere, bucolic or bubonic, flat or pictorial, conscious or unconscious, cheap or expensive? Or are they blasphemous irresponsibilities because they predicate their own oil-based scatology before they redeem themselves critically? Are Peter's paintings pretty, petty or pithy?

Lets face it, short of describing this libidinous ectoplasm that spills over medium-rarefied surfaces normally occupied by resolutely existential groans, one thing is for sure, with a maleficent winter-stillness born from razor-stalactite pointillism, Nature-Doig has carpeted the path upon which the *return of the repressed* skis on its merry way to a mocking prodigal return.

Penetrating into the clearing from way beyond the unconscious, charging deadly silent on superconductive iceskates, snuff-Doig erupts through Modernism's painterly cotton-duck with evil stabs, striating the pellicle with acne and Grünwald's bubonic pustules, unleashing a viroid surface distemper, a sub-zero Eboli mutation that sets to work devouring the saturated melancholia of wide-eyed Bambi-ites who huddle around picture-postcard images of beneficent nature, *oh yes you do*.

Who's afraid of these howling white-trash tragedies chewed over by bourgeois pathos-addicts, aesthetic vampires who don't have the knees to snowboard but are keen nonetheless to sink teeth into noumenal realms not yet depleted by beady eyes, but I warn you, if you look too blinking hard your eyes will drop out and we'll never find them in this snow.

'Snow?' Says the snowman. 'Its not snow'

Its bleached agent orange with luminous sparks of light leaping into your gaping retina, or radioactive icing-sugar lightly dusting a toxic scalp, an autistic menage of lurid holographic hallucinations made palatable for those too hyperconscious to realize they are beneficiaries of *a psychedelic sublime*.

> **Peter Willberg**

> Doig/Krisanamis exhibition catalogue

> 1998

> example spreads

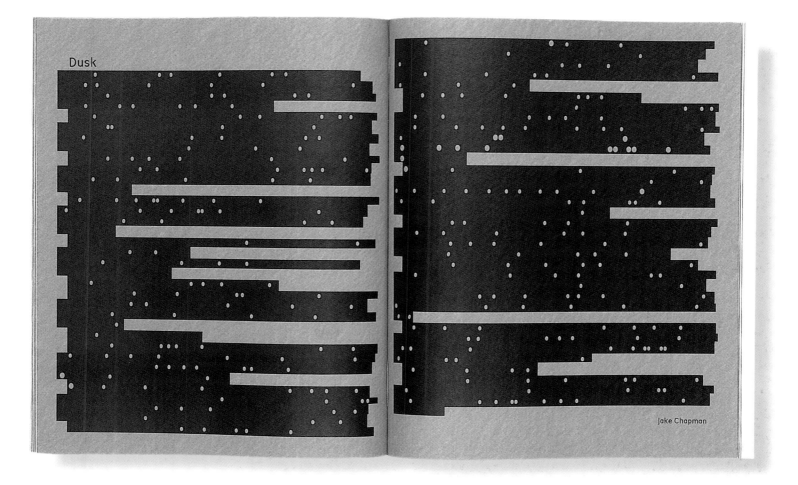

Peter Willberg	240 x 290mm
Peter Doig/Udomsak Krisanamis exhibition catalogue	1998

>Above and left: Exhibition catalogue for the Arnolfini Gallery in Bristol, UK, accompanying the work of artists Peter Doig and Udomsak Krisanamis. Working in close collaboration with the artists and writers, Willberg was able to make synchronous and complementary connections between the intentions of the artists and the book. Krisanamis bases his artworks on an exploration of the letter 'O' and a fascination with the counter within that letterform. Two spreads entitled 'Dawn' and 'Dusk' offer alternative versions of the text as a counterpoint to the artist's work — one filling the voids in each letter 'O', the other offering a reverse perspective on the same theme, obliterating everything but those spaces. The stock chosen by Willberg was MG Posterprint, an opacified paper usually used for poster production because of the highly dense masking properties which obscure high contrast images or tones behind. This proved a useful tool for the designer in the production of the book, allowing strong typographic treatments on the reverse of high-quality colour image reproductions.

grateful for all the support we have received towards the education and outreach programmes and towards the expenses of artists' projects. Page 128 lists the many organisations and individuals who have contributed to this year's project. We should like to add special thanks to the Arts Council of England, for their ongoing support for the course, and to the John Lyon's Charity, for their provision of student bursaries.

The curators of this exhibition have shown a determination to reflect emerging practice and to chart areas of activity which have seldom been presented in gallery exhibitions. In this enterprise they have been more than usually indebted to all the artists, for their generous engagement with the ambitions of the project, their willingness to commit time and to find ways of adapting to limited means. We offer our sincere thanks to them all.

Teresa Gleadowe
Course Director
Visual Arts Administration: Curating and
Commissioning Contemporary Art

8

democracy!

The naming of any exhibition provides a clue to the curatorial stance adopted. As curators we strongly felt our role should be one of collaboration and inclusiveness. In this spirit we invited the artists group No Problem Agency to title this show. This in no way devolved our responsibility, but instead added new voices to the discussion. So we arrived at **democracy!**, an understanding of which differs from person to person. For some, democracy is the continued struggle for freedom of choice and the ability to live life on one's own terms, for others it is contrasted with authoritarian political systems under which personal freedom remains unobtainable. In the context of this exhibition, we see the title as a point of departure, a tool for debate. Such a title can only result in questions being asked.

democracy! seeks to renegotiate the relationship between artist, spectator and participant. The social

democracy!
A Partial Glossary of Terms

Access Originally used to refer to the physical accessibility of the gallery or institutional space, 'access' has been adopted as an umbrella term, used by art institutions to denote areas of education and outreach and to describe policies of social inclusion. **Activism** Historically, activism and art have had a number of flirtatious encounters. Interventionist tactics have provided art with the means to become active outside its own discursive arena – taking its slogans and manifestos onto the street – whilst at the same time enabling the development of a more self-directed 'institutional critique' (see *Institutional Critique, Intervention, Manifesto*). Recent exhibitions at the ICA and the independent space Cubitt in London have highlighted the current re-emergence of activist strategies within

status of art — its meanings, constituencies, ambitions, venues and audiences — has always been in flux. There has never been a consensus of opinion regarding the way in which art reaches out, who it reaches out to, and to what ends. Artists have banded together or formed allegiances with the world at large, in order to find new directions, new roles within a lived reality. This could appear as a reaction against the privileging of the individual, a desire to promote practices independent of the art market situation. Or is it simply that the art world is not enough?

The recent World Trade Organisation summit in Seattle provoked the staging of an International Day of Protest, in a multitude of political pressure points around the world. A 'call for action' posted on the N30 website opened with the statement, 'Let our resistance be as transnational as capital... we must

9

> **Peter Willberg**

> Democracy! exhibition catalogue

> 2000

> example spreads

employed to fulfil gallery education requirements. This exhibition seeks to place such practice at the heart of the equation, to share the process rather than instruct.

The projection of artists as problem solvers and service providers appears central to much of this work. The services they provide range from the pragmatic to the ephemeral. Ventures include the production of 'biogas' energy units in African villages; the provision of housing for fellow artists; a mobile library for anarchist texts; the creation of an alternative tourist office for the World Athletics Championship in Gothenburg, Sweden. Art appears as a free space for experimentation; there is still room to breathe, to create alternatives. In many ways such collective activity has at its core a faith in the future. The mission is not to save the world, but to offer alternatives to individuals, a 'do-it-yourself utopia on a small scale'.

exhibition, but also to add new voices to the debate. It is through participation and outreach to others that this work gains its gravity and meaning. Democracy, like many collective projects, remains an abstract model unless it is realised by the people concerned.

Mark Beasley

production of co-authored or multi-authored projects.
Anthropology
Anthropological terms such as 'fieldwork', ethnographer/ethnographic' and 'participant observation' are frequently employed both to describe artistic processes and to cast a negative light upon them. For some 'anthropology' has almost become a derogatory term. For others, the 'quasi-anthropological scenario' described by Hal Foster in *The Artist as Ethnographer* is a highly complex and sensitive issue. For example, it should be acknowledged that critical anthropology recognises the problematic nature of the traditional concept of 'participant observation'. At issue in this scenario is the extent to which artists are 'speaking for' or 'othering' the 'subject' of their practice. 'Shared anthropology' may be useful as a way of describing situations in which the participants themselves are able to define the nature of the 'study', and in which communication is a two-way process.
Anti-art 'The anti-art of the late 1950s and early sixties stated that visual art was a useless medium for creativity and thinking. It was the radiation of art into pure existence, into social life, into urbanism, into action and into thinking which was regarded as the important thing.' Asger Jorn, quoted in Tony Godfrey, *Conceptual Art*, Phaidon, 1998 See *Situationism/ist, Situationist International*
Authorship Throughout the 1990s there has been a discernible critical reaction to the 'art star' phenomenon. This mistrust of media hype and careerism, combined with a shift towards social engagement and fluid roles, has clearly impacted upon notions of authorship. Individual practice is in many cases rejected in favour of 'co-authored' or 'multi-authored'

At present there is no adequate shorthand to describe such practices. The catch-all term 'community art' fails to define an increasingly diverse position. Is this a new form of context-sensitive art? Or a lived public art that no longer acts as liberal urban decoration? The work appears both generous and demanding, serious and playful, committed and detached. A new set of artistic idioms, such as 'culture-broker', 'socio-economic integration', 'everyday aesthetics' and 'multidisciplinarity', have come into use to describe some of the current concerns of artists, curators and critics. It is not our intention to tidy up the experience of these new practices or to present comforting distractions, and we acknowledge that much of this work requires a strong level of engagement from the viewer. Instead we choose to present democracy as an ongoing process, a set of entangled relations that may never be fully realised. This catalogue is intended not only to document the

12

13

Peter Willberg	170 x 230mm
Democracy! exhibition catalogue	2000

>Above and left: Catalogue designed by Peter Willberg to accompany the **Democracy!** exhibition at the Royal College of Art, London, UK. Willberg chose to incorporate footnotes and a partial glossary of terms relating to the text in the book, placing them on a central yellow strip running across each text page. In this way, the glossary can serve as a useful adjunct to the main text, allowing the reader to directly refer to further contextual material and definitions, while at the same time highlighting the wider historical and cultural context. The book is printed on 130 gsm Munken Lynx uncoated stock in full colour throughout and utilises a limited colour palette for text pages, with full-bleed colour sections for the main images of work in the exhibition.

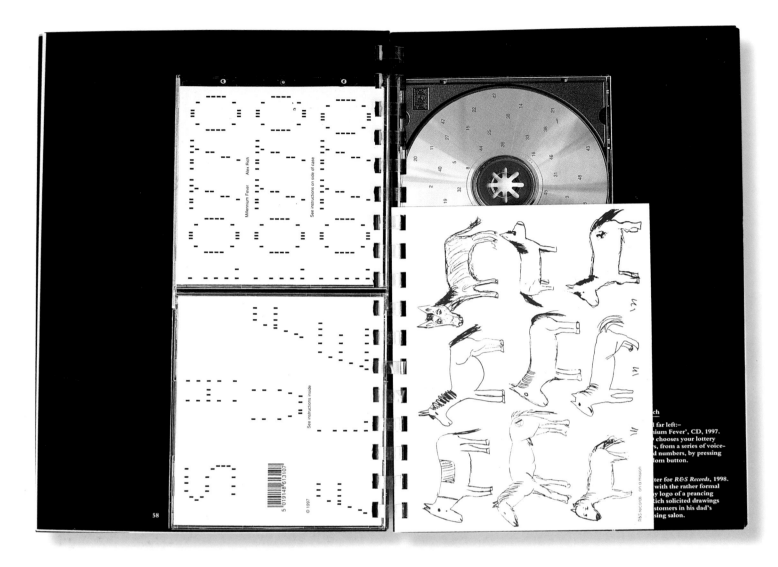

> **Graphic Thought Facility**

> Stealing Beauty exhibition catalogue

> 1999

> example spread

> see also overleaf

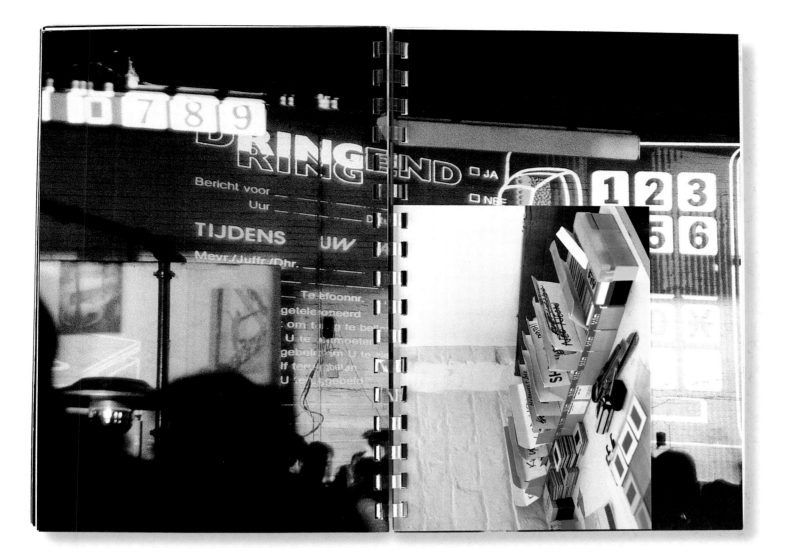

Graphic Thought Facility		170 x 250mm
Stealing Beauty exhibition catalogue		1999

>Above and overleaf: Catalogue designed by GTF to accompany the exhibition **Stealing Beauty** at the Institute of Contemporary Arts, London 1999. The catalogue shows both a fascination with process and a sense of fun on the part of the designers. A variety of different pieces of work (printed matter, postcards, CD artwork) relating to each of the artists and designers within the show are bound together using a cheap plastic comb-binding. The small rectangular pieces of coloured paper which were die-cut from the pages as a by-product of the binding process were then collected by the designers and scattered in a random pattern for the cover design (pages 96–97), relating directly to both the manufacturing and production processes used, and to the catalogue's visual contents.

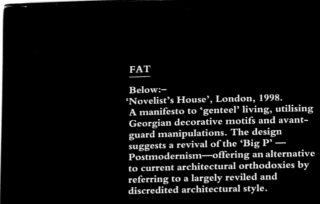

FAT

Below:–
'Novelist's House', London, 1998.
A manifesto to 'genteel' living, utilising Georgian decorative motifs and avant-guard manipulations. The design suggests a revival of the 'Big P' — Postmodernism—offering an alternative to current architectural orthodoxies by referring to a largely reviled and discredited architectural style.

Right:–
'The Chez Garson', house conversion, London, 1996.
A homage to Archigram's 'suburban sets' which examines the aesthetic of modern interiors where image is synonymous with lifestyle.

Insert:–
'Submarine House'
From the project Utopia Revisited (1997) Holly Street Estate, Hackney. As the estate was being demolished, alternatives were suggested based on residents' own Utopian ideals.

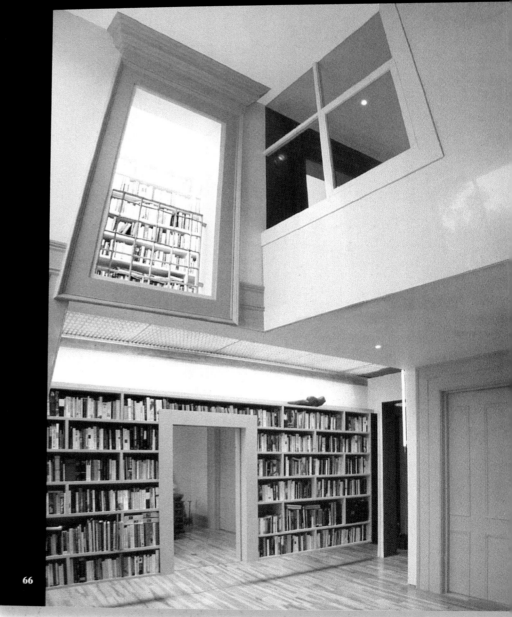

66

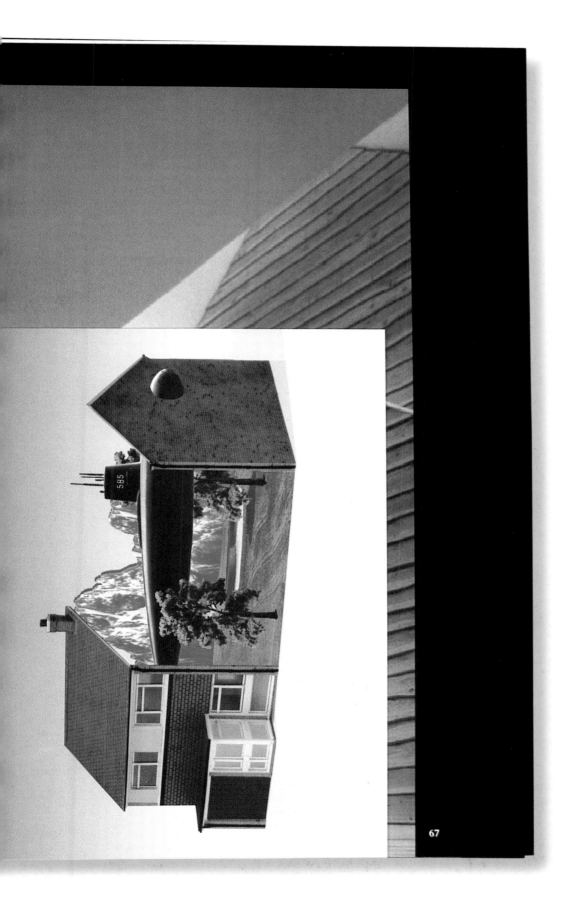

67

ISBN 1-900300-20-6

9 781900 300209

ICA
Institute of Contemporary Arts

STEALING BEAUTY

BRITISH DESIGN NOW

AN ICA EXHIBITION IN ASSOCIATION WITH
PERRIER-JOUËT CHAMPAGNE

Interview Peter Willberg

Clarendon Road Studios **April 2001**

Your work seems to move beyond traditional modes of graphic design production. How do you approach individual projects and the collaborative process of working with artists and galleries?

Of course all of my work is commissioned and is very often about solving the problems and addressing the needs of the client. In those terms the projects are not self-generated, they are about a reaction to that situation, driven by content or budget but also about creating something worthwhile. Sometimes I am working with only the latest six paintings by an artist and I am attempting to produce something which is more than just a pamphlet or catalogue. If you are very tough about it, a publication can be a mail order catalogue. Typography, format, sequence, paper, colour, choice of printer — that's my job. The other stuff is highly interesting but in the end I have to make sure the artwork is reproduced in the most convincing way. I do always try to make more of it, to create a narrative, to make more cultural sense of the project. The work is collaborative in that I work together with both artists and galleries. It takes at least two to make one genius.

In the books you produce with artists and galleries, are you attempting to create a new space — a way in which to see the original work differently, in effect to go beyond the representation of a gallery wall?

Obviously it's different, because it's in a different media and is a reproduction of the original, although I don't know if I could ever have any fixed view on a certain piece of work, or that anybody can have a fixed view. Often what looks incredibly good in real life looks awful when reproduced in a catalogue. For example, an Agnes Martin artwork which is 200cm wide will, by the time it is reproduced 20cm wide, be incredibly boring because it doesn't live in this world — it's a different object. In each publication I try to present the work in a space that allows you to see it in a way the artist intended the original to be seen. Of course it has always to be enticing and shown in such a way as to let you enjoy the work.

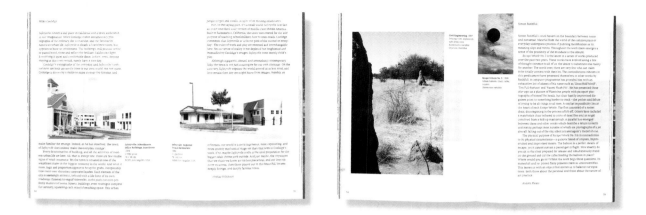

One of our interests in this book is to explore beneath the surface of a design piece to try to understand the designer's intention in creating it.

Much of what I do concerns my interpretation or reaction to the artworks I'm dealing with; the focus for me is always how to present the work in the best possible way for the work. Some of the conditions I work within are already established. The dish is ordered, so to speak, and I have to find out how to make it in the most absolute and perfect way.

You use colour in a particular way on a certain projects...

I think a good example is the **Campaign Against Living Miserably** catalogue (pages 78-79) produced for the Royal College of Art in London. The budget we had to work with was tiny and as a result we could only afford the thinnest paper. The printer who sponsored the printing had a five-colour press. I used the fifth colour to block out the colour images on the following page so there would be no show-through. An image on the recto page would have a field of colour printed on the following verso. This had a huge design impact but was also extremely functional. Often this type of approach only works with smaller budgets because clients are happy to take risks. The more money a project blows in, the safer the client wants it to be.

Are your design choices tied into the intention of the artist and their work?

I always try to meet with each artist during the project and the longer I know them the better it becomes. It is about building trust and so it runs. By the fifth or sixth catalogue or book together we are able to produce surprising things. I say 'we' because the client or artist has to be credited with the ability to trust.

Have you had the perfect or ideal job yet?

I don't know when that might come — the one which is just at the printers now? — who knows. You can only truly know when the thing is in your hand completed. Certainly it is much easier to judge in hindsight than during the process of making. In my experience

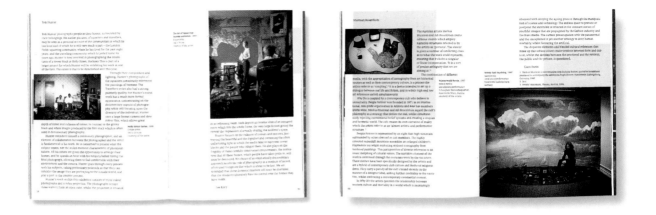

all projects need ups and downs. With nearly all projects you have to go through crisis points. When clients say no you can't do that or they put their foot down, they will have a point — although they might not be able to pinpoint it. If you have an intelligent client they will feel that something does or doesn't work. When that happens they are right and as a designer you have to find out for them what needs to be changed.

It seems important to you that your expertise as a designer is tied to technical knowledge. When you talk about neutrality or perhaps invisibility as a designer is that tied to craft or attention to detail?

Everything depends on budget — thank god that with some clients the budget is no issue; they want the best money can buy. This can also be a problem — as a designer you have no excuses in that you can always have another set of proofs. I am working on a project at the moment which is at the absolute limits of the technology — we are reproducing the drawings at six hundred dots per inch. When I am working with transparencies of paintings I will go to the artist's studio or warehouse where the originals are stored and check these against the paintings themselves. I will then revisit the artist at one or more proof stages and compare the proofs again with the originals. Finally I will take the responsibility for passing the job on press. I have to find out what each individual painting or work of art is doing. What is this Howard Hodgkin painting doing? Is it playing the red against the yellow? Does it play the green against the orange? What is the key to this painting? and then I push these aspects in the reproduction.

In a recent article Derek Birdsall was discussing proportional representation and in particular the system he had devised for a book about Rothko's work. Do you develop a system or rationale for each book?

There are always various different agendas with scale of reproduction — if it were not the concept of the artist to use a linear scale or proportional representation then I wouldn't do it.

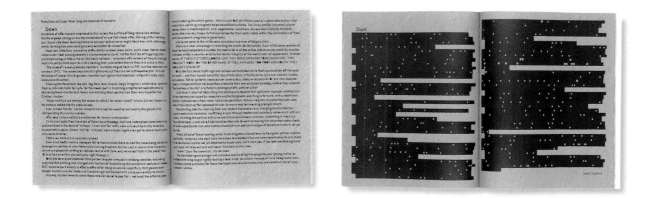

As well as running your studio you also teach design. How important is teaching to you, and what is the relationship between your teaching and your studio practice?

I totally enjoy teaching and that is a good enough reason in itself. This is because when I am teaching I have to explain a lot – why something works for example – and I don't have to explain that to myself when I am working in the studio. I was educated as a designer with certain stringent values, and teaching has forced me to look again and question what I thought I knew. Certainly in an age where we are much less concerned with beauty in design and attempting to achieve tension it has the function of bringing into sharp focus that which is impossible to deal with in any other way. When I am working in the studio six days a week and I see only clients and artists there is a possibility I will become locked into a certain way of thinking and that is dangerous as a designer. Teaching is the only steady thing I do; in the studio one telephone call can throw the evening or weekend away. I also believe that graphic design as a profession should be taught as an art, allowing the space and time to think, to explore different avenues, to encourage students to use the space. It's not always about do, do, do. When I first went to study at the Royal College of Art, UK, I was amazed when I wandered into the fine art studios, that fine art students would just sit around and smoke cigarettes.

You have already mentioned some of the problems of working on your own a great deal. What happens when a project becomes difficult to progress?

When I am working on a project and I feel that it is becoming laboured or a little pregnant, then I stop and do something else, like go and have a haircut or take a bus ride. It is important to have the nerve to go closer and closer to the deadline. It is often easier to see the world from the top of the bus – not only can you see more, you also see things you would not normally see.

words and pictures

CONSTRUCTING IDENTITIES AN

SIGN AND SIGNIFIER

>CRUDELY PUT, THE TOOLS OF THE GRAPHIC DESIGNER ARE IMAGES AND WORDS. THESE CENTRAL DEVICES ARE EMPLOYED IN BOTH COMBINATION AND OPPOSITION TO CREATE MEANINGFUL RELATIONSHIPS WITHIN THE PROCESS OF LAYOUT. IMAGES AND THEIR RELATIONSHIP TO WORDS OR TEXT ARE AS ENDEMIC TO OUR CULTURE AS SPEECH IS. WORDS, HISTORICALLY USED TO CREATE ENDURING NARRATIVES BASED ON A TRADITION OF FOLKLORE AND STORYTELLING, OR TO DOCUMENT A TRANSACTION OR AGREEMENT, ARE MIRRORED BY EARLY EXAMPLES OF PICTORIAL NARRATIVES ON THE WALLS OF CAVES AND BUILDINGS (FOR INSTANCE AT LASCAUX IN SOUTHERN FRANCE, OR IN THE HIEROGLYPHICS OF THE EGYPTIAN PYRAMIDS).

>A LARGE AMOUNT OF WORK ALREADY EXISTS ON THE DEVELOPMENT OF ALPHABETIC SYSTEMS BASED ON THE PHONETICS OF LANGUAGE, AND THE DISTINCTIONS BETWEEN ALPHABETIC WRITING AND OTHER COMMUNICATION SYSTEMS, FOR INSTANCE PICTOGRAMS. IN THE LAST CENTURY, MUCH WORK WAS DONE TO INVESTIGATE THE RELATIONSHIP BETWEEN SPOKEN AND WRITTEN LANGUAGE, HOW WE READ IMAGES — IN PARTICULAR SINCE THE DEVELOPMENT OF PHOTOGRAPHIC AND LATER MOVING-IMAGE TECHNOLOGY — AND THEIR RELATIONSHIP TO WORDS.

>THE WORK UNDERTAKEN BY ACADEMICS TO THEORISE LANGUAGE SYSTEMS, SUCH AS FERDINAND DE SAUSSURE'S ANALYSIS OF THE SPOKEN WORD (STRUCTURALISM), AND JACQUES DERRIDA'S THEORIES OF THE WRITTEN WORD BASED ON AN OPPOSITION OF SPEECH VERSUS WRITING (POST-STRUCTURALISM), INFORMED A GENERATION OF WRITERS AND CULTURAL THEORISTS. THE FRENCH PHILOSOPHER ROLAND BARTHES WORKED IN THE FIELD OF SEMIOTICS (I.E. THE INTERPRETATION OF IMAGES, IN BARTHES'

APPING INTERACTIONS

WORK PARTICULARLY THE PHOTOGRAPH AND ADVERTISING IMAGE), AND WAS TO HAVE A MAJOR INFLUENCE BOTH ON THE VISUAL ARTS AND WITHIN THE WIDER CONTEXT OF ARTS AND HUMANITIES EDUCATION.

>IT IS POSSIBLE TO DEMONSTRATE HOW IDEAS STEMMING FROM THESE THEORIES CAN BE USED TO DESCRIBE WHAT IS AT WORK WITHIN A LAYOUT. FOR EXAMPLE, SAUSSURE'S DESCRIPTION OF SIGN, SIGNIFIER AND SIGNIFIED IS DEALT WITH BY JOHN A. WALKER AND SARAH CHAPLIN IN THE PREFACE TO 'VISUAL CULTURE: AN INTRODUCTION'; "This book is a material object made from paper and printing ink. You can hold it on your hands or use it as a doorstop. If people who cannot read the Roman alphabet/the language opened its pages all they would see are signifiers – horizontal lines of black marks on a white ground – but they would not be able to grasp their signifieds – mental concepts – consequently they would not understand the meaning of the linguistic signs, the combination of signifiers and signifieds, which in this instance we call words and sentences." DERRIDA'S IDEAS CONCERNING THE SIGNIFICANCE OF THE WRITTEN WORD IN RELATION TO THE SPOKEN HAVE A DIRECT AND OBVIOUS CONNECTION TO TYPOGRAPHY AND LAYOUT, AND POINT TO HOW THE USE OF A PARTICULAR TYPEFACE AND ARRANGEMENT CAN TRANSFORM WRITING AND ENHANCE OR CHANGE MEANING AND INTENTION.

>IN RECENT TIMES THEORIES SUCH AS THESE HAVE BEGUN TO INFLUENCE THE APPROACHES UNDERTAKEN BY GRAPHIC DESIGNERS, PARTICULARLY THROUGH THE IMPACT OF CULTURAL STUDIES AND THE LIBERAL ARTS WITHIN DESIGN EDUCATION. THESE NEW PERSPECTIVES ON THE RELATIONSHIP BETWEEN TYPOGRAPHY AND LANGUAGE BUILD UPON THE ESTABLISHED TRADITIONS OF TYPO/GRAPHIC DESIGN WITHIN VISUAL COMMUNICATION, AND HAVE ALLOWED DESIGNERS TO FURTHER DEVELOP THE

PROCESS OF COMMUNICATING A MESSAGE. INDEED, THE SIGNIFIED OF THE ROMAN ALPHABET IS TRANSFORMED BY STYLISTIC DEVICES SUCH AS SPACING, TYPEFACE AND PAGE LAYOUT.

>SOME ACADEMICS HAVE FURTHER DEVELOPED SEMIOTIC THEORY BY BRINGING A VISUAL OR DESIGN EXPERTISE TO THE INTERPRETATION OF IMAGES. IN THIS WAY, AN IMAGE OR PHOTOGRAPH MAY BE READ EITHER BY ITS APPARENT CONTENT, OR BY ITS JUXTAPOSITION WITH WORDS OR OTHER IMAGES, BUT ALSO THROUGH THE VISUAL TREATMENT OF THE IMAGE ITSELF. THE USE OF COLOUR FOR INSTANCE, OR THE REPRODUCTION AND PRINTING TECHNIQUES UTILISED, AS WELL AS THE CROPPING, SEQUENCE AND THE LAYOUT OF THE PAGE, ALL HAVE AN IMPACT ON THE READING OF THE IMAGE.

MAPPING MEANINGS

>THE ROLE OF THE DESIGNER IN SELECTING APPROPRIATE TYPEFACES AND IN THE COMMISSIONING OF IMAGES, OR IN COLLABORATING WITH PHOTOGRAPHERS AND ILLUSTRATORS, IS UNDERTAKEN AS PART OF A LARGER FIELD OF OPERATION. THIS IN TURN RELATES TO THE OVERALL APPROACH TO THE DESIGN OF A PARTICULAR JOB. MUCH OF THE WORK OF A DESIGNER IN CREATING VISUAL STRUCTURES AND SYSTEMS WITHIN LAYOUTS COULD BE DESCRIBED AS A FORM OF MAPPING. WRITER AND DESIGNER ANNE BURDICK HAS DESCRIBED THIS PROCESS: "Just as the map actively constructs a particular world-view, so does the layout of the page." TYPOGRAPHIC FORM AND THE PLACEMENT OF IMAGES FORM THE BASE ELEMENTS OF THIS MAPPING.

>IN THIS SENSE, THE MAP IS NOT JUST A FORMAL DIRECTIONAL OR NAVIGATIONAL STRUCTURE, BUT SOMETHING WHICH DIRECTS THE READER TO A PARTICULAR POSITION RELATIVE TO THE INFORMATION PRESENTED. THIS PROCESS OF OPINION-FORMING THROUGH THE VISUAL ARRANGEMENT WITHIN THE LAYOUT OF THE PAGE, AS WELL AS THROUGH THE WRITTEN OR VISUAL CONTENT HELD WITHIN IT, CAN BE USED BY THE DESIGNER TO GENERATE OTHER MESSAGES OR MODES OF ENGAGEMENT.

>AS DISCUSSED IN THE PREVIOUS CHAPTER, CERTAIN DESIGNERS MAY PRESENT THEIR WORK AS A FORM OF DIALOGUE, AN OPEN QUESTION FOR THE READER OR VIEWER TO ACTIVELY ENGAGE WITH. THIS FORM OF MEDIATION OF THE MESSAGE WITHIN THE WORK OF, FOR INSTANCE, JAN VAN TOORN, IS REALISED IN OTHER WAYS BY SOME OF THE DESIGNERS FEATURED HERE. ONE APPROACH WHICH GOES SOME WAY TO FOREGROUND THE 'MAPPING' OF THE LAYOUT DESIGN IS THE USE OF A VISUAL PAGE WITHIN THE PAGE. THIS DEVICE, AS SEEN IN THE WORK OF GÜLIZAR ÇEPOĞLU (PAGES 128–131) AND STEPHEN COATES (OPPOSITE AND OVERLEAF) FOR INSTANCE, MAY BE EMPLOYED BY THE DESIGNERS TO DIFFERENT ENDS, BUT DOES OFFER A RANGE OF CONNOTATIONS TO THE READER.

Stephen Coates

Dumb, Eye magazine No.22

236 x 300mm

1996

>Above and overleaf: The article entitled **dumb** in the pages of Eye magazine, written by Will Novosedlik, deals with the changing role of print, image and type in the late 20th Century. The design of the two spreads which make up the article is organised by Stephen Coates to depict a page within a page, the main text falling as if photographed as an object and then reproduced within the magazine. Interestingly, harking back to an earlier age of print, the article is annotated with marginal references and footnoting by designer and writer Andrew Blauvelt. The layout of the pages seems to suggest that the viewer should be reminded that the process of reading is somehow under threat from the increase in pictorial communication and the legions of those from within the profession ready to embrace a future without printed material. These themes are addressed within the text by Novosedlik and would appear to have found a mirror in the design by Coates which simultaneously interrupts our gaze and reminds us of the design's historical association with printed books.

>As a metaphorical gesture, the page within a page can offer a striking visual clue as to the nature of the message presented. The reader is reminded that the object they are holding and reading is not transparent — it has a surface with which he or she interacts. In a similar fashion, the tactics employed by Cubist painters and artists in the early nineteenth Century, such as the use of overlapping planes and collaged objects, presented the viewer with the flat surface of the canvas rather than the post-renaissance illusion of perspective.

>This visual device also dates back to the illuminated manuscripts and religious documents of the Middle Ages, where texts were set within a central boundary and notes were juxtaposed in the outer margins of the page. Such a device, which in this instance presents a dialogue between two writers, is used by Stephen Coates in the layout of an article by Will Novosedlik and Andrew Blauvelt in Eye magazine 1996. The article is shown as an image of a book spread within the 'actual' spread of the magazine, with Blauvelt's 'notes in the margin' around the outer edge.

>The page within a page is also utilised for slightly different ends by Turkish designer Gülizar Çepoğlu, who uses the method as a strong linking theme throughout the publication accompanying the 6th International Istanbul Biennial art exhibition. By varying the presentations of the 'virtual' page within the page with the more standard setting incorporating text in a more traditional grid and full-bleed images, the reader is constantly jolted from familiarity and reminded of the book-as-object in their hand.

Typographic Interludes

>Nick Bell's collaboration with Rudy VanderLans to produce typographic interruptions in the pages of Emigré magazine fulfils a slightly different objective. These spreads, which Bell terms 'humm compositions', are designed to distract the reader from the flow of the magazine, to make them stop and think. As such, they present an interlude which breaks from the visual narrative or typographic noise of the publication, in an attempt to "prevent the flow of information dissolving into a blanket of syrup where anything can be said to mean anything you like without the strength of context to qualify it". The use of articulately worded open phrases, such as 'this page is a door' which is backed by 'this is the waiting room', present the reader with an intriguing puzzle to solve at the same time as reminding them of the process of communication at work.

It's not images or texts, its images and texts. The primary vehicle of communication today is not the image alone, but the combination of images and text in a relationship in which the text acts as anchor and determines the meaning of the image, otherwise provides an interpretation, so what we see supplements what we read. Positioned against the image, the text retains a privileged status that we retain a privileged status that we retain is simply given, accepted without question, as the de facto standard against which images will be judged. 'Logic and concept' are placed on the side of the text. The 're-mediation' of the image in translation now works in reduction to language metaphors, the means to semiosis, has so heavily influenced our critical understanding of images that it simplifies the developments of a theory of the image which is not somehow deemed to be a failed version of verbal language.

In a book entitled *The Image*, author Daniel J. Boorstin argues that since the latter part of the nineteenth century, the image has supplanted the word as the primary vehicle of communication. Technological advancements in the movement of information, from telegraphy to television, have made the meaning-centred discourse of printed text far too slow a medium to meet the demands of an information-hungry public and the exigencies of an industrial economy bent on profit. The "graphic revolution", as Boorstin refers to the combined inventions of photography and telegraphy, allowed for a rapid proliferation of images that could deliver a message with far greater speed and emotion to far greater numbers of people than mere text ever could. And like all technologies, it not only provided new ways in which information could be delivered, but profoundly altered the way in which that information was interpreted. The increased volume of imagery and the speed of its delivery demanded shorter attention and a quicker reaction. Under such conditions, as Sven Birkerts has written, impression and image take precedence over logic and concept, presentation structures reception, and expectations about how information is organised eventually change.[8]

In step with these developments, typography in the early part of this century became less verbal and more visual, and print culture became less about reading and more about looking. Futurism, Dadaism, Constructivism and De Stijl all attempted to bend visual form to the task of communication. Most readers of this magazine will be familiar enough with the typographic experiments of this era, a time during which artists, poets and designers sought to free type from its utilitarian status as a neutral carrier of language and turn it into expressive visual form. The nascent concepts of visual communication that characterised these movements later formed some of the tenets of the graphic curriculum at the Bauhaus. As Ellen Lupton and J. Abbott Miller have pointed out, part of the legacy of the Bauhaus is the attempt to establish a "language of vision, a code of abstract forms addressed to immediate, biological perception rather than to the culturally conditioned intellect".[9] It was seen as a language analogous to, but distinct from, verbal language.

Lupton and Miller also remind us that it was this focus on vision as "an autonomous realm of expression" that is largely responsible for the hostility towards verbal language which is common to post-war design education. Without an interest in verbal language, design became so focused on visual form that Paul Rand could say "a design student whose mind is cluttered with matters that have nothing directly to do with graphic design is a bewildered student."[10] Rand's obsession with form was symptomatic of his time, and it was perhaps epitomised by the emerging discipline of corporate identity, in which the simplest of forms were employed to symbolise the most complex of corporations. In the late 1950s, the *Harvard Business Review* could say that "the image . . . negates the complexities of the modern diversified corporation. But this does not make it any less workable as an operational tool. In fact, it is the reality which creates the need for illusion."[11]

Thus we have image standing in for reality, creating a mask of believability in a world where people have neither the time nor the desire to ask difficult questions. Although it would be wrong to say that our historical bias towards the power of visual imagery has produced an entire profession of myopic image-makers, it has in many designers produced a marked lack of interest in critical thinking. It is precisely this kind of intelligence, satisfied by its fixation on visual form, that is ideally suited to the disciplines of corporate and brand communications. In commercial and consumer culture, a deeply critical mind is inimical to success. As Lewis Lapham, the editor of *Harper's* magazine, so succinctly puts it: "The success of the American Dream, like the success of MasterCard and the Republican Party, presupposes the eager and uncritical consumption of junk in all its commercial declensions."[12]

Although I may not agree that every consumer product is a form of junk, I cannot argue with the inference that commerce is fuelled by the rapid, unquestioning consumption of huge quantities of manufactured goods and services. The language of branding, which is primarily visual and heavily designed, must be as laconic as possible in order to drive this consumption. It therefore must bypass "the logical, rational centers of the brain and go

The idea of making independence of representation is unconscious. Our awareness with everything we don't is always a mediated experience, whether it is through texts or images. Critical thinking is not immediately impaired by reading printed texts or producing less image-orientated design. The lack of criticality in our apprehension of both texts and images is at the heart of the matter.

8. Sven Birkerts, *The Gutenberg Elegies*, p. 122.

9. Ellen Lupton and J. Abbott Miller, *The ABC's of . . . : The Bauhaus and Design Theory*, New York: The Herb Lubalin Study Center of Design and Typography, 1991, p. 32.

10. Paul Rand, *Design, Form and Chaos*, New Haven and London: Yale University Press, p. 217.

11. Richard Hollis, *Graphic Design: A Concise History*, London: Thames and Hudson, 1994, p. 120.

12. Lewis Lapham, *Hotel America: Scenes from the Lobby of the Fin de Siècle*, London and New York: Verso, 1995, p. 182.

straight to the part that understands without thinking". Not surprisingly, what drives magazines like *Ray Gun*, *Speak* and *Blur* off the magazine racks at alternative book stores is the same magic that moves soup tins and dog food out of the supermarket.

I doubt that Marvin Scott Jarrett, publisher of *Ray Gun*, *Bikini*, *huH* and *Blah Blah Blah*, would disagree with this statement. He has recognised a niche, discovered a formula that works in it and is milking it for everything it's worth. A page from *Ray Gun* might look a lot different from a box of cake mix or the spread from an annual report, but they are all agents of the same process; it is just that their targets are different. A Harvard business professor would simply call it good marketing.

Design, whether falsely deconstructed by its practitioners or blithely decoded by consumers, seems to be most successful when it avoids strategies that require verbal intelligence. In favouring a "language" of images over a language of words, it would appear that many designers have contributed significantly to the dumbing-down of culture so passionately lamented by writers like Birkerts and Postman. And, considering the unstoppable force with which printed text is being superseded by hypertext, what chance has design to make any future contribution to the development of knowledge?

DESIGN AS AN INTEGRATIVE FIELD

Perhaps the only chance we have for achieving such a goal lies at the level of university education. Writing in *Design Issues*, the American design educator Gunnar Swanson recently put forward a case for transforming design into a liberal art. Using the Aristotelean model of liberal arts as subjects that are studied for their own intrinsic value and not merely to develop skills that will allow one to earn a living, he proposes that design become an academic subject, much as philosophy, sociology or psychology are today. Recognising that design education has until now been more a form of vocational training than of education, Swanson points out that design is an integrative field that bridges many subjects that deal with communication, expression, interaction and cognition: "Design should be about meaning and how meaning can be created. Design should be about the relationship of form and communication. It is one of the fields where science and literature meet. It can shine a light on hidden corners of sociology and history. Design's position as a conduit for and shaper of popular values can be a path between anthropology and political science . . . Designers, design educators and design students are in a more important and interesting field than we seem to recognize."[13]

Design has not only been integrative but also integral to the development of culture. But it still lacks the legitimacy of other more established subjects of academic study, and Swanson is right in saying that its concerns will not be seriously addressed by academia until it becomes an academic subject. There are, however, larger and more ominous obstacles to be overcome. Even if design could become recognised as a liberal arts subject rather than just a vocational skill, this would happen in a society that is growing increasingly inimical towards a liberal arts education. In a market-driven world, education is not so much seen as a process of developing an enquiring mind but of preparing oneself for gainful employment. An informed and thoughtful citizen is as likely to question a law, a product or a politician as to accept them, and such critical behaviour has the potential of being extremely unproductive in a growth-oriented economy. As Lewis Lapham has said: "We don't like, and we don't trust the forces of intellect – not unless they can be tied securely to a commercial profit or a scientific benefit."[14]

Clearly, designers are not the only ones with this problem, but until we can get beyond our preoccupation with visual imagery and begin to understand the effect that our work has had, and can have, on culture, we are doomed to play a Cinderella role on the stage of human development. Our culture may well be moving from text to hypertext, but by celebrating the "End of Print" we hypocritically mock the medium that Manutius gave us, throwing out 500 years of the history of ideas in the process. The currents of that history run deep. Design can choose to plumb the depths and chart a meaningful course into the future, or to float aimlessly on its surface at the mercy of millennial change.

If designers have contributed to the dumbing-down of culture it is not because they are obsessed with images or fragmenting text, it is because they have acted as the shapers of banal messages and dubious information – whatever its style. If many are suspicious of verbal language, theory and criticism, it could be because their interest in the visual has so often been marginalised or denigrated.

The notion of design as a field of study and as practical application is widely and undervalued. After all, it is the preserve of graphic design – no matter how winning or limiting – that provides the basis for a theory of graphic design. This is not to say that the education of graphic designers needs to be end in somehow to professional practice than a sooner engage in courses which challenge designs usual function toward understanding or professional legitimacy. The calls for graphic design to be a liberal art – a quest for academic legitimacy – need to be supplemented by strategies which foster 'critical making', nurturing ideas, how and why to question things.

Notes in the margin
by Andrew Blauvelt

13. Gunnar Swanson, "Graphic Design Education as a Liberal Art: Design and Knowledge in the University and the Real World", *Design Issues*, vol. 10, no. 1 (Spring 1994), p. 59.

14. Lewis Lapham, *Hotel America*, p. 181.

Stephen Coates <
Dumb, Eye No.22 <
1996 <
example spread <

>ANNE BURDICK IS ANOTHER DESIGNER WHO ADOPTS RADICAL APPROACHES TO THE PRESENTATION OF INFORMATION ON THE PAGE. HER WORK AS GUEST EDITOR FOR EMIGRÉ MAGAZINE NO.36 INVOLVED HER AS BOTH WRITER, EDITOR AND DESIGNER FOR LARGE PARTS OF THE PUBLICATION. HER DESIGN LITERALLY TURNS THE MAGAZINE INSIDE-OUT, BY STARTING WITH AN INTRODUCTION ACROSS THE CENTRE SPREAD OF THE ISSUE. SHE BEGINS HER INTRODUCTION/INSCRIPTION WITH THE STATEMENT; "The middle of a magazine might seem like an odd place for an introduction" BEFORE GOING ON TO DESCRIBE THE PIECE AS "Perhaps an attempt to write my way out." HER WORDS ARE INTERCUT WITH TITLES FROM EACH OF THE ARTICLES IN THE MAGAZINE BETWEEN THE LINES, AND SEVERAL QUOTES ARE SET INTO SPACES IN THE TEXT COLUMNS. THESE COLUMNS OF TEXT ARE OF VARYING WIDTH, WITH SOME TEXT BLOCKS RUNNING ACROSS EACH OTHER, IN EFFECT PUSHING PART OF THE NEXT COLUMN TO ONE SIDE.

>BURDICK ALSO DESIGNED THE LAYOUT OF AN ARTICLE IN THE MAGAZINE WRITTEN BY TYPOGRAPHER AND WRITER GÉRARD MERMOZ, IN WHICH A COMPLEX OVERLAPPING GRID IS AGAIN EMPLOYED TO PRESENT SEVERAL INTERCONNECTED TEXTS. MERMOZ HAS SAID THAT, "typography is language in performance", A SUCCINCT DESCRIPTION OF THE ACTIVITY OF TYPO/GRAPHIC DESIGN WHICH ALLOWS THE POETIC NATURE OF VISUAL CONSTRUCTION TO BE FOREGROUNDED WITHOUT THE CONTENT BEING OVERRIDDEN OR RENDERED OBSOLETE — A DANGER WITHIN EXPRESSIVE TYPOGRAPHIC TREATMENTS.

SYSTEMATIC DESIGN

>GRAPPA BLOTTO, BASED IN BERLIN, GERMANY, APPROACHES EACH OF ITS PROJECTS WITH AN ONGOING AGENDA. ITS WORK FOR THE HEINRICH BÖLL FOUNDATION INCORPORATES BOTH PRINT AND WEB-BASED TYPOGRAPHIC SOLUTIONS WHICH ARE BASED ON A CORE TYPOGRAPHIC SYSTEM AND RELATED TO THE DIN PAPER SYSTEM. THE GRID STRUCTURE IS BASED ON FOLDS OF AN A-SIZED SHEET IN THE PROPORTIONS 3 X 2. THIS IN TURN FORMS THE BASIS OF THE TYPOGRAPHIC SYSTEM WHICH UTILISES A MONOSPACED FONT, EACH LETTER BEING APPORTIONED AN EQUAL AMOUNT OF SPACE.

>GRAPPA BLOTTO'S ATTENTION TO DETAIL WITHIN ITS APPROACH TO LAYOUT AND STRUCTURE IS DRIVEN BY A DEEPER INTENTION TO ENGAGE WITH CLIENTS WHOM IT BELIEVES OPERATE WITHIN A SIMILAR PHILOSOPHICAL FRAMEWORK. IN THE CASE OF THE HEINRICH BÖLL FOUNDATION, WHICH IS CONNECTED TO THE GREEN PARTY IN GERMANY AND CONCERNED TO PROMOTE DEMOCRACY, FREE SPEECH AND HUMAN RIGHTS ABROAD, GRAPPA AIMED TO CREATE A DEMOCRATIC LOGO AND TO ADOPT A DEMOCRATIC APPROACH TO, FOR EXAMPLE, THE USE OF TYPOGRAPHY.

>FORMED AROUND THE TIME OF THE COLLAPSE OF THE COLD WAR AND BASED IN BERLIN — THE SYMBOLIC FOCUS FOR THE WORLD AT THAT TIME DUE TO THE DISAPPEARANCE OF THE WALL BETWEEN EAST AND WEST — IT IS HARDLY SURPRISING THAT GRAPPA FELT CONCERNED TO EXPLORE AGENDAS IN ITS WORK BEYOND THE SURFACE OR VISUAL LOOK.

VISUAL PERSISTENCE

>GRAPPA'S COMMITMENT TO A DEEPER INTENT WITHIN ITS WORK IS EXEMPLIFIED BY THE VISUAL PERSISTENCE OF ITS APPROACH TO IDENTITY DESIGN. THIS DETERMINATION TO SEE AN IDEA TO FRUITION LED TO THE WORK WHICH EVENTUALLY MADE UP THE POSTERS AND BOOK JACKET FOR A LENI RIEFENSTAHL EXHIBITION IN BERLIN. THE IDEA WAS ORIGINALLY PRESENTED AS AN IDENTITY CONCEPT FOR THE NEUES MUSEUM IN WEIMAR, GERMANY, INVOLVING THE DEPLOYMENT OF THREE YELLOW STRIPS WITH REVERSED TYPOGRAPHY.

>THE NEUES MUSEUM POSTERS WERE ORIGINALLY INTENDED AS PART OF A SERIES OF 'POSTER COUPLES' WHERE THE BRIEF REQUIRED EQUAL STATUS TO BE GIVEN TO THE ARTEFACTS WITHIN THE COLLECTION AND THE ARTISTS FEATURED. STRONG HORIZONTAL YELLOW BARS ACT AS A LOGO OR DEVICE, OFFERING MULTIPLE USES. THEY DELIBERATELY OPERATE AT INTERFERENCE LEVEL AGAINST THE BACKGROUND IMAGE — A MORE 'TRADITIONAL' TYPOGRAPHIC APPROACH MIGHT ALLOW THE IMAGE MORE SPACE IN WHICH TO DOMINATE THE LAYOUT. THEY COULD ALSO BE USED TO HIGHLIGHT A LIST OF EVENTS OR CERTAIN ARTISTS WITHIN THE CATALOGUE, AND THE YELLOW TEXT STRIPS COULD BE FLYPOSTED DIRECTLY ONTO THE FRESHLY WHITENED 'LITFASSÄULEN' (THE NUMEROUS CIRCULAR 'POSTER-COLUMN' SITES AROUND THE CITY).

>WHEN THIS DESIGN WAS REJECTED IN FAVOUR OF ANOTHER APPROACH, THE GROUP DECIDED TO WAIT FOR THE MOMENT AND PROJECT WHEN THE CONCEPT WOULD AGAIN BE RELEVANT. THEY LATER FOUND A PLACE FOR THE WORK IN THE IDENTITY DESIGN FOR THE LENI RIEFENSTAHL EXHIBITION, DEVELOPING THE YELLOW TEXT STRIPS FURTHER TO CREATE A REVERSED-OUT TYPEFACE WHICH IS APPLIED ACROSS BACKGROUND PHOTOGRAPHS ON THE EXHIBITION CATALOGUE AND POSTERS.

GRAPPA BLOTTO 1998

HEINRICH BÖLL STIFTUNG

> **grappa blotto**
> Heinrich Böll Foundation
 identity
> 1998
> cover spread
> see details overleaf

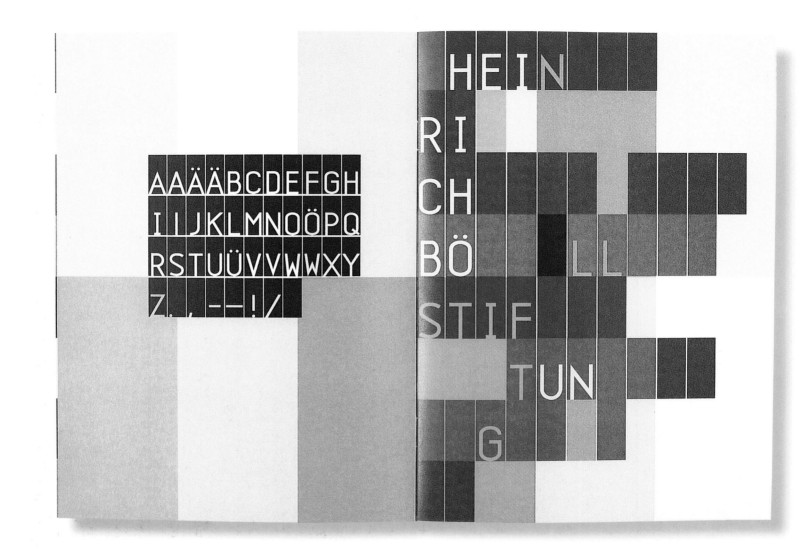

> **grappa blotto**
> Heinrich Böll Foundation identity
> 1998
> example system spreads

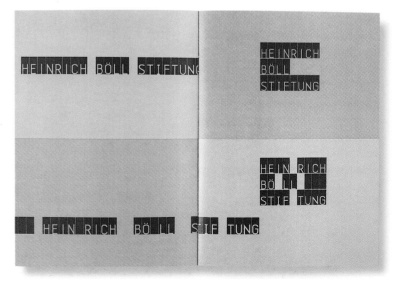

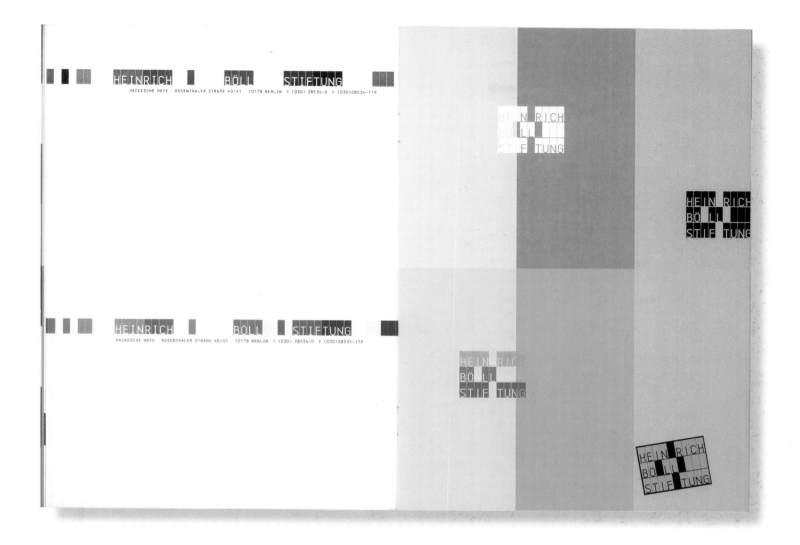

grappa blotto		148.5 x 210mm
Heinrich Böll Foundation identity		1998

>Previous pages, above and left: System for corporate identity, designed by grappa blotto for the Heinrich Böll Foundation, Germany. After winning a competition to design a new identity for the foundation, the designers explored the issue of how to produce a democratic typeface or how to develop a democratic approach to the layout of a typeface. The resulting monospaced font is die-cut from a rectangle which, when grouped in a block, forms the ratio 3:2. The ideals of the Foundation are exemplified in the background images showing through a template of the font, echoing transparency, openness and tolerance. The use of colour reinforces the message of the Foundation's relationship with the Green Party in Germany, utilising a palette based on the colour green.

This page is silent This silence is a mirror

> **Rudy VanderLans/Nick Bell**

> Humm compositions
 Emigré No.22

> 1992

> example spreads: (above left) 'This page is silent';
 (above right) 'This silence is a mirror'; (right)
 'Ocean'; (far right) 'This page is a compass'

ocean

This page is a compass

Rudy VanderLans/Nick Bell		287 x 425mm
Humm compositions, Emigré magazine No.22		1992

>Above, left and overleaf: Design for interludes in magazine spreads, termed **humm compositions** by designer Nick Bell, based on a theme he had explored within a brief to students whilst teaching at the London College of Printing, UK. This issue of Emigré magazine, which focused on Bell's work and teaching practice, was designed by Emigré founder/editor Rudy VanderLans, collaborating with Bell on a number of spreads. The **Humm compositions** are designed to encourage the reader to pause and reflect. Bell describes the layout spreads as an attempt to interrupt, but designed and phrased so as to avoid appearing as a mistake: "With humm, pauses are not accidental or mistakes, but in fact are expected, wanted and intentional; the nature of the medium itself."

by a generation of designers all being actively involved, if, as I said before, we truly realize the great responsibility we have as graphic designers. My own impact so far has been dependent upon and limited to the opportunities that I've had in my own work up to now. I've touched little on social issues. It follows that our clients also must be made to realize that graphic design has a more socially responsible role to play than they first thought, but it is up to us to tell them.

Emigre: After reading the briefs and articles that you sent me, I was overwhelmed. The briefs are truly inspirational and thought-provoking. But at the same time, aren't you worried that the students are going to be quite disappointed and disillusioned once they finish school? Don't you fear that most students will eventually fall victim to the same frustrations as you did?

Nick: Yes, they will be disappointed. I was disappointed when I left college; that happens anyway. It is why at college we call the outside world the "real world," in anticipation of leaving our little ideal world. As a teacher, I am deliberately offering an alternative by producing briefs that contrast greatly to the ones they get all the other days of the week. It is a different perspective, a heightened one. Some of the students may have views on certain social issues, but maybe they don't believe that they could express these views through graphics. I simply try to point out there are ways to do this.

Emigre: After they graduate, what do you expect them to do with the things you teach them?

Nick: What I teach them is a small part beside that which they learn from all the other tutors on the course. I can understand your skepticism, and sometimes I worry whether I am just creating more problems for them. It sounds stupid, but just because there is no evidence out there of a market with an appetite for using socially conscious designers, this doesn't mean that I shouldn't provide them with that working perspective. For 80 percent of the time, the students will be taught the skills to help them operate with ingenuity, as graphic designers have always operated over the past ten years or so, solving the same problems for the same sorts of client; there is nothing wrong with that. But the rest of the time, by doing one of my briefs, they will become skilled in ways of working for clients that aren't usually so lucky; e.g. the homeless. When they graduate, I would expect them to believe that as graphic designers they can achieve more through their discipline than is popularly told them through the example the "real world" gives them at the time they leave.

Emigre: But graphic design can't achieve much by itself. As a designer, you're always go-

[CONTINUED ON PAGE 11]

8.

> **Rudy VanderLans/Nick Bell**

> Humm compositions

 Emigré No.22

> 1992

> example spread:

 'This page is a door'

This page is a door

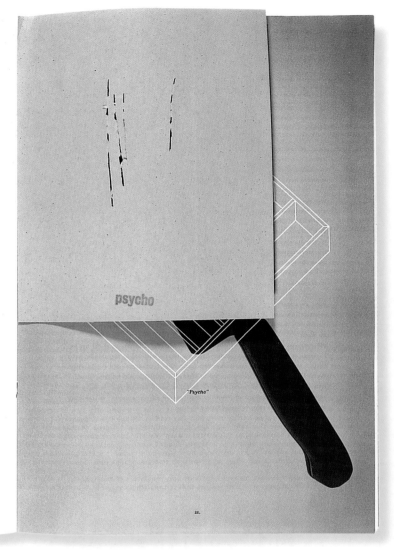

Psycho

My interest in Nick Bell's work was aroused after he sent me some samples of his work which were accompanied by a rather cryptic series of short letters printed on butcher paper. The first letter started off, conventionally enough, with "Dear Rudy" but then continued to list the titles of a series of articles recently published in various graphic design magazines. All articles dealt with the topics of experimental type design and legibility.

The letter continued with the following warning: "Concerning font design and random font design: the repercussions of what Erik van Blokland, Just van Rossum, Jon Barnbrook, Neville Brody, FontShop, Fuse and Emigre are all doing might well lead to the following..."

On the second sheet a simple statement was typed: "Nick Bell has designed a typeface called 'Psycho.' The printed version of Psycho bears no relation to the words you see on screen. Instead it leaves stab wounds by randomly accessing a cutlery drawer."

The third letter contained an actual sample of what this typeface Psycho looked like. In order to understand why Psycho is considered to be a typeface at all one needs to refer to the text on the following page in which Bell elucidates his thesis.

To further illustrate his point Nick Bell provided Emigre with original, hand made copies of Psycho (see insert). The production of these inserts was executed by Nick and his students at the London College of Printing during an event appropriately titled "Norman Bates' Big Night Out."

Nick Bell		287 x 425mm
'Psycho' typeface, Emigré magazine No.22		1992
>Above and right: Design by Nick Bell for the typeface **Psycho**, from the US design journal Emigré. In this issue of the US design journal, UK-based designer Nick Bell explores conceptual approaches to font design. Concerned with the exploration of a wider, or more propositional, context for type design, Bell offers the reader a photograph of a kitchen carving knife with		obvious associations to the murder weapon used in the Hitchcock film 'Psycho'. This is interleaved with a smaller sheet of slashed paper. In the same issue Bell also proposes another typeface referencing contemporary cinema. Entitled **Zelig** after the Woody Allen movie, the font takes on the physical characteristics of any typeface/s that can be found in its immediate vicinity.

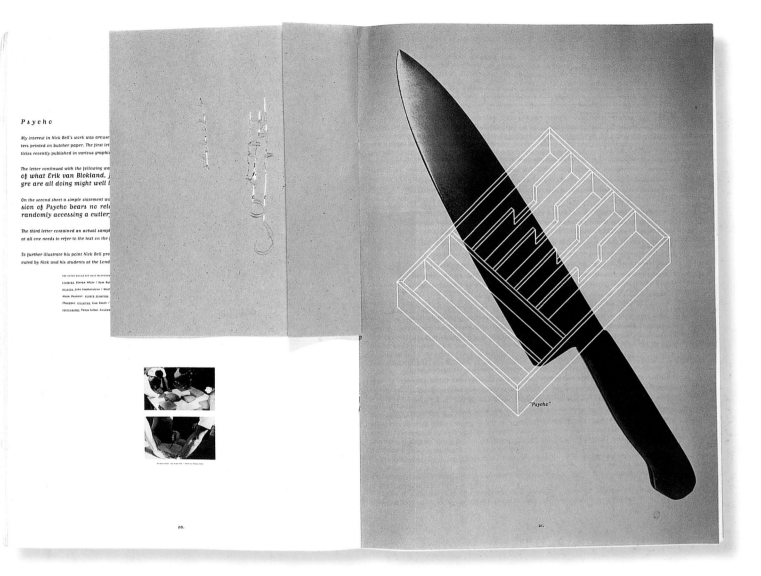

Psycho

My interest in Nick Bell's work was aroused
ters printed on butcher paper. The first let
ticles recently published in various graphi

The letter continued with the following wa
of what Erik van Blokland, j
gre are all doing might well b

On the second sheet a simple statement wa
sion of Psycho bears no rela
randomly accessing a cutler

The third letter contained an actual sampl
at all one needs to refer to the text on the

To further illustrate his point Nick Bell pro
cuted by Nick and his students at the Lond

"Psycho"

Nick Bell <

'Psycho' typeface, Emigré No.22 <

1992 <

example spreads <

ON
**TYPOGRAPHIC
REFERENCE**
(PART ONE)

Gérard Mermoz

As recent polemics around the new typography show, the crite-
ria used by its detractors tend to be grounded in a few unques-
tioned assumptions about legibility, transparency and alleged
readers' interests. These assumptions, formulated and publi-
cized by Stanley Morison, Beatrice Warde, Emil Ruder, Paul
Rand and, more recently, Robin Kinross, have set an agenda for
WHEN USED IN A CONTEMPORARY CONTEXT, NEW TYPOGRAPHY REFERS TO THE BROAD RANGE OF WORK PRESENTED BY RICK POYNOR IN HIS BOOK TYPOGRAPHY NOW:
typographic criticism, one that has forced alternative positions
THE NEXT WAVE.™" WHEN USED WITH REFERENCE TO THE TWENTIES AND THIRTIES, IT TRANSLATES THE GERMAN EXPRESSION "NEUE TYPOGRAPHIE," AN ESSAY IN WHICH
to define themselves within that agenda, against norms set by
JAN TSCHICHOLD OUTLINED NEW TYPOGRAPHIC VALUES BASED ON THE FULFILLMENT OF "PRACTICAL REQUIREMENTS" AND "VISUAL DESIGN." THIS ESSAY INVITES READERS
typographic orthodoxy rather than through independent,
TO CONSIDER THE IRONY WHEREBY THIS LEGACY HAS PROVIDED THE ARGUMENTS THAT HAVE IN TURN BEEN USED AGAINST THE CONTEMPORARY "NEW TYPOGRAPHY."
"organic" theoretical elaborations.
This makes a case for design criticism to shift its focus from
abstract design principles (the "isms" of art and design history)
to the micro-physics of specific design interventions, taking

> **Anne Burdick**

> Mouthpiece, Emigré No.36

> 1996

> example spreads

into account intents, contexts and effects, in an effort to redefine appropriateness within the ambit of cultural pluralism.

The exponents of the new typography have been provoked/ induced to defend their positions within the framework of a problematic dualism: responding to criticism by means of counter-claims, justifications and derision. Their strategies of subversion are not as radical as they claim to be, for they locate substitutions within an existing order without challenging that order. They neglect, in the process, the more urgent and difficult task of identifying, then importing into typography, the body of theories that could help us explore new grounds and redefine the relations between language-speech-writing-typography-reading and interpretation.

see the responses to "Cult of the Ugly" and more recently, the critical exchanges of Kritikos' Fellow Readers in Emigre 36

One chief aim of this discussion is to argue for theory as a means for providing new perspectives that allow more diversified typographic practices, in the hope that theory will no longer be seen as an expendable adjunct, grafted onto practice, but as an essential dimension of the design process. Moreover, I expect design criticism to be informed by theory if it is to address the theoretical preoccupations and implications of specific works, rather than use external appearance as a pretext for praise or derision.

NOT JUST AS A TOOL, BUT AS SYNONYMOUS WITH DESIGN: **theory as design**

where does this lead/leave us?
In book design, two significant strategies of disruption express discrete sets of concerns:
strategy one: Elaborated at Cranbrook Academy during the seventies and eighties, it was applied in the book Cranbrook Design: the new discourse (1990), among others. Katherine McCoy: "The intention is a conservative book format rooted in classical book design, but with

where next...

We could begin by developing an awareness of the complexity of the problems at hand and collaborate with specialists from those disciplines which can throw light on the relations between typography and language.

By focusing on typographic reference—that is, on the process whereby typography gives a body to a text— I wish to draw attention to the implications of theory on typographic practice.

FROM WHICH READERS NEGOTIATE THE MEANING/S OF THE TEXT

By turning to the work of the Russian Formalists and the Linguistic Circle of Prague, more precisely, the semiological aesthetic of Jan Mukarovsky, I hope to make clear that the language and methodologies currently used in our discussions on typography are not adequate to describe typography in all the variety and complexity of its functions. The debate on legibility that too frequently conflates typographical issues with questions of optical ergonomics has hindered discussion of the other functions of typography, which have been obscured as well by repeated references to oversimplified notions of (inappropriate self-)expression and aesthetic (self-)indulgence. However, looking back to Germany in the 1920s and 1930s, we see that a few texts had already begun to theorize typographic communication on a more complex "functional" basis.

"Modernism/s" revisited

In an article titled "Elements of New German Typography" published in 1930, Otto Bettmann contrasted "functional typography" with "historical print, which cultivates traditional forms from an aesthetic point of view." (p.116)
Bettmann characterized the new functional typography as one ruled by purpose:

Purpose is the leading principle of typographic work in Germany. Only what directly serves to express the meaning and helps to understand the word is acknowledged... every element of typography is to have a function of its own.

For Bettmann and others, this reduction of form to its simplest functional expres-

subtle interventions to break the rules of normalcy. Hopefully, on a quick scan, the pages appear traditional, but when read will reveal subtle aberrations that make the reader conscious of the syntax or grammar of book text." K. McCoy, "Book Format Design Concept," Emigre 19, unpaginated.
Within this strategy, typographic intervention works on the parameters of a genre—book design—not on the specificity of the text. However, the typographic intervention is

current limitations
IN SPITE OF A FEW TENTATIVE MOVES TO BRING SAUSSURE AND LINGUISTICS INTO THE DEBATE, CONTEMPORARY DIS-COURSES ON TYPOGRAPHY DO NOT ADEQUATELY ADDRESS THE ISSUES INTRODUCED BY THOSE THEORETICAL TEXTS THAT MAY THROW LIGHT ON THE RELATIONS BETWEEN TYPOGRA-PHY AND LANGUAGE. FURTHERMORE, CURRENT WRITINGS ON TYPOGRAPHY ARE TOO LITERAL, THEY DO NOT SUFFICIENTLY PROBLEMATIZE THE OBJECT THEY SCRUTINIZE, THE PROCESSES THROUGH WHICH THEY COME ABOUT AND THE CONTEXTS IN WHICH THEY OPERATE AND TAKE EFFECT. THIS GIVES CAUSE FOR CONCERN ABOUT THE LONG-TERM NEGATIVE IMPACT OF SECOND HAND PARAPHRASES PLEDGED BY AN IMPRECISE USE OF KEY CONCEPTS. CONCEPTS ARE COMMONLY BORROWED FROM NEIGHBOR-ING DISCIPLINES, OUT OF CONTEXT AND WITHOUT PROP-ER ATTENTION TO THEIR HEURISTIC VALUES WITHIN THE CONTEXTS OF THEIR ELABORA-TION. TO MAKE MATTERS WORSE, LINGUISTIC CONCEPTS ARE INVARIABLY IMPORTED WITHOUT REFERENCE TO THE CONTROVERSIES THEY GENER-ATE AMONG LINGUISTS. THIS HAS IMPORTANT CURRICU-LUM IMPLICATIONS FOR THE TRAINING OF GRAPHIC DESIGN-ERS, DESIGN HISTORIANS AND CRITICS ALIKE, AS IT SUGGESTS THAT THE CURRENT PROVI-SIONS FOR THEORY ARE INADE-QUATE, GIVEN THE COMPLEXITY OF THE ISSUES INVOLVED. UNDERGRADUATE COURSES ARE INVARIABLY OBLIGED TO CUT CORNERS...
THE SHORTCOMINGS OF SUCH LIMITED EXPOSURE SHOWED IN THE AMBITIOUS SPECIAL ISSUE OF VISIBLE LANGUAGE DEVOTED TO FRENCH THEORY. GRADUATE STUDENTS AT CRANBROOK WERE GIVEN A CRASH COURSE ABOUT STRUCTURALISM BE-FORE TACKLING THE JOURNAL'S DESIGN. THE INTENTION WAS GOOD, BUT THE MEANS WERE LIMITED. SEMIOLOGICALLY, THE DESIGN REMAINS WITHIN A STRATEGY OF DISRUPTION OF THE FLOW OF THE TEXT, WITHOUT SEEMINGLY ADDRESS-ING THE TEXT IN ITS SEMANTIC SPECIFICITY.

Anne Burdick		208 x 285mm
Mouthpiece, Emigré magazine No.36		1996

>Above and left: Design by Anne Burdick for Emigré magazine No.36. Subtitled **Mouthpiece**, issue numbers 35 and 36 of the magazine were guest edited by Burdick, with a number of individual contributors as writers and designers. Each article in the issue was intended to be a collaboration between an invited writer and a designer, with Burdick playing a central role as facilitator of the collaborations and designer of both the magazine's editorial pages and one or more individual articles. Within issue No.36, Burdick designed a layout for an article by Gérard Mermoz entitled **On Typographic Reference** (above), and acted as writer/designer/editor on the **Introduction/Inscription** across the centre spread of the magazine (see pages 126–129).

share experiences, assess the current state of research, identify prospective
research viewpoints and methodologies and devise concrete projects. This inves-
tigation will attempt to enrich typography with concepts and methods presently
scattered across different fields that are relevant to its theorizing and its practice.

It is important that we develop writing strategies that open multiple perspectives,
beyond anthologies and collections. We need to exchange views and collaborate
on projects rather than unfold unilinear arguments. Inspired by a more generous
desire to understand the other—even/especially if provoked by his or her posi-
tion—this approach would delay the process of judging in a peremptory manner,
favoring the decentering of dialogic modes, through a plural writing of differing
voices.

The form of the "polylogue" adopted by Derrida in Cinders, the textual strategies
found in "Tympan," Glas, Derridabase/Circumfession and their semiological impli-
cations, the theorizing of the "figural" by Lyotard in Discours, figures, Irigaray's
attention to the gendered basis of language and numerous other texts could, if
closely studied, open perspectives for theorizing typography on the extended basis
of more complex and newly recognized functionalities.

"polylogue" University of Nebraska Press, 1991
 textual strategies
Margins of Philosophy, University of Chicago Press, 1982 University of Nebraska Press, 1982
 semiological implications
 Minnesota, 1971
theorizing of the "figural"
J'aime à toi, Paris: B. Grasset, 1992
the gendered basis of language

numerous other texts

it represents a significant move beyond styling.

the cyclic history of the line

brian schorn andrew slatter · smletherland

> **Anne Burdick/Andrew Slatter/Simon Letherland**

> Mouthpiece, Emigré No.36

> 1996

> example spreads

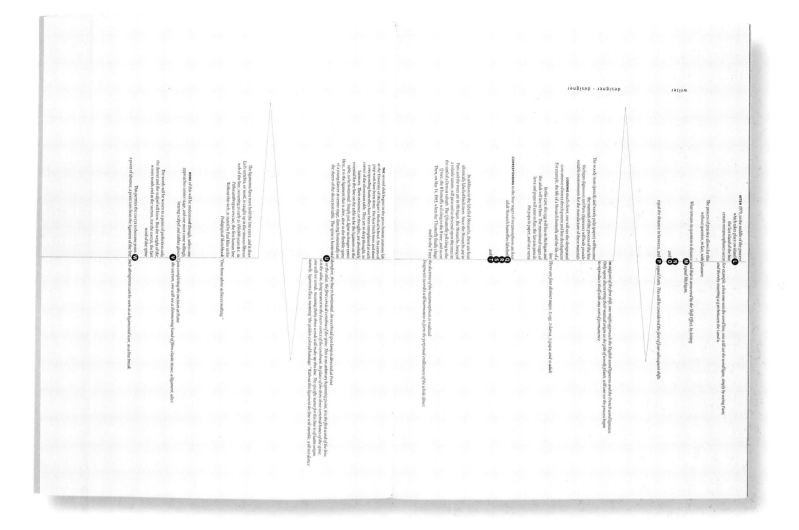

Anne Burdick/Andrew Slatter/Simon Letherland	208 x 285mm
Mouthpiece, Emigre magazine No.36	1996

>Above left: Final page of article by Gérard Mermoz, designed by Anne Burdick, leading into a guest article designed by graduates Andrew Slatter and Simon Letherland (above right). Written by Brian Schorn and entitled **the cyclic history of the line**, the piece is a creative essay giving an introduction to the work of the Oulipo (Ouvroir de Littérature Potentielle), or "workshop of potential literature" based in Paris. Reflecting the experimental nature of the subject matter, the designers turn the page layout on its side, with two intersecting sections of the text meeting at a central line which links each spread. Circular points on the line highlight particular letters discussed within the essay, allowing the text to flow both from and through each point.

Introduction/Inscription
ANNE BURDICK

The middle of a magazine might seem like an od

But right now I am in it so deep, I simply can't get outside. Therefore, this is an inscription, a "writing into"; perhaps an attempt to write my way out.

Emigre 35 and *36* are parts one and two of Mouthpiece: CLAMOR OVER WRITING AND DESIGN. An ongoing project, it began with a CALL for papers/ projects in February 1995 and continues in various forums and forms. Parts one and two showcase a few of the many excellent projects that had answered the CALL.

WHAT HAPPENS WHEN THE WORLDS OF WRITING AND DESIGN COINCIDE, OVERLAP OR COLLIDE?

Mouthpiece talks through the sometimes differentiated, sometimes dissolved categories of writing and design. As processes, as acts that open the door to meaning, design is writing and writing is design. As professions, their areas of expertise are separate but connected; typography is the intersection at which they meet. And yet the instant that words are made material, the individual meanings of the "writing" and of the "design" can no longer be

DESIGNS ON PAINTING, JOANI SPADARO AND ANDREW BLAUVELT

drawn apart. With typography, they become one.

With this presupposition as a basis and with close to one hundred responses to the CALL, I began including and excluding, editing, demarcating, defining a discourse on my own terms. What were/are my terms? They are many, shifting and sometimes contradictory. The more steadfast "rules" to which I adhered were: 1. No stamp-sized reproductions of existing work. Any work shown has to be read, as well as seen, for I am interested primarily in design that speaks to the "semantic

TYPOGRAPHY AND REFERENCE, GÉRARD MERMOZ

specificity of the text," to quote Gérard Mermoz. 2. The work included has to explore issues that relate to the project through both the content and the form of the inquiry. For example, I would not include a piece about formal English gardens mere-

THE SOCIAL SPACE OF THE PAGE, STUART MCKEE

ly because it had been written and designed by a sole author. However, if the subject of formal English gardens were used metaphorically to discuss, say, the ordered social gathering space of the book, I might include it.

During the editing process, issues specific to design and w rose to the surface, weaving their way through the contents o one and two: the form-fixing, shape-giving, delimiting functi writing, of design), and conversely, the messiness of meaning the edges of definition, seeping between the cracks, defyin

"TO GO ABOUT NOISILY": CLUTT

paradox of the prison and the flight of language. I was also int ations and uses of the material word—voice, presence, auth

THE FUTURE OF WRITING, JOHANNA DRUCKER

agency—issues we live every day in our lives and in our work

BITING THE MONSTER AT CHIMNEY LEVEL, BR

books, direct interactive media, teach typography or write de

"I do not distinguish between creative and all writing is creative... And all writing same shifting, selection, scrutiny and judgm .hand." —Nancy Mairs, *Voice Lessons: On Beco*

Mouthpiece contains a range of conventional n from poetry to photography to criticism. At the same time, rations cross categories or manipulate conventions, using dialects in a self-conscious way. I included both fiction and each for the opportunities it affords. The experience and exp ual designers and writers vary greatly as well. In the end, I spoke to the issues I wished to cover, regardless of the spea only by the dexterity with which the chosen language was sp

For example, Kevin Mount, Elliott Earls and Stuart McF means to examine the published word, arriving at very differ the time and pages of Mouthpiece parts one and two, Kevin's from imaginary books, The Voyages of the Desire, based in pa

THE VOYAGES OF THE DESIRE, KEVIN MOUNT

the Elizabethan pirate-explorers, navigate the space between the in/authentic and the authority of the printed page, while face of language and desire. Elliot, in his manifesto WD40: c David Holzman's Diary in Mouthpiece part one, harnesses sumption *and* production and takes them for a wild, but not r the traditional boundaries of publishing. In a more academic at community identity as it takes shape in the worlds of publ the construction of the public face of graphic design in his ess of the Page, contained in this issue.

Inter-Views, a set of interviews and comments from *Feed Nuts* participants, is a departure from the conventional interv stock in the words of the individual author-genius. While reproductions too small to be read, (rules *were* made to be l offers an overview of a network, shifting the focus from prod

situation impossible, more so today than
 But he must be there, absent and present,
uths, that of document and fiction."¹
 Godard, *Germany Year 90 Nine Zero*

or an introduction.

an examination of the multiple viewpoints, inter-connections and relationships that facilitate the creation, production and distribution of work. A similar set of "inter-views" with graphic design-er/collaborator/joint venturer Steve Farrell,

EVE BAKER

writer/collaborator Steve Tomasula and poet/per-formance artist/joint venturer Daniel X. O'Neill, will spill over into *Emigre 37*.

The Mouthpiece project was initiated with the question, What issues come into play when the writer and the designer are one and the same person? Historically, William Morris, Jan Tschi-chold, Emil Ruder, Paul Rand and others made their ideologies manifest in both words and form. Artists such as Filippo Marinetti, Guillame Apollinaire and the Fluxus group pushed the boundaries of language and its material expression in very different ways at different moments. While pictures of these artists' work litter historical sur-veys of graphic design, critics have only recently addressed their textual contents and historical con-texts.³ Where the writer/designer is concerned, there are whole oceans yet to be charted.

Contemporary projects of this nature would include Robin Kinross's self-published statements and the critical, editorial and curatorial work of Ellen Lupton and Abbott Miller, in which these designers/critics design the books that house their words, as well as the personal, poetic and/or fic-

OF DAVID HOLZMAN'S DIARY, ELLIOTT EARLS

tional visual/verbal explorations of Allen Hori, Martin Venezky and Brian Schorn.⁴ In the literary world, more frequently in "experimental" or

THE CYCLIC HISTORY OF THE LINE, BRIAN SCHORN

"underground" literature, projects such as Raymond Federman's Double or Nothing push the semantic and syntactic dimensions of both word and page. "Fine" artists and comic book artists have been engaged in text/image work for quite some time.

The visual-verbal (i.e. bilingual) "speaker" can exploit the capacity of each language to signify, shifting between the two as necessary. At this juncture, this overlap or collision, what transpires between the writing and the design? What parts of a mes-sage can only be conveyed through words? Which expressions can

CLICK, LOUISE SANDHAUS

only be transmitted through the visual? What takes place in a collab-oration? Does the design drive the writing, or does the writing drive the design? In the more conventional designer/writer relationship, does a graphic designer "glom" her work on top of the writing, to use Louise Sandhaus's distinction, or does she erase the writer com-pletely, axe the writer out in a futile attempt to capture the reins of meaning, as Adriano Pedrosa proposed in Mouthpiece part one?

The contributors to Mouthpiece worked through these questions as they brought their design and writing into being. There were no formatting constraints; each essay was interpreted individu-ally, whether the designer wrote the content himself, collaborated

A FEW PRINCIPLES OF TYPOGRAPHY, FELIX JANSSENS

with a writer, or designed it without input from the writer. The visu-

WRITING AND DESIGN AND THE SUBJECT, ADRIANO PEDROSA

al clamor that results reflects the varied contents. It is a strategy that was influenced in part by Barbara Glauber's editorial/curatorial pro-ject for the Lift and Separate exhibition catalog, in which the indi-vidual writers designed their own pieces, as well as by Reverb's design for the art and culture magazine, *Now Time*, in which the design of each article was derived conceptually from the content of each individual text.

Students from three universities were invited to design three of the essays that appear in this issue. Intelligent and provocative self-initiated projects arrived in response to the CALL from a diverse array of colleges. But rather than merely show a large number of small *pic-tures* of existing student work—in repose—I decided to give Emigre readers the *experience* of the work of fewer students who designed the actual pages to be read. Brad Bartlett, a senior at North Carolina State University has situated Stuart McKee's, The Social Space of the Page. Simon Letherland and Andrew Slatter, recent graduates from Ravensbourne, collaborated across 200 miles on The Cyclic History of the Line, a creative essay by Brian Schorn. Russ Bestley, a senior at The University of Portsmouth is very present on the pages of Anne Bush's Criticism and the Politics of Absence.

While I didn't specifically address every contribution here, I felt it was important to clarify the choices I made, allowing the pages with-in which I've written to tell the rest of the story. It was clear from the

> **Gülizar Çepoğlu**

> 6th Istanbul Biennale publication

> 2000

> example spreads

0/10 0/11

Gülizar Çepoğlu	167 x 230mm
6th Istanbul Biennale exhibition publication	2000

>Above and overleaf: Publication to mark the **6th International Biennale exhibition** in Istanbul, Turkey, organised by the Istanbul Foundation for Culture and Arts. Designed by Gülizar Çepoğlu, the publication is reproduced in 4- and 2-colour sections, with a standard text and image grid, some full-bleed images, and some work reproduced within a page frame on the page. The brief to the designer was to incorporate a wide range of artists' work, in a range of media, within one overall publication. Çepoğlu chose to show the work as if it were exhibits on a gallery wall, highlighting the pieces as physical, three-dimensional objects. By alternating between full-bleed images and 'pages' within pages, the reader is forced to confront the surface of the book.

CARSTEN HÖLLER

Kuşku Günleri · 1999 · *Tage des Zweifels*
(Days of Doubt) · Yerleştirme; kağıt üzerine
el yazısı, fotoğraflar, vitrin ve kitap · *Installation;*
handwriting on paper, photographs, vitrine and
book · Courtesy Galerie Schipper & Krome izniyle

Carsten Höller'in
kuşku günleri

İstanbul, Köln, Londra, Köln, Malmö, Köln, Brüksel, Köln,
Donegal, Köln, Berlin, Zuoz, Köln, Stokholm, Köln ve İstanbul'da

31.07.1999 / 17.09.1999

1/**120**

1/**121**

> **Gülizar Çepoğlu**

> 6th Istanbul Biennale publication

> 2000

> example spreads

Höller'in
günleri

n, Malmö, Köln, Brüksel, Köln,
öln, Stokholm, Köln ve İstanbul'da

/ 17.09.1999

31.07.1999 >

2 Ağustos 1999 / İstanbul

(+ Özet 31 Temmuz 1999 / 1 Ağustos 1999)

Bu, benim herkese açık güncemin ilk sayfası. İstanbul'a varışımla başlıyor –bu ilk gelişim– ve yeniden geleceğim gün sona eriyor, gene bu yılın 9 Eylül'ü sıraları herhalde. Güncenin başlığı "Kuşku Günleri" [1] olacak. Buraya, 17 Eylül günü açılışı yapılacak olan 6. İstanbul Bienali'ne katılmak üzere davet edildiğim için geldim. Düne kadar Bienal için yapacağım işin ne olabileceği konusunda bir fikrim yoktu– tek bildiğim, kuşkuyu işin içine katmak istediğimi, kendi yaptığım işlerle ve bütün o haralagürele ile ilgili kuşkuyu. Her gün bir fotoğraf ya da başka bir resim seçeceğim ve kuşku üzerine bir metin yazacağım. Sonra bu biriken metinler Türkçeye çevrilecek ve küçük SIW-Defteri formatında yayınlanacak ve tabii parasız olarak dağıtılacak. Bunları Almanya'ya da götüreceğim, orada Türkçe bilmeyenler ona sadece bir resimli kitap olarak baksınlar diye.

(1) Dün bu işe "Days of Doubt" adını verdik, Paolo ile ben, güzel bir ses uyumu.

2 Ağustos 1999 / II

İlk resim, 31 Temmuz tarihli –resimlerin daha çok zamanı karakterize eden bir niteliği var– Şafak'la beni Galata Köprüsü üzerinde gösteriyor, buraya gelişimden aşağı yukarı iki buçuk saat sonra. Seyyar bir fotoğrafçı tarafından çekildi ve fotoğrafçı resim konusunu ortalamaktansa, Türk bayrağını ikimizin arasına denk getirmeyi daha anlamlı buldu.

Baldo Hanser'den alıntılıyorum: "C.H. 1989'dan bu yana güvence, gelecek, çocuklar, sevgi, mutluluk, uyuşturucu, taşıma araçları ve evler gibi 'büyük temalar'la hesaplaştı, anlamlı ve bana kalırsa acil

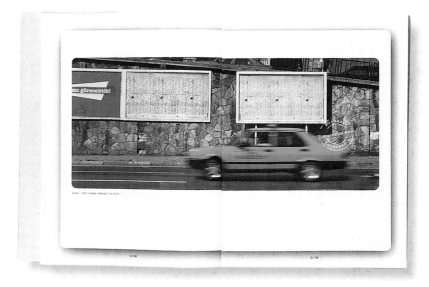

ANSELMO BÖMMELS

BOETTI BÜTTNER

MANZONI DE DOMINICIS DAHN

FABRO DISLER

ANDRE PENONE DOKOUPIL

FLAVIN FETTING

JUDD SALVO OEHLEN

LONG

LEWITT CHIA HARING

TORONI CLEMENTE

CUCCHI ARMLEDER

ROEHR DE MARIA BULLOCH

PALADINO FLEURY

ART & LANGUAGE OPIE

BARRY KIEFER RUFF

BUREN SCHOLTE

BURGIN FELDMANN SCHÜTTE

DARBOVEN SCHUYFF

KAWARA KNOEBEL TAAFFE

KOSUTH

AUFFRISCHENDER WIND AUS WECHSELNDEN RICHTUNGEN
INTERNATIONALE AVANTGARDE SEIT 1960 – DIE SAMMLUNG PAUL MAENZ STURTEVANT
JANUAR BIS DEZEMBER 1999 NEUES MUSEUM WEIMAR BURGPLATZ 4 99423 WEIMAR

PAOLINI

> **grappa blotto**

> Neues Museum identity

> 1998

> example posters

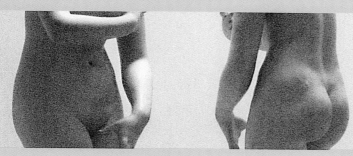

AUFFRISCHENDER WIND AUS WECHSELNDEN RICHTUNGEN – INTERNATIONALE AVANTGARDE SEIT 1960

DIE SAMMLUNG PAUL MAENZ

NEUES MUSEUM WEIMAR

MANZONI – ANDRE FLAVIN JUDD LONG LEWITT TORONI – ROEHR – ART & LANGUAGE BARRY BUREN BURGIN DARBOVEN KAWARA KOSUTH – PAOLINI – ANSELMO BOETTI DE DOMINICIS FABRO PENONE – SALVO – CHIA CLEMENTE CUCCHI DE MARIA PALADINO – KIEFER – FELDMANN – KNOEBEL – BÖMMELS BÜTTNER DAHN DISLER DOKOUPIL FETTING OEHLEN – HARING – ARMLEDER BULLOCH FLEURY OPIE RUFF SCHOLTE SCHÜTTE SCHUYFF TAAFFE – STURTEVANT – KUNSTSAMMLUNGEN ZU WEIMAR – JANUAR BIS DEZEMBER 1999

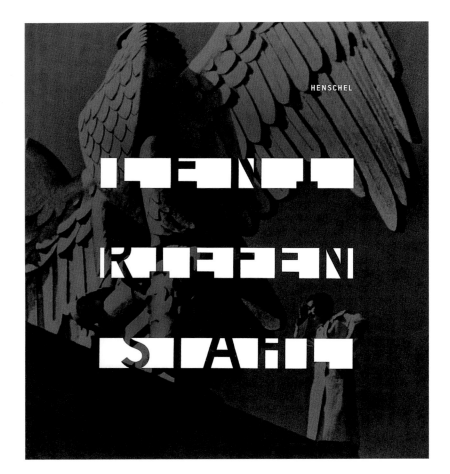

grappa blotto	640 x 960mm
Leni Riefenstahl exhibition catalogue/poster	1998

>Previous pages, above and right: The posters featured on the previous spread were originally part of a proposal for the New Museum in Weimar, Germany, where the brief required an equal importance to be given to the artefacts within the collection and the artists featured. Although not selected, the concept behind the project was recycled by the designers and utilised for an exhibition of the work of film director Leni Riefenstahl at the Film Museum in Potsdam, Berlin (book jacket above and poster opposite). The yellow strips have at this point been refined so as to act as an integral element within the typography rather than simply a supporting device. The theme was continued by grappa blotto within the exhibition catalogue and supporting publicity material, providing an easily recognisable visual identity which can be varied across a range of products. Key elements remain constant – the yellow colour bands and bold upper case sans serif type – but the work can be adapted to suit a variety of potential outcomes, both print and screen-based.

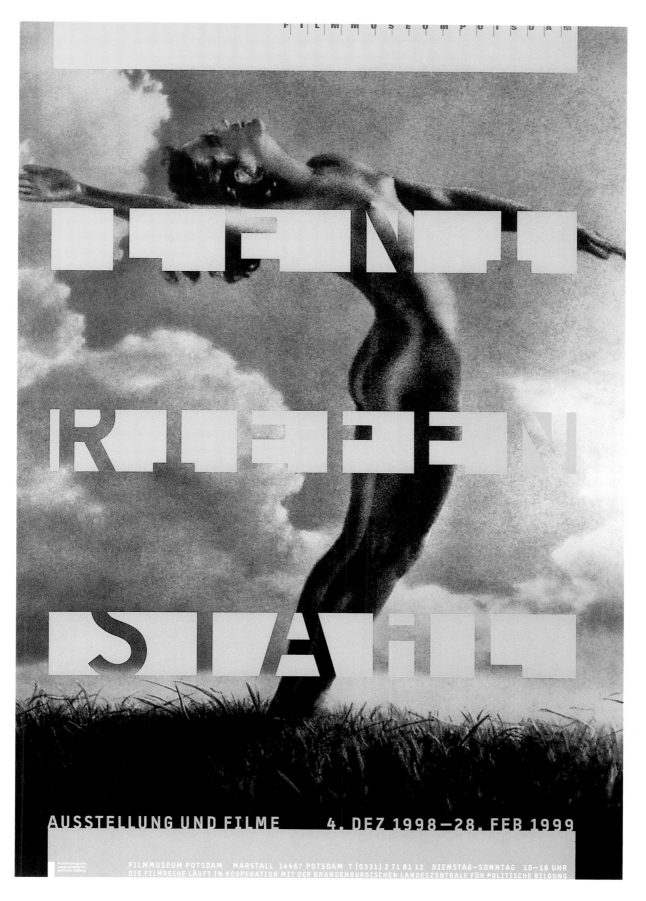

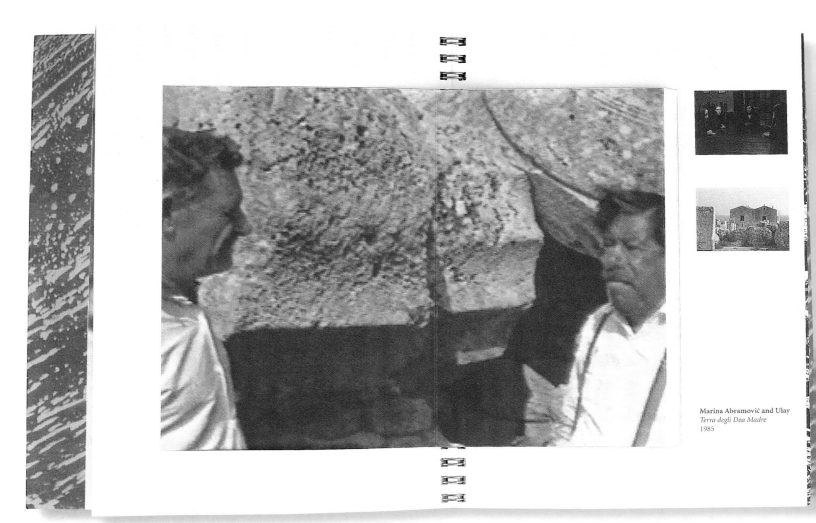

Marina Abramović and Ulay
Terra degli Dea Madre
1985

> **John Gillett**

> Lie of the Land
 exhibition catalogue

> 1998

> sample spreads

> see also overleaf

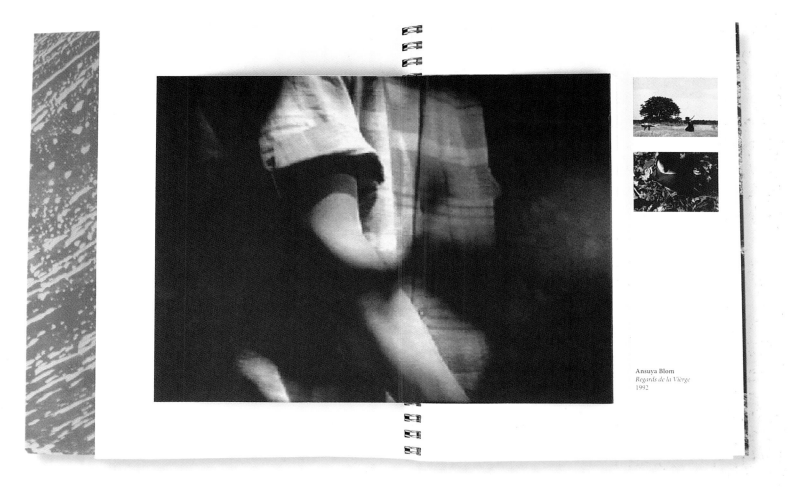

Ansuya Blom
Regards de la Vierge
1992

John Gillett	163 x 230mm
Lie of the Land exhibition catalogue	1998

>Above, left and overleaf: Catalogue designed by John Gillett to accompany the **Lie of the Land: Earth, Body, Material** exhibition organised jointly by the John Hansard Gallery, Southampton, UK, and the Arnolfini Gallery, Bristol, UK. Printed on a heavy matt stock, the book employs a series of complex folds and die-cuts, with central full-colour images folding out from the page in front of the metal spiral binding. Text pages are trimmed to 140mm wide, interspersed in sections between the folded and bound image pages. Each colour section of eight pages is made up of one sheet, 652mm x 230mm, folded in concertina fashion and bound into the spiral bind. On the reverse of each folded section, the earth-coloured landscape photographs by Paul Carter are repeated in monochrome, and used once again on the cover. The cover utilises an unusual manufacturing process, termed half-Canadian binding, where the cover is bound to the metal spiral at the reverse edge, then folded round outside the binding to simulate a traditional flat spine and front cover.

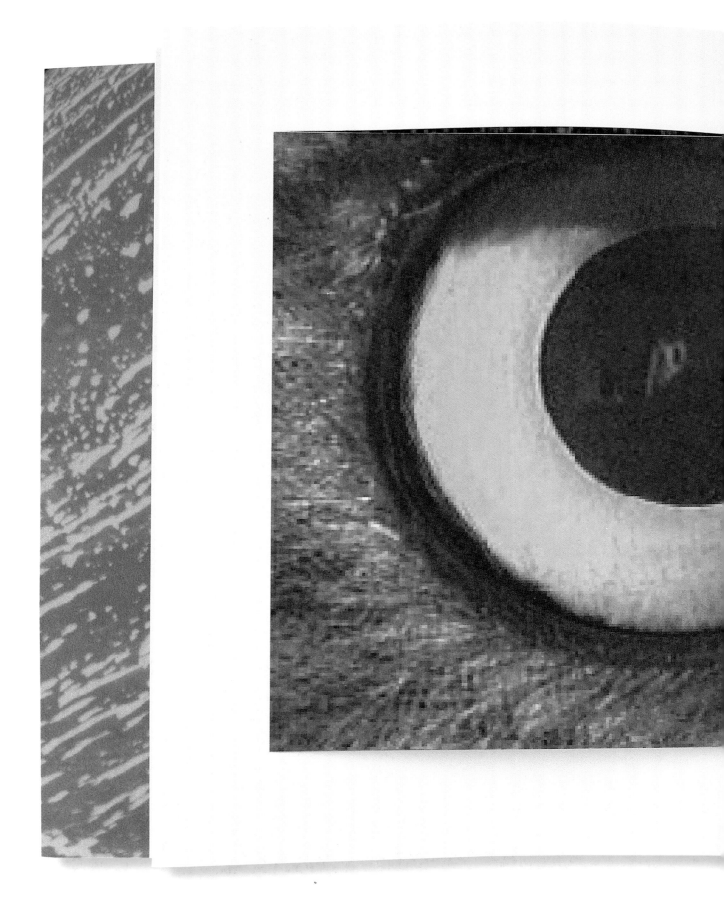

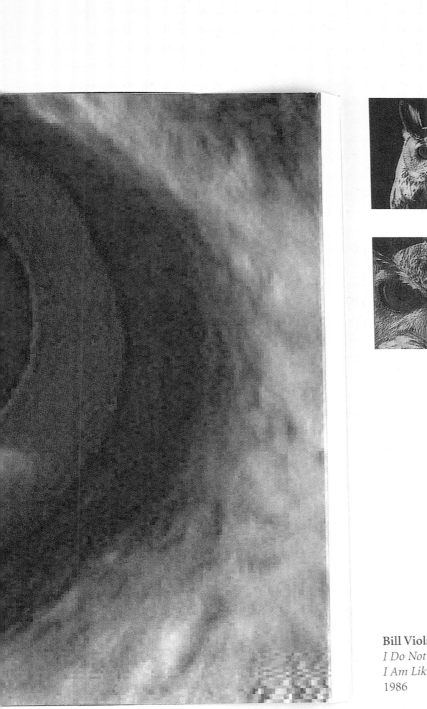

Bill Viola
I Do Not Know What It Is
I Am Like
1986

Anne Burdick

Die Fackel Wörterbuch: Redensarten

230 x 310mm

2000

>Previous pages and above: A Dictionary of Idioms in the work of Karl Kraus, taken from literary journals first published between 1899 and 1936, and produced in collaboration with the Austrian Academy of Sciences, Commission for Non-Fictional Literature. The collaboration between designer and client had a huge impact on both editorial direction and outcome, with the translation of the texts and the layout forming an integral part of the editorial process. Burdick attempts to remain true to the original concepts through the use of a three-column grid. The central column is employed to contain texts from the original Fackel journals, often keeping the typographic form and visual identity of the original publication, whilst the left column, termed 'documentation', contains citations and references. The right column gives further interpretations and contextual information.

> **Anne Burdick**

> Die Fackel Dictionary

> 2000

> example spreads

etwas auf Lager haben

etwas auf Lager haben

mir san ja eh die reinen Lamperln

Was er noch immer auf Lager hat

1930; F 838,90

♦ dankend erhalten
♦ man sagt
♦ jemandem zu einer Stellung verhelfen
♦ mit jemandem bekannt werden

mir san ja eh die reinen Lamperln

1918; F 499,13

Mir san ja eh die reinen Lamperln

Was Schiedsgericht und Völkerbund!
Sie Kellner, bringen S' ein paar Stamperln!
So etwas brauchen wir nicht und
mir san ja eh die reinen Lamperln!

Wir sind ja eh die reinen Schaferln
Umsoweniger nach meinem Geschmack ist aber eine Niederlassung
auf das Niveau des politischen Wirtshauskrakeels, die sich
hinterdrein als ein so reines Lamperitum darstellt
ein goldenes Vlies von einem reinen Lamperl
der innern Natur jener reinen Lamperln, die wir ch' sind
wo die reinen Lamperln neben den Löwen gerast haben
Mir san ja eh die reinen Lamperln, das ist jetzt die tägliche Tonart
der Wölfe

Nicht gebucht

Erfasste Belege: 37

1918; F 484,164 wenn die Regierungsmaxime »Mir san ja eh die reinen Lamperln« täglich ein beglückende Tat umgesetzt würde

1918; F 499,U1 Inhalt: Weltgericht / Lied des Alldeutschen / Mir san ja eh die reinen Lamperln / Österreichs Fürsprech bei Wilson / Heldengräber/ Hausmannskost / Absage / Die Sintflut

1918; F 499,13 Mir san ja eh die reinen Lamperln

1918; F 499,14 So etwas brauchen wir nicht und mir san ja eh die reinen Lamperln

1919; F 501,5 Was Völkerbund! Das is doch stier! Sie Kellner, bringen S' noch paar Stamperln! Was Selbstbestimmung! Mir san mir, und mir san eh die reinen Lamperln!

1919; F 501,31 ein Staat, dessen Regierungsmaxime »Mir san ja eh die reinen Lamperln« wirksam nur durch den Vorsatz »Schön stad san«

1919; F 501,89 Mir san ja eh die reinen Lamperln, das ist jetzt die tägliche Tonart der Wölfe

1919; F 501,106 nicht wie Menschen aufgeführt haben, so geben wir die Möglichkeit bloß –im Hinblick– auf den Umstand zu, daß wir ja eben die reinen Lamperln sind

1919; F 501,117 fehlt nicht der Hinweis darauf, daß wir eh die reinen Lamperln sind diese beherzte Zugsführerrattitüde, der nur statt der Virginier ein goldenes Vließ von einem reinen Lamperl eignet

1919; F 501,U4 Inhalt des vorigen Doppel-Heftes 499/500, 20. November 1918: Weltgericht / Lied des Alldeutschen / Mir san ja eh die reinen Lamperln / Österreichs Fürsprech bei Wilson / Heldengräber/ Hausmannskost / Absage / Die Sintflut

1919; F 508,24 / Lied des Alldeutschen / Mir san ja eh die reinen Lamperln / Die Gerüchte / Die Ballade vom Papagei / Heldengräber/ Hausmannskost /

1919; F 508,29 II. Inschriften (Orakel; Wien im Krieg) / Mir san ja eh die reinen Lamperln /

1919; F 508,33 / Staatsprüfung / Mir san ja eh die reinen Lamperln / Die Ballade vom Papagei (Couplet macabre, geschrieben 1915: mit begleitender Musik) /

1920; F 521,97 / Karl Kraus: Als Bobby starb; Die beiden Züge (Zum ewigen Gedächtnis); Anrede über die Presse (mit Zitat aus Kierkegaard*); Die Ballade vom Papagei (Melodie vom Verfasser); Die letzten Tage der Menschheit, V, 45; Mir san ja eh die reinen Lamperln (Melodie nach Angabe des Vortragenden)

1920; F 544,11 II. Mir san ja eh die reinen Lamperln / Hans Müller in Schönbrunn / Aus: Die letzten Tage der Menschheit: II, 11 (Grüßer); V, 45 (Die Generalstäbler) /

1921; F 557,31 — Frank Wedekind: Die Hunde / Das Lied vom armen Kind [zum erstenmal gedruckt in der Fackel Oktober 1904] (beide nach der Originalmelodie) / Der Zoologe von Berlin (zum erstenmal gedruckt in der Fackel Juni 1905). — Karl Kraus: Mir san ja eh die reinen Lamperln**) / Hypnagogische Gestalten.

1921; F 557,62 das Alibi der Wölfe ist ihre Verkleidung und das Plaidoyer, mit dem sie noch immer Eindruck auf ihre Opfer machen möchten, ist, daß sie eh die reinen Lamperln seien

1921; F 561,3 Sie sind ja eh die reinen Lamperln, und weil sie der Terror

1921; F 568,17 Wir sind ja eh die reinen Schaferln, und ich sehe es der Reichspost an, sie verlangt das Zugeständnis, daß der kindliche Kronprinz noch harmloser wäre

1921; F 57,70 / Wiener Faschingsleben 1913 / Mir san ja eh die reinen Lamperln / Das Ehrenkreuz /

1921; F 57,73 — Zugaben: Johann Nestroy: Lied von der Chimäre / Karl Kraus: Mir san ja eh die reinen Lamperln

1922; F 588,66 — Aus: Ein christlicher Dreh. — Mir san ja eh die reinen Lamperln [Mit Begleitung]. — Post festum

1922; F 595,67 — Karl Kraus: Die Ballade vom Papagei / Mir san ja eh die reinen Lamperln / Couplet des Schwarz-Druckers aus »Literatur«

mir san ja eh die reinen Lamperln

Innerhalb des »Fackel«-Heftes vom 20. November 1918, das mit dem Aufsatz »Weltgericht« beginnt und mit dem Aufsatz »Die Sintflut« endet, ist das Gedicht »Mir san ja eh die reinen Lamperln [F 499,13f.] das Gegenstück zu dem unmittelbar vorangehenden, stolz sich zur eigenen Barbarei bekennenden »Lied des Alldeutschen« [F 499,6ff.]. Leitmotivisch dient die Wendung fortan zur satirischen Kennzeichnung aller Versuche, die Brutalitäten österreichischen Verhaltens während des Krieges und nach dem Krieg als auch zur Unterscheidung von den deutschen Bundesgenossen. Danach und darüber hinaus werden in der »Fackel« mit dieser Wendung die offiziellen Bestrebungen, die österreichischen Unschuldslämmer von den umgebenden reißenden Tieren zu unterscheiden, gereizt, wobei durch manche der Vorstellungen entstellte biblische Friedensbilder schimmern, das des Wolfes etwa, der bei dem Lamme zu Gast ist, und das Bild dieser beiden, einträchtig mit dem Löwen weidend (vgl. Jes 11,6 und Jes 65,25).

54 546

547

20 Paintings
Mark Strand

Poetry, Art and
Humane Letters
Poetry Reading
Harold Williams Auditorium
April 27, 2000, 7pm
Sponsored by the
Getty Research Institute

1. The paintings of A were of rock piles
2. The paintings of B were influenced by A
3. The paintings of C were of miracles flattened
4. The paintings of D were of cruise ships on fire
5. The paintings of E captured a lost transparence
6. The paintings of F contained a number of frozen animals
7. The paintings of G seemed always larger at night
8. The paintings of H announced the approach of the unreachable
9. The paintings of I completed themselves endlessly
10. The paintings of J stood in relation to nothing
11. The paintings of K were like parties under water
12. The paintings of L acknowledged the power of chance
13. The paintings of M offered readings of sunrise and smoke
14. The paintings of N left nothing to the imagination
15. The paintings of O contained elements of emptiness
16. The paintings of P were of babies swimming
17. The paintings of Q were of nudes having lunch
18. The paintings of R foretold the coming of midnight
19. The paintings of S seemed to shrink as they were looked at
20. The paintings of T were conceived in unison
21. The paintings of U referred to the Age of Vegetables
22. The paintings of V concealed their humble origins
23. The paintings of W hastened the end of self-portraiture
24. The paintings of X suggested the fury of something or other
25. The paintings of Y couldn't be looked at without music
26. The paintings of Z died of neglect the minute they were shown.

> **Anne Burdick/Jennifer Lee**
> Light, Mortality, History
> 1999
> example spreads

Anne Burdick/Jennifer Lee	280 x 314mm
Light, Mortality, History	1999

>Above and left: Designer Anne Burdick collaborated with architect Jennifer Lee on this 'poetry installation' project-concept for the Getty Research Institute, Los Angeles. Poems flash-printed on UV sensitive paper are designed to fade and disappear when exposed to sunlight. The installation was devised to operate in two specific sites: in the J. Paul Getty Museum lobby before a poetry reading, where poems are removed and kept as souvenirs, and within the Research Institute, behind glass as specimens, protected from light and view. The designers were interested in the nature of archiving and the instability of print as a long-term medium. Within the Research Institute, books are kept away from light to preserve them for the future. This dilemma, between the distribution and preservation of written material, is made explicit to the reader when they take the free loose-leaf poems away from the museum, destroying the work in the process as the UV sensitive pages are exposed to sunlight.

Interview Ian Warner

Chaumont Poster Festival **May 2001**

I wonder if there is an overriding or central philosophy to what grappa blotto does?
I think that structure and formalism are key; certainly in the approach to the layout
of the page or indeed the screen. Last summer we were talking as a group about
'commercial' work and Andreas (grappa blotto partner) summed us up well when he said
that we weren't a group who would design washing-powder packaging unless we could play
an important role in the manufacture of the washing-powder itself. A direct manifestation
of this approach is the work we are doing on the programming and production of a
project database for architectural clients. The database will soon be packaged and
marketed, something fairly inconsiderable for us had we not been actively involved in
the creation of its content from the early stages of the project.

What is grappa blotto's approach to print design and layout in particular?
We are trying to think and talk more about that ourselves as a group. I think that it
has to do with the bridge between education and professional work. By that I mean our
training and our current practice as designers. What surprised me when I first started
working with grappa blotto in Berlin was the very formal approach to working or going
about things. This is supported by the fact that we talk on both a meta and macro level
about design — our philosophy as a group or analysing what's on a page or what should
be on a page, elements such as foreground, hierarchy, composition for example. This is
very different from my own education where a great proportion of time went into the
theoretical background of a project.

Do you think there is such a thing as a grappa blotto style?
If we do have a style then it's probably a direct result of how we work, or of the
structures which come into play — the ways of organising information, or imposing a
hierarchy to information. I think there is received style and transmitted style.
Transmitted style is applying a surface coat to something; making something 'hip' for
an intended audience for example, whereas received style is more a perceived set of

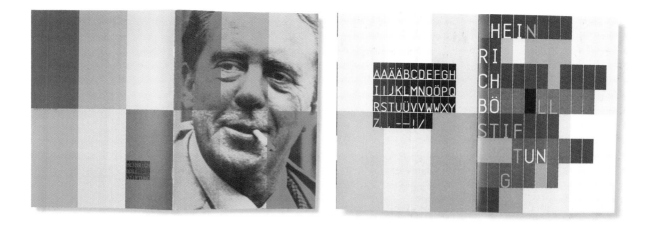

visual codes. These codes become recognisable, but aren't a conscious attempt to define a house style for its own sake. This doesn't mean we're immune to trends though, although I think as a group we're fairly suspicious of Zeitgeist. With the Heinrich Böll-Foundation project for example, Tilman (freelancer at grappa blotto) and I asked ourselves how do you create a democratic typeface? The result was a monospaced face where each character is die-cut out of a rectangle. When this is grouped into a 3:2 (ratio) block it forms the proportions of the DIN paper sizes. The idea of a transparency of structure (openness, tolerance) exemplified by the Foundation is conveyed by the fact that you can see through the letter forms in the layout. This struck us as pretty original, but people will always say "Yes, this is very typical of grappa blotto."

That was a particularly large project which I understand developed over a long period of time. Was that a unique opportunity for you as designers?

From the outset we always knew it was going to be a big project and it has taken four years to get to the point where there is a published design manual. We entered and won a competition to design the Böll Foundation's identity. They are connected to the Green Party in Germany and work inland and overseas promoting democracy, free speech and human rights etc. We posed ourselves this question – how do you make a democratic logo or a democratic form of typography? What started as a bit of a designers' joke, gradually became a serious approach to the project, extending our ideas about what could be visually achieved. The logo is simply a monospaced font which we designed ourselves, although it's based on the proportions of the font 'Isonorm'. This is a democratic thing in itself, as each letter is allocated exactly the same space – an almost utopic approach to working with type. We started on a very banal level by setting the Foundation's name in Courier and seeing what we could achieve with that; the rhythm of the letters for example. What we ended up with is a corporate identity which is really a typeface. We simply had a lot of fun typing the logo into QuarkXPress, randomly inserting spaces between the letters and then pulling the text box into different shapes to see what

would happen. No matter what you did, the letters stayed in their own grid. So we imagined everyone in the Foundation being able to make their own logo as and when they pleased, for every format. It was also an attempt to make an identity which would be more transparent, to be able to overlay it and let the background show through or affect the typeface, even, a kind of non-fixed identity, constantly changing. In the end though of course, the client wanted a more fixed logo so after about two years we reduced it down to two variations.

How did you approach the use of colour for this project – did you apply a similar democratic structure and rationale?
I think that the use of the colour green was significant because of the obvious association with the Green Party and really the use of colour within the project in general was built around how far can we develop or stretch that idea.

As a design group, how do you operate when working with clients?
We will always try to work as closely as possible with clients. With smaller individual projects we have more of a free rein, larger clients usually want more control, that's probably the same for all designers. And yes, we do turn people down occasionally. for political reasons. We almost know from the first meeting when we're not going to be able to work with someone. But people who come to grappa blotto usually know roughly what to expect, so we don't get too many phone calls from oil companies or car manufacturers.

Returning to your democratic approach to design, is the grappa blotto studio a democratic working environment?
No, not all. We argue quite a bit about our work. But it's not a case of whoever shouts loudest wins; more, who shouts the most convincingly. We talk about playing 'ping-pong' with each other's XPress documents; a lot of file sharing goes on. Even in the beginning though, when grappa was first coming into the public eye – and I'm thinking of the time

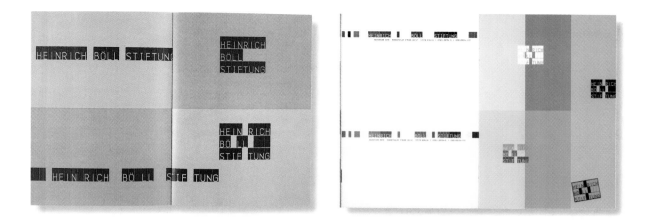

when they produced a book (**4-11-89, Protest Demonstration Berlin DDR**) about the demonstrations in East Berlin before the fall of the Wall, about the fight for democracy – the studio realised that you can't always work democratically. In the current set-up there are three partners: you could say there is no boss or that we are all bosses.

As you get more successful, is grappa blotto becoming part of the graphic design establishment?
I'm not too sure that we are – it has a lot to do with size and profile – keeping it small deliberately and choosing to work with certain clients. Interestingly, we are much smaller as design group now than when grappa was first founded!

How do you feel as an English designer working in Berlin?
I'm not sure I ever had time to feel like an English designer since I've never practiced in England, fitting in is more to do with a sympathy for a way of working and the approach to work or methods employed. For me personally, when I started working with the group, it was difficult to get over the 'hero factor' – it took about two years for me to say that I didn't like something that Heike (grappa blotto partner) had done, for instance. Becoming critical within the group was very difficult, but naturally vital.

A last question – why the name grappa blotto?
The addition of 'blotto' to the name 'grappa' is completely based on aesthetics – they look the same and have the same sequence of consonants and vowels. Also, in lower case 'grappa' only has descenders and 'blotto' only has ascenders.

biographies
glossary of terms
bibliography
acknowledgements

PETER WILLBERG TRAINED AS A TYPOGRAPHER AT D. STEMPEL AG, FRANKFURT AM MAIN, GERMANY, AND WAS A MEMBER OF THE ATELIER GROUP, ATELIER DUTTENHOEFER, WIESBADEN. WILLBERG LATER BECAME A TYPE DESIGNER FOR LINOTYPE FONT SHOP, FRANKFURT AM MAIN, GERMANY. FOLLOWING THIS PERIOD WILLBERG WENT ON TO STUDY TYPOGRAPHIC DESIGN AT THE ROYAL ACADEMY OF ARTS IN THE HAGUE, THE NETHERLANDS, AND WORKED AT TOTAL DESIGN, AMSTERDAM. RETURNING TO STUDY GRAPHIC DESIGN AND ART DIRECTION AT THE ROYAL COLLEGE OF ART, LONDON, DURING THE LATE EIGHTIES HE WENT ON TO BECOME A RESEARCH FELLOW OF THE ROYAL COLLEGE OF ART.

SINCE 1991 HE HAS WORKED AS AN INDEPENDENT DESIGNER WITH CLIENTS IN THE CULTURAL FIELD IN THE UK, EUROPE AND USA. HE CONTINUES TO TEACH AT THE LONDON COLLEGE OF PRINTING AND THE ROYAL COLLEGE OF ART AS WELL AS LECTURING AT GLASGOW SCHOOL OF ART AND MERZ ACADEMY, STUTTGART, GERMANY. HE HAS BEEN A JUDGE AT THE SELECTION OF THE FIFTY MOST BEAUTIFUL BOOKS FOR GERMANY (FRANKFURT) AND INTERNATIONAL BOOKS (LEIPZIG).

MARK PAWSON IS A SELF-CONFESSED IMAGE JUNKIE, PHOTOCOPIER FETISHIST AND AFFICIONADO OF LO-FI PRINTING METHODS, HIS FAVOURITE TOYS/TOOLS ARE RUBBERSTAMPS AND COPIERS. HE'S A VIRTUAL ONE-MAN PRODUCTION LINE CREATING A CONSTANT STREAM OF ARTIST'S BOOKS, PRINTS, POSTCARDS, BOOKS, BADGES, T-SHIRTS AND OTHER ESSENTIAL EPHEMERA. HIS BOOKS HAVE BEEN ACQUIRED BY THE TATE GALLERY LIBRARY, UK, AND MOMA NEW YORK, HIS WORK HAS ALSO APPEARED IN CREATIVE REVIEW (DEC 1996), CHEAP DATE, VARIANT AND THE MODERN REVIEW MAGAZINES. THE 1999 RETROSPECTIVE EXHIBITION 'NO NEW WORK' WAS REVIEWED IN ART MONTHLY (SEPT 1999).

HE'S CURRENTLY WORKING ON A MEMORIAL BOOK ABOUT THE MUCH-LOVED CANON NP9030 PHOTOCOPIER WHICH HE USED TO SHARE HIS BEDROOM WITH AND SCOURING JUNK SHOPS AND CAR BOOT SALES FOR NOGGINS — '60S WOODEN VIKING FIGURES WITH FUR BEARDS. BOOKS, BADGES AND OTHER EPHEMERA ARE AVAILABLE FROM CINCH AND ARTOMATIC IN LONDON AND PRINTED MATTER, NEW YORK.

IAN WARNER/GRAPPA BLOTTO

'GRAPPA DESIGN' WAS FOUNDED IN MARCH 1989 BY THE DESIGNERS KERSTIN BAARMANN, THOMAS FRANKE, DIETER FESEKE, DETLEF FIEDLER AND ANDREAS TROGISCH. IN 1990 DANIELE HAUFE AND HEIKE GREBIN JOINED THE GROUP, AND IN 1993 FIEDLER AND HAUFE LEFT TO FORM THE GROUP 'CYAN' WHILE UTE ZSCHARNT BECAME A NEW MEMBER. 1996 SAW ANOTHER SPLIT WITHIN THE GROUP AND THE TWO SISTER FIRMS 'GRAPPA BLOTTO' AND 'GRAPPA.DOR' WERE FORMED.

AS A FREELANCE DESIGNER, TILMAN WENDLAND WAS AN IMPORTANT FIGURE IN 'GRAPPA DESIGN' AND THEN 'GRAPPA BLOTTO' BETWEEN 1992 AND 2000 WHEN HE DECIDED TO CONCENTRATE MORE INTENSELY ON HIS CAREER AS AN ARTIST. IAN WARNER JOINED GREBIN, TROGISCH AND ZSCHARNT AT 'GRAPPA BLOTTO' IN 1997 AS A FREELANCE DESIGNER AND THEN BECAME A PARTNER TOGETHER WITH MARION BURBULLA IN 2000 SHORTLY BEFORE UTE ZSCHARNT'S DEPARTURE. MARION BURBULLA THEN LEFT THE GROUP AT THE END OF 2000, LEAVING HEIKE GREBIN, ANDREAS TROGISCH AND IAN WARNER AS THE REMAINING PARTNERS.

'GRAPPA BLOTTO' ARE CURRENTLY WORKING TOGETHER WITH THE FREELANCE DESIGNERS DOROTHEA WEISHAUPT, BORIS BRUMNJAK AND ENIKÖ GÖMÖRI. AS OF JANUARY 2002 IT IS PLANNED THAT THE NAME 'GRAPPA' WILL BE DISBANDED COMPLETELY LEAVING TWO COMPLETELY AUTONOMOUS GROUPS WITH NEW NAMES AND STRONGER INDIVIDUAL IDENTITIES.

NICK BELL

UNA (LONDON)

5.5 ALASKA 500 BUILDING

61 GRANGE ROAD

LONDON SE1 3BA, UK

T +44 (0)20 7394 8838

E LONDON@UNA-DESIGN.NL

ANNE BURDICK

3203 GLENDALE BOULEVARD

LOS ANGELES

CALIFORNIA 90039, USA

T +1 (0)323 666 7356

E ANNE@BURDICKOFFICES.COM

WWW.BURDICKOFFICES.COM

GÜLIZAR ÇEPOĞLU TASARIM OFISI

PALANGA CAD. NO. 32

KARDESLER APT., DAIRE 3

ORTAKOY, 80840,

ISTANBUL, TURKEY

E GULIZAR@APPLEONLINE.NET

STEPHEN COATES/AUGUST MEDIA

116–120 GOLDEN LANE

LONDON EC1Y OTL, UK

T +44 (0)20 7689 4400

WWW.AUGUSTMEDIA.CO.UK

JOHN GILLETT

WINCHESTER GALLERY

PARK AVENUE

WINCHESTER SO23 8DL

HAMPSHIRE UK

T +44 (0)1962 852500

GRAPHIC THOUGHT FACILITY (GTF)

UNIT 410

31 CLERKENWELL CLOSE

LONDON EC1R OAT, UK

T +44 (0)20 7608 2441

MARK PAWSON

P.O.BOX 664

LONDON E3 4QR, UK

WWW.MPAWSON.DEMON.CO.UK

JUSTY PHILLIPS

24C VICARAGE GROVE

LONDON SE5 7LW, UK

T +44 (0)7970 952371

WWW.BEYONDSPACES.COM

WALKER ARTS CENTRE

VINELAND PLACE

MINNEAPOLIS

MINNESOTA 55403, USA

T +1 (0)612 375 7600

WWW.WALKERART.ORG

JAN VAN TOORN

JAVAKADE 742

1019 SH

AMSTERDAM, NL

T +31 (0)20 419 4163

E WJVT@XS4ALL.COM

UNA (AMSTERDAM)

MAURITSKADE 55

1092 AD

AMSTERDAM, NL

T +31 (0)20 668 6216

E AMSTERDAM@UNA-DESIGN.NL

RUDY VANDERLANS

EMIGRÉ

4475D STREET

SACRAMENTO

CALIFORNIA 95819, USA

WWW.EMIGRE.COM

IAN WARNER/GRAPPA BLOTTO

ZEHDENICKER STRASSE 21

10119 BERLIN

GERMANY

T +49 (0)30 4435 0302

WWW.GRAPPABLOTTO.DE

PETER WILLBERG

CLARENDON ROAD STUDIO

25 CLEVELAND ROAD

LONDON E18 2AN, UK

T +44 (0)20 8530 7359

E PBWILLBERG@AOL.COM

ALIGNMENT: RANGED LEFT, RAGGED (OR UNJUSTIFIED) RIGHT

A STYLE OF SETTING TYPE IN WHICH THE TYPE ALIGNS LEFT, CREATING A HARD LEFT VERTICAL EDGE AND REMAINS RAGGED OR UNJUSTIFIED ON THE RIGHT. THE LINES OF TYPE ARE SET WITH EQUAL INTER-WORD SPACING, RESULTING IN IRREGULAR LINE LENGTHS. TYPE IS SET TO A DETERMINED MEASURE OR LENGTH. THE RAGGED EDGE IS DETERMINED BY THE NUMBER OF WORDS THAT WILL FIT ON EACH LINE. IN TEXT THAT IS UNHYPHENATED A WORD THAT IS TOO LONG TO FIT ON THE LINE WILL BE TAKEN OVER TO THE NEXT LINE, A RESULTING GAP IS LEFT AT THE END OF THE PREVIOUS LINE. JUDICIAL USE OF WORD BREAKS ARE USUALLY NECESSARY, ESPECIALLY ON TECHNICAL SETTING WITH LONGER WORDS AND OVER SMALLER MEASURES. THIS STYLE OF SETTING IS MORE COMMONLY FOUND IN ASYMMETRIC DESIGN.

ALIGNMENT: RANGED RIGHT, RAGGED (OR UNJUSTIFIED) LEFT

THIS STYLE ALIGNS THE TYPE RIGHT, CREATING A HARD RIGHT VERTICAL LINE, LEAVING THE LEFT EDGE RAGGED OR UNJUSTIFIED. NOT AS IMMEDIATELY READABLE AS LEFT ALIGNED TEXT, ESPECIALLY WHEN MORE THAN A FEW LINES ARE SET.

ALIGNMENT: CENTRED

A STYLE OF SETTING TYPE THAT INVOLVES A CENTRAL AXIS. IT IS A STYLE MOST ASSOCIATED WITH CLASSICAL TYPOGRAPHY AND IS A CHARACTERISTIC OF SYMMETRICAL DESIGN. EACH LINE IS CENTRED ONE UNDER THE OTHER, CREATING A RAGGED OR UNJUSTIFIED EDGE ON BOTH THE RIGHT AND LEFT SIDES OF THE TYPE. THE OUTLINE SHAPE OF THE LINES OF SETTING AND THE RELATIVE AREA IT OCCUPIES IS USUALLY TAKEN INTO ACCOUNT.

ALIGNMENT: JUSTIFIED

THE SETTING OF WORDS TO A PRE-DETERMINED MEASURE, WHERE THE LEFT AND RIGHT EDGES ALIGN. THIS IS ACHIEVED BY INSERTING A STANDARD WORD SPACE BETWEEN EACH WORD IN A LINE. SPACE IS THEN ADDED TO OR SUBTRACTED FROM THIS STANDARD SPACE TO ACHIEVE A MAXIMUM NUMBER OF WORDS PER LINE. MEASURES OF MORE THAN 60 CHARACTERS TEND TO BE TIRING TO READ AND UNLESS WORDS ARE BROKEN FROM TIME TO TIME THE WORD SPACING TENDS TO SUFFER.

BINDING

THE PROCESS BY WHICH PAGES ARE ASSEMBLED AND COVERS ARE FIXED TO THE BODY OF A BOOK. MECHANICAL BINDING METHODS INCLUDE COMB BINDING AND RING BINDING. BOOK BINDING METHODS INCLUDE: CASE BINDING, SECTION-SEWN, SIDE-SEWN, PERFECT BINDING (ADHESIVE, NOTCHED, DOVE-TAIL AND BURST) AND SADDLE STITCH (STAPLED).

CHAPTER

THE MAIN DIVISION IN A BOOK THAT SIGNIFIES A KEY CHANGE IN CONTENT.

CMYK

THE ABBREVIATION OF THE FULL- OR FOUR-COLOUR PRINTING PROCESS COLOURS: CYAN (C), MAGENTA (M), YELLOW (Y) AND BLACK OR KEY (K). BLACK IS REFERRED TO AS KEY AS IT PROVIDES THE KEY OR GUIDE FOR THE REGISTER OF THE OTHER THREE PROCESS COLOURS. CYAN IS A SPECIAL SHADE OF BLUE. MAGENTA IS A SPECIAL SHADE OF RED (PINK IN APPEARANCE).

COATED AND UNCOATED STOCK

COATED IS ALTERNATIVELY KNOWN AS ART PAPER IN THE UK. THE SURFACE OF THE PAPER HAS A MINERAL COVERING SUCH AS CHINA CLAY APPLIED. THIS COATING ALLOWS FOR INKS TO 'SIT' ON THE SURFACE OF THE PAPER RATHER THAN BEING ABSORBED. COATED PAPER IS IDEAL FOR REPRODUCTION OF HALF-TONE IMAGES. THE SURFACE HAS A SMOOTH FINISH TO THE TOUCH. UNCOATED PAPERS DON'T HAVE SUCH A COATING AND ABSORB THE INK READILY INTO THE BODY OF THE PAPER.

COLUMN(S)

THE DIVISION OF A PAGE INTO VERTICAL UNITS WITHIN THE MARGINS. COLUMNS ARE SEPARATED BY SPACE. THEY CONTAIN TEXT OR OTHER MATTER. COLUMNS ARE MEASURED BY THEIR WIDTH, KNOWN AS THE 'MEASURE'. COLUMNS FORM WHAT IS COMMONLY KNOWN AS THE GRID. A GRID UNIFIES ALL MATTER INTO A CO-ORDINATED WHOLE.

COLUMN INTERVAL

ALSO REFERRED TO AS THE INTER-COLUMN SPACE OR GUTTER. THIS IS A MEASUREMENT THAT SEPARATES COLUMNS INTO INDIVIDUAL DIVISIONS.

COVER

THE PAPER OR BOARD TO WHICH THE BODY OF A BOOK IS BOUND AND THEREBY PROTECTED.

DIE-CUT

THE CUTTING OF PAPER OR BOARD, TO A PARTICULAR DESIGN OR SHAPE, BY PRESSURE FROM THIN BLADES MOUNTED ONTO A FORM CALLED A DIE. DIE-CUTTING IS USED WHEN THE SHAPE IS TOO COMPLEX TO BE TRIMMED BY GUILLOTINE

EM AND EN

AN EM IS A MEASUREMENT, USUALLY A SQUARE, THAT IS THE SAME WIDTH AS THE TYPESIZE BEING SET; A 12PT EM OR PICA EM IS 12PT WIDE. THE TERM DERIVES ITS NAME FROM THE LETTER M WHICH IS NORMALLY EQUIVALENT TO A SQUARE. AN EN IS HALF THIS WIDTH.

FONT(UK)/FOUNT(US)

FONT IS NOW THE UNIVERSALLY ADOPTED TERM. TRADITIONALLY A FONT REFERRED TO A SET OF TYPE OF THE SAME DESIGN, STYLE AND SIZE (INCLUDING UPPER- AND LOWERCASE LETTERS, NUMERALS AND PUNCTUATION MARKS). CURRENTLY THE TERM DEFINES A FONT AS A SET OF CHARACTERS OF THE SAME DESIGN AND STYLE. THE TERM HAS BEEN USED, SOME WOULD ARGUE INCORRECTLY, TO DESCRIBE ALL STYLES (BOLD, ROMAN, ITALIC, ETC) AND SIZES OF A TYPEFACE.

FORE-EDGE

THE OUTER EDGE OF A BOOK PARALLEL TO THE BACK.

FORMAT

FORMAT USUALLY REFERS TO THE SIZE OF A PAGE, BOOK OR PUBLICATION, BUT CAN ALSO INCLUDE THE STYLE, SHAPE AND OVERALL APPEARANCE AS WELL. 'TO FORMAT' MEANS TO ATTRIBUTE TYPE CHARACTERISTICS SUCH AS FONT, SIZE, WEIGHT, TRACKING, LEADING, ETC.

FRENCH FOLD

A SHEET OF PAPER, PRINTED ON ONE SIDE AND THEN FOLDED TWICE, ONCE VERTICALLY AND ONCE HORIZONTALLY, TO FORM AN UNCUT FOUR-PAGE SECTION. THE PRINTED PAGES ARE 1, 4, 5 AND 8.

GOLDEN SECTION

THE GOLDEN SECTION, LIKE ALL PURE PROPORTIONS, CAN BE CONSTRUCTED FROM A CIRCLE AND A SQUARE. CLOSELY RELATED TO THE FIBONACCI SERIES (1, 1, 2, 3, 5, 8, 13, 21, 34). ONCE THE SEQUENCE REACHES 21, ADJACENT PAIRS STABILISE AROUND THE RATIO OF 1:1.618. WIDELY CONSIDERED TO BE ONE OF THE MOST HARMONIOUS AND PLEASING PROPORTIONS. JAN TSCHICHOLD UTILISED IT FOR THE PENGUIN BOOK SERIES (UK).

GUTTER

THE SPACE OR BACK MARGIN AT THE CENTRE OF A DOUBLE PAGE SPREAD. ALSO REFERS TO THE SPACE BETWEEN TWO ADJACENT COLUMNS (SEE COLUMN INTERVAL).

HALFTONE

THE PROCESS BY WHICH CONTINUOUS TONE IMAGES SUCH AS PHOTOGRAPHS ARE CONVERTED TO A PATTERN OF DOTS OF VARYING SIZES AND DENSITY NECESSARY FOR PRINTING. HALFTONES MAY BE BLACK AND WHITE, DUOTONES OR FULL COLOUR.

HEAD MARGIN

THE MARGIN OR SPACE AT THE TOP OF A PAGE; BETWEEN TYPE AND TRIMMED EDGE.

HEADLINE

SEE TEXT.

IMAGE

A TERM USED TO DESCRIBE THE SUBJECT REPRESENTED IN A REPRODUCTION PROCESS.

IMPOSITION

THE LAYING-DOWN OF PAGES IN POSITION FOR PRINTING, IN SUCH A WAY AS TO ENSURE THE CORRECT SEQUENCE WHEN PRINTED, FOLDED AND TRIMMED. ADJUSTMENTS ARE MADE TO MARGINS ACCORDING TO WHERE PAGES FALL IN THE SECTION.

JAPANESE BINDING

A SPECIAL FORM OF BINDING WHERE THE FORE-EDGE REMAINS UNTRIMMED. THIS ALSO DESCRIBES A BINDING WHERE SEWING IS TAKEN THROUGH A BOOK FROM FRONT TO BACK COVER.

KERNING

THE OPTICAL ADJUSTMENT OF SPACE BETWEEN TWO ADJACENT CHARACTERS IN ORDER TO CREATE THE APPEARANCE OF EVENNESS. LETTERS SUCH AS A L T V W NEED PARTICULAR ATTENTION.

LEADING

ALSO KNOWN AS LINE FEED, INTERLINE SPACING OR PITCH. THE TERM ORIGINATES FROM HOT METAL SETTING AND THE PRACTICE OF INSERTING STRIPS OF LEAD BETWEEN SUCCESSIVE LINES OF TYPE. LEADING THEREFORE IS THE SPATIAL INTERVAL BETWEEN LINES. TO ASCERTAIN THE AMOUNT OF LEADING UTILISED, BASELINE TO BASELINE MEASUREMENTS ARE MADE.

LOOSE LEAF

A METHOD OF BINDING THAT FACILITATES THE INSERTION OR REMOVAL OF INDIVIDUAL LEAVES OR PAGES. EXAMPLES INCLUDE WIRE, RING AND COMB BINDING.

UPPERCASE AND LOWERCASE

THESE TWO TERMS ARE A LEGACY FROM THE DAYS OF METAL SETTING AND THE PRACTICE OF STORING TYPE IN CASES. CAPITAL LETTERS OR MAJUSCULES WERE CONTAINED IN THE CASE ABOVE THE CASE OF THE SMALL LETTERS OR MINUSCULES. LOWERCASE LETTERS ARE THE ALPHABET SET OF SMALL LETTERS AS OPPOSED TO CAPITALS. UPPERCASE, CAPITALS, OR CAPS, DERIVE THEIR NAME FROM THE STYLE OF INSCRIPTION AT THE HEAD, OR CAPITAL, OF A ROMAN COLUMN.

MARGIN

THE SPACE AROUND THE PERIMETERS OF A PAGE THAT DEFINES THE TEXT AND IMAGE AREA. THE FOUR MARGINS ARE ENTITLED HEAD (TOP), TAIL OR FOOT (BOTTOM), BACK (INSIDE) AND FORE-EDGE (OUTER).

A

HEAD OR
TOP MARGIN

B

FOOT OR
BOTTOM MARGIN

C

FORE-EDGE OR
OUTER MARGIN

D

BACK-EDGE OR
INSIDE MARGIN

E

COLUMN

F

INTER-COLUMN SPACE
OR GUTTER

E F

The cap height of this line of text is
aligning with what is called a hanging or
drop line. Photographs and illustrations
can also align from this point. A hanging
line is often adopted in order to create
a feeling of space and to avoid the page
appearing to be jam packed.

C

1 First line of text.
2
3 This column of type is set to a measure
4 of 56mm and demonstrates the number of
5 lines possible of 7/10pt OCRF.
6
7 The cap height of the first line of
8 text aligns with the top or head margin
9 (9mm from the top of the page) and the
10 baseline of the last line of type (the
11 folio and running foot) aligns with the
12 bottom or foot margin (9mm from the
13 bottom of the page) two lines below the
14 last line of body text.
15
16 The text is divided into paragraphs with
17 one line space separating them.
18
19 Lorem ipsum dolor sit amet, consect et
20 adipiscing elit, sed diam nonummy nibh
21 euismod tincidunt ut laore et dolore
22 magna aliquam erat volutpat. Ut wisi enim
23 ad minim ven iam, quis nostrud exerci
24 tation ullam corper suscipit lobortis nisl
25 ut aliquip ex ea commodo consequat duis
26 autem vel eum iriure dolor in hendre rit
27 in vulputate velit esse molestie conse
28 quat, vel illum dolore eu feugiat nulla
29 facilisis at vero eros.
30
31 Et accumsan et iusto odio dignissim qui
32 blandit praesent luptatum zzril delenit
33 augue duis dolore te feugait nulla facil
34 isi. Lorem ipsum dolor sit amet, consect
35 etuer adipiscing elit, sed diam nonummy
36 nibh euismod tin cidunt ut laoreet dolore
37 magna aliquam erat.
38
39 Ut wisi enim ad minim veniam, quis nos
40 trud exerci tation ullamcorper suscipit
41 lobortis nisl ut aliquip ex ea commodo
42 consequat. Duis autem vel eum iriure
43 dolor in hendrerit in vulputate velit esse
44 molestie consequat, vel illum do lore eu
45 feugiat nulla facilisis at vero eros et
46 accumsan et iusto odio dignis sim qui
47 blandit praesent luptatum zzril delenit
48 augue duis dolore te feugait nulla.
49
50 Nam liber tempor cum soluta nobis
51 eleifend option congue nihil imperdiet
52 doming id quod mazim placerat facer
53 possim assum. Lorem ipsum dolor sit
54 amet, consectetuer adipiscing elit, sed
55 diam nonummy nibh euismod tincidunt
56 et accumsan et iusto odio dignissim qui
57 blandit praesent luptatum zzril.
58
59 Last line of text (59 lines in total).
60
61
62 Folio and running foot

B

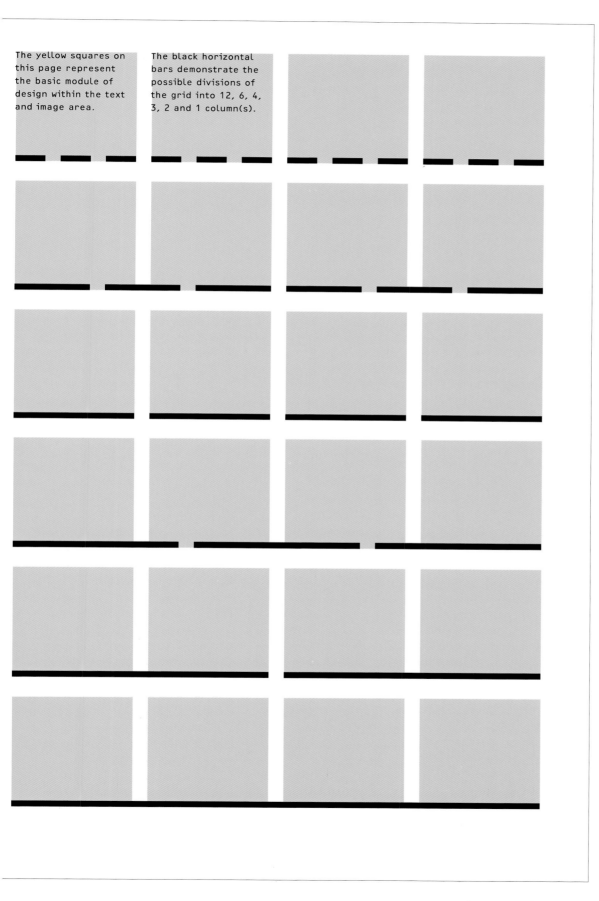

The yellow squares on this page represent the basic module of design within the text and image area.

The black horizontal bars demonstrate the possible divisions of the grid into 12, 6, 4, 3, 2 and 1 column(s).

MEDIATION

The process by which information is communicated between parties by an intermediary.

MODERNISM

Term describing the range of art and design movements and subsequent ideas that emerged during the first half of the twentieth century. Also referred to as the modern movement.

In reaction to the craft movement and ideas surrounding decoration and adornment, practitioners developed a new approach which celebrated the possibilities of the then-new technologies and methods of mass production to enable a better society for all.

Many of the art and design movements connected to modernism, such as De Stijl, Constructivism and The Bauhaus, endeavoured to celebrate functionalism and rationality under the maxim that 'form follows function'.

The Modernist approach to layout and design in general focused upon the use of white space and sans-serif typography that utilised asymmetry. This was driven by an adherence to the grid, based on geometry and the proportion of the page, as a controlling device.

MODULE

An individual unit used in the construction of a design on a page. Devised by the equal sub-division of a page both horizontally and vertically.

PAGE NUMBER OR FOLIO

For ease of reference and collation in binding, pages within a book are numbered. Page numbers are also referred to as folios. The process of numbering is known as pagination.

PANTONE

A universal colour matching system used by designers and printers to ensure accurate colour reproduction. Colour reference manuals that utilise a four figure system are available for specification.

Pantone colours are reproduced on both coated and uncoated stock in order to demonstrate the variance of colour in reproduction.

PAPER SIZES: A SIZES AND IMPERIAL SIZES

The International Standards Organisation (ISO) has determined a range of metric paper sizes.

The papers are referred to as the A, B and C series and are available in subdivisions of the largest sheet (A0). The series are related by the proportion of

1:1.414 (root 2). The proportion has the unique property that when divided in half along its long edge, it retains its original proportions. Imperial sizes are a non-metric standard size of writing and printing papers measured in inches.

PAPER WEIGHT

The weight of paper is generally expressed in grams per square metre (gsm) in Europe and pounds (lbs) in North America. Thick paper or board may be expressed in microns.

PERFECT BOUND

This method of binding books entails the trimming of the back of the leaves of a book after collation, which are then glued but not sewn. (See binding).

POSTMODERNISM

Movement that grew out of a rejection of the ideas of modernism. Significantly many of the original values of modernism had, by the late 1960s, become regarded by designers as dogmatic and only offering a fixed view or superficial style. Postmodernism celebrated a return to earlier ideas of the value of decoration and more eclectic approaches to the design process. Rejecting order or discipline in favour of expression and intuition, many of the key progenitors within the field emanated originally from Schools such as Basle in Switzerland and later Cranbrook in the US, and were tutored by central figures such as Wolfgang Weingart and Katherine and Michael McCoy.

The Postmodern lexicon of historical reference, decoration, wit and the ironic employment of vernacular or non-designed elements, such as hand-drawn typography, constitutes a departure from the rationality of earlier approaches. This significant development brought about a reappraisal of the process of visual communication within design. Embracing theoretical ideas from architecture, twentieth-century philosophy and semiotics, practitioners have attempted to advance the discussion of how relevant approaches, related to specific groups or cultures, could be developed, rather than aspiring to a universal visual language.

PROPORTIONS/FIBONACCI SERIES

Certain proportions for book production have proven themselves. The size and proportion of a book is very much determined by its use. Will the book be held by one hand or two or will it be viewed on a table? These are amongst the determining factors.

The following are popular choices in book proportions: the square; the Fibonacci series of 1:2, 2:3, 3:5, 5:8

(RATIONAL APPROXIMATION OF THE GOLDEN PROPORTION);
THE RATIONAL PROPORTIONS OF 3:4 AND 5:9;
THE IRRATIONAL PROPORTIONS OF 1:1.414 (ROOT 2),
1:1.732 (ROOT 3) AND 1:1.618 (GOLDEN PROPORTION).
THE PROPORTION OF A BOOK IS AS EQUALLY LIKELY TO BE
DETERMINED BY PRODUCTION CONSTRAINTS AND OTHER
AESTHETIC FACTORS.

RAGS
USED IN PAPER PRODUCTION. COLLOQUIAL TERM FOR THE
RAGGED LINE ENDS IN UNJUSTIFIED SETTING.

RECTO/VERSO
RECTO IS THE RIGHT-HAND PAGE OF AN OPEN BOOK,
USUALLY BEARING AN ODD-NUMBERED FOLIO. VERSO IS
THE LEFT-HAND PAGE OF A BOOK, USUALLY BEARING AN
EVEN-NUMBERED FOLIO.

RGB
THE ABBREVIATION OF THE SCREEN-BASED COLOURS OF
RED (R), GREEN (G) AND BLUE (B).

RIVERS
THE UNSIGHTLY STREAM OF WORD SPACES VERTICALLY AND/OR
DIAGONALLY WITHIN TEXT, CREATING STREAKS OF WHITE SPACE.
CAUSED BY INSUFFICIENT LEADING AND POOR JUSTIFICATION
OF TYPE.

RUNNING HEAD
THE TYPE AT THE HEAD OR TOP OF SEQUENTIAL PAGES.
THE RUNNING HEAD IS OFTEN THE TITLE OF THE BOOK OR A
CHAPTER TITLE CONTAINED WITHIN THE BOOK. THE CONVENTION
IS FOR THE BOOK TITLE TO BE PRINTED ON THE LEFT-HAND
PAGE AND THE CHAPTER TITLES TO BE PRINTED ON THE
RIGHT-HAND PAGES. RUNNING HEADS AT THE BASE OF THE
PAGE ARE REFERRED TO AS 'FOOTERS'.

SADDLE-STITCHED
THIS IS A METHOD OF BINDING BROCHURES AND BOOKLETS,
THAT INVOLVES THE SECURING OF PAGES WHILST OPENED
OVER A SADDLE-SHAPED SUPPORT. WIRE STAPLES ARE
INSERTED THROUGH THE FOLDING LINE AT THE BACK INTO
THE CENTRE SPREAD WHERE THEY ARE CLINCHED.

SECTION
A SHEET FOLDED TO FORM FOUR OR MORE PAGES OF A BOOK.
ALSO A DIVISION OF A PUBLICATION THAT IS EITHER SMALLER
THAN A CHAPTER OR COMPRISING OF MORE THAN ONE CHAPTER.

SERIF/SANS SERIF TYPE
A SERIF IS THE SMALL TERMINAL STROKE AT THE END
OF THE MAIN STROKE OF A LETTER. SANS SERIFS ARE A
CLASSIFICATION OF TYPEFACE THAT ARE CHARACTERISED BY

AN ABSENCE OF SERIFS. THEY ARE COMMONLY CONSTRUCTED
FROM STROKES OF APPROXIMATELY EVEN THICKNESS
(MONOLINEAR).

TEXT/HEADLINE
TEXT IS INFORMATION PRESENTED AS CONTINUOUS BODY COPY
SET IN COLUMNS ON A PAGE, FORMING THE MAIN BODY OF A
PUBLICATION. HEADLINE IS THE LINE OF TYPE AT THE TOP
OF THE PAGE ALTERNATIVELY KNOWN AS THE RUNNING HEAD.
A HEADLINE IS ALSO THE MAIN TITLE OF A NEWSPAPER OR
MAGAZINE (ALTERNATIVELY KNOWN AS A BANNER-HEAD).

TRACKING
TRACKING REFERS TO THE OVERALL LETTERSPACING OF A
WORD, LINE OR TEXT, AS OPPOSED TO THE INDIVIDUAL
SPACING OF CHARACTERS, WHICH IS KERNING.

TYPESIZE
TYPESIZE REFERS TO THE INVISIBLE BODY ON WHICH A
CHARACTER IS 'CAST', OR DESIGNED, AND NOT THE APPARENT
HEIGHT OF THE CAPITAL LETTERS. TYPE SIZE IS MEASURED
IN POINTS.

UNIT
A UNIT IS A PART OF A WHOLE. IN RELATION TO TYPE
MEASUREMENT A UNIT IS A SUBDIVISION OF THE EM.
COMPUTER SOFTWARE PACKAGES SUCH AS QUARKXPRESS AND
ADOBE ILLUSTRATOR EXPRESS KERNING AND TRACKING IN
TERMS OF UNIT DIVISIONS OF AN EM.

WIDOWS AND ORPHANS
A WIDOW IS A SHORT LINE OR INDIVIDUAL WORD THAT
APPEARS AT THE END OF A PARAGRAPH, COLUMN OR PAGE.
AN ORPHAN IS A SINGLE WORD OR LINE AT THE END OR
BEGINNING OF A PARAGRAPH, THAT HAS BECOME SEPARATED
FROM THAT PARAGRAPH AND APPEARS ISOLATED, EITHER AT
THE TOP OR BOTTOM OF A COLUMN OF TEXT. IT IS
CONSIDERED DESIRABLE TO CORRECT THESE EDITORIALLY.

WORD SPACING
IN SIMPLE TERMS, THE INTERVAL BETWEEN WORDS. IN
JUSTIFIED SETTING IT IS IMPORTANT TO CONTROL THE
EVENNESS OF WORD SPACING AS THIS AIDS READABILITY.
IN UNJUSTIFIED SETTING THE WORD SPACING IS VISUALLY
EVEN. COMPUTERS HAVE STANDARD DEFAULT SETTINGS THAT
CAN BE ALTERED.

BOOK LIST

Designing Books: Practice and Theory
Jost Hochuli and Robin Kinross
Hyphen 1996

20th Century Type: Remix
Lewis Blackwell
Laurence King 1998

Typography: Macro and Micro Aesthetics
Willi Kunz
Niggli 1998

The New Designers Handbook
Alastair Campbell
Little Brown and Company 1993

Typographic Design:
Form and Communication
Rob Carter, Ben Day and Philip Meggs
Van Nostrand Reinhold 1985

Production for the Graphic Designer
James Craig
Watson Guptill 1974

Hart's Rules For Compositors
and Readers
Oxford University Press 1983

Introduction to Typography
Oliver Simon
Faber and Faber 1946

Techniques of Typography
Cal Swann
Lund Humphries 1969

Typography: Basic Principles
John Lewis
Studio Books 1963

Printing Theory and Practice 4
Bookwork and Imposition
Charles L Pickering
Pitman 1948

Finer Points in the Spacing and
Arrangement of Type
Geoffrey Dowding
Hartley and Marks 1995

The Thames and Hudson Manual
of Typography
Ruari McLean
Thames and Hudson 1980

The Form of the Book
Jan Tschichold
Hartley and Marks 1991

A Dictionary of Printing Terms
Linotype 1962

'Entranced by Motion, Seduced by
Stillness'
Michael Worthington
Eye Vol.9, No.33, Autumn 1999

The Idea of Design – A Design
Issues Reader
Ed. Victor Margolin & Richard
Buchanon
MIT Press 1995

'Graphic Design Education as a
Liberal Art: Design and Knowledge in
The University and the "Real World"'
Gunnar Swanson
Design Issues Vol.10, No.1,
Spring 1994

Design Without Boundaries – Visual
Communication in Transition
Rick Poynor
Booth-Clibborn 1998

Designer's introduction, Die Fackel
Anne Burdick
Verlag der Österreichischen Akademie
der Wissenschaften 1999

Zed Magazine issues 1–5
Ed. Katie Salen
The Center for Design Studies,
Virgininia Commonwealth University
1995–2000

Visual Culture: An Introduction
John A. Walker & Sarah Chaplin
Manchester University Press 1997

ACKNOWLEDGEMENTS AND THANKS

Without the help and advice of many people it would not have been possible to realise this publication:

To our better halves, Susan and Sarah, for their forbearance and support during the making of the project.

To Kate Noël-Paton for her insightful editorship and guidance.

To Tony Pritchard for his enthusiasm and expertise in compiling the technical sections of the book.

To our colleagues and the students at the London College of Printing and to the many designers who gave so generously of their time and in permitting access to their work, we would like to say THANK YOU.